Nicholas & Payson—
Thanks!
Enjoy The Year—

Dave
7-2021

COVID
THROUGH
THE LENS

COVID THROUGH THE LENS

2020 Photography Yearbook

David J. Bell

gatekeeper press
Columbus, Ohio

Covid Through the Lens: 2020 Photography Yearbook

Published by Gatekeeper Press
2167 Stringtown Rd, Suite 109
Columbus, OH 43123-2989
www.GatekeeperPress.com

The editorial work for this book is entirely the product of the author. Gatekeeper Press did not participate in and is not responsible for any aspect of this element.

ISBN (hardcover): 9781662910302

Printed in the U.S.A.

FOREWORD AND INTRODUCTION

Welcome!

Thank-you for purchasing my journey through the year 2020 or "Covid Through The Lens". This was a year which will be remembered for decades, if not centuries!

My goal with this book, as an active and ambitious photographer, is to provide a chronological log to the year—January to December and that is how the book is organized.

As you page through the book, watch for the changing seasons, the evolving beauty of winter to spring, finally, summer then fall, and a return to winter! My home base is a photographer's paradise—mountains, deserts, mesas, rivers and streams, aspen forests, ranches, expansive vistas, and wildlife galore!

I am a resident of Pinedale, and have raised my family in this wonderful community tucked into the foothills of the Wind River Mountains of western Wyoming. I can be found most anytime on the hiking trails of western Wyoming or on a photography safari across Wyoming and surrounding states.

I'd like to thank my wonderful wife for her generous support of this hobby. We enjoy our time together in the field exploring the beauty of our country.

2020 was quite a year, but for those of us in rural parts of the country, the dreaded impacts of the COVID virus were greatly minimized. In fact, as I review my life versus those of my friends in other parts of the country, life was mostly normal—except the news every day.

We took advantage of the year to shoot over 100,000 images. Every image in this book was taken during 2020.

I hope you enjoy the book and the beauty of nature.

–Dave Bell, Pinedale
Email: davidj_bell@msn.com
Web: www.wyomingmountainphotography.com
Facebook: Wyoming Mountain Photography

CONTENTS

JANUARY

Normal Year

January began a new year and by all signs it was going to be another awesome year for America. It was an election year, but aside from all that, it was looking pretty good for America. By the latter part of the month things were still mostly normal. I had a great month of photo safaris and actively shot in Wyoming and parts of Montana.

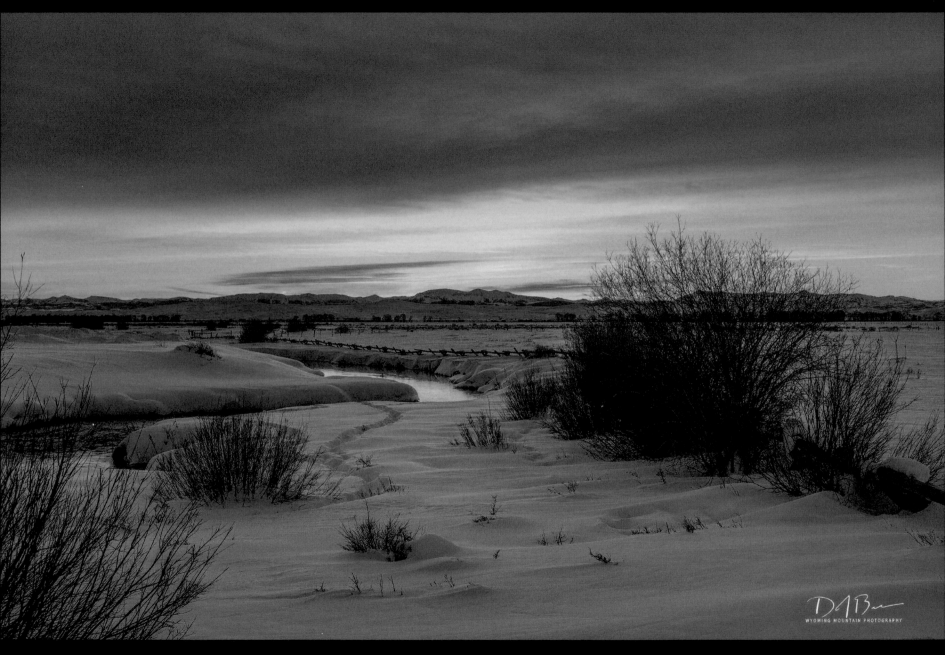

Color

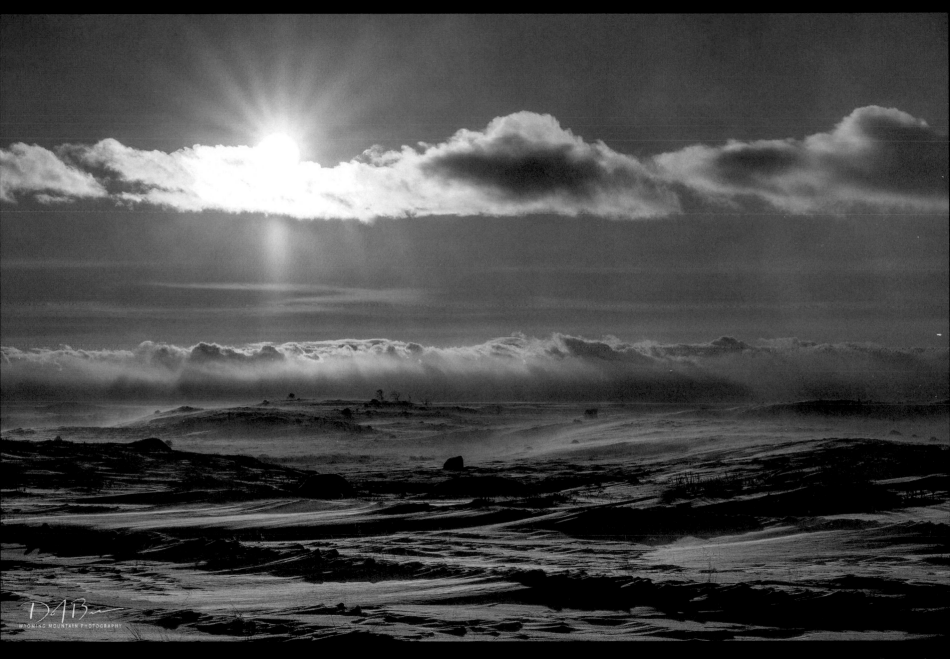

Sometimes It Is Like This

January

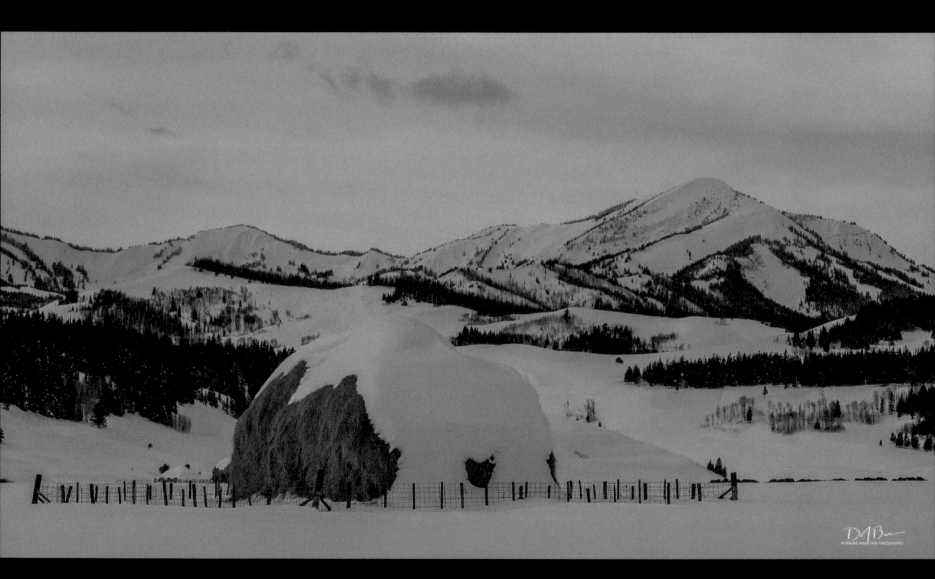

Cold Morning In Bondurant

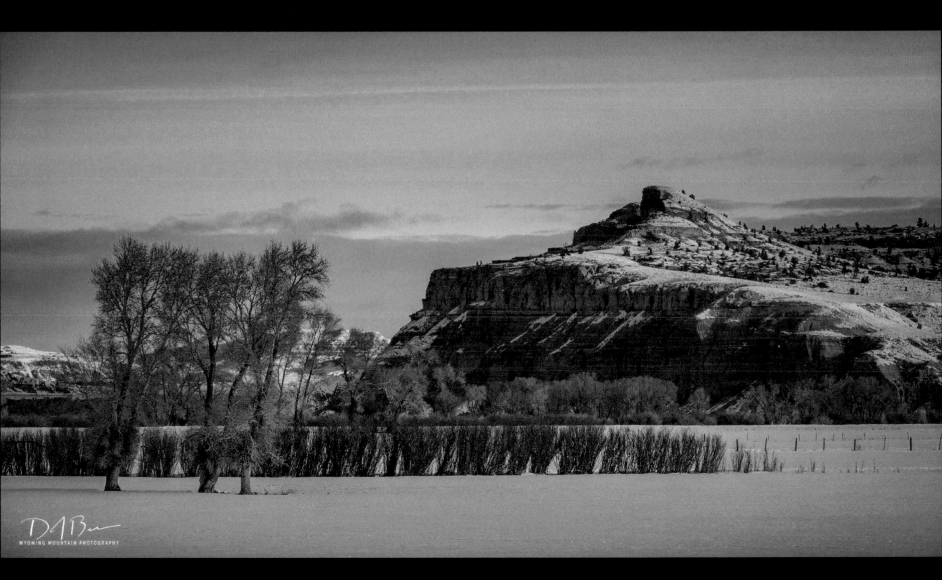

LaBarge Beauty

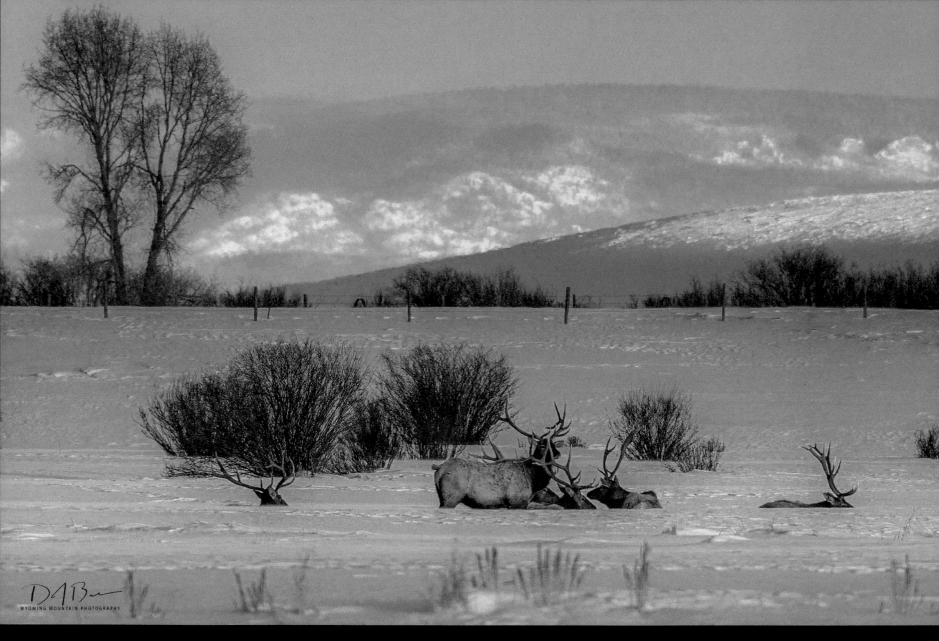

Standing Watch

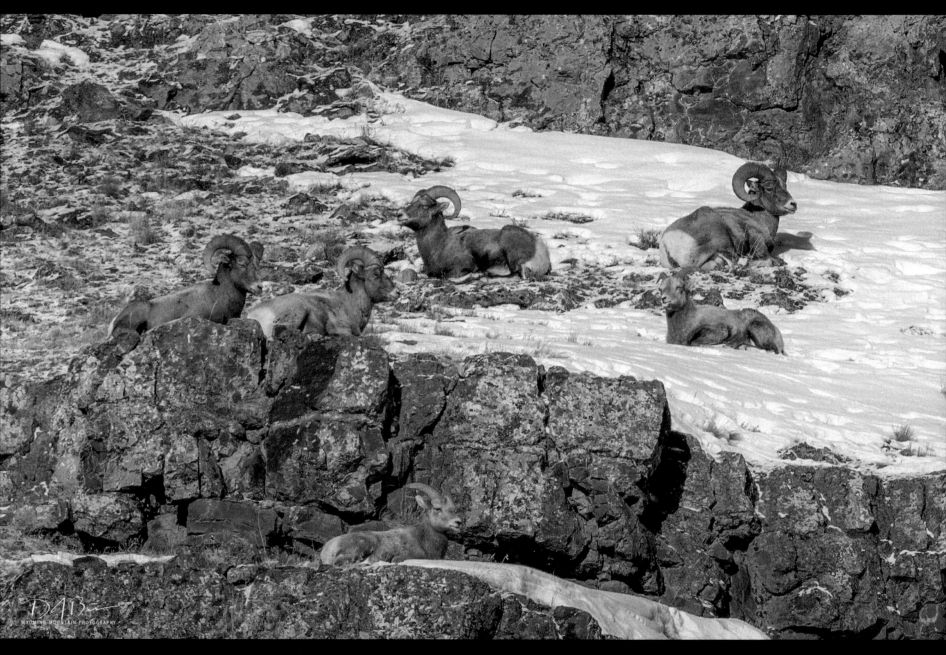

Life Is Good

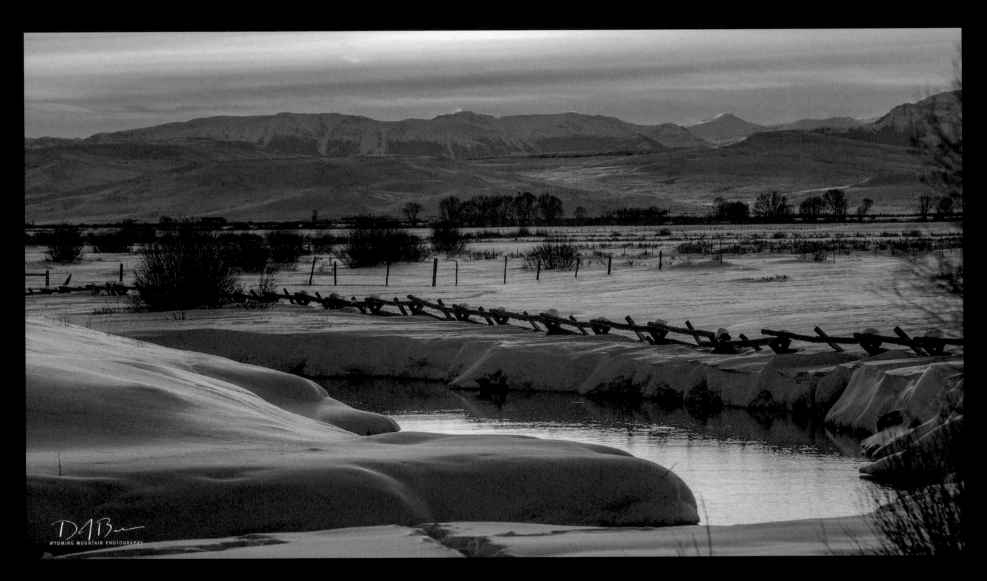

Sunset Glow

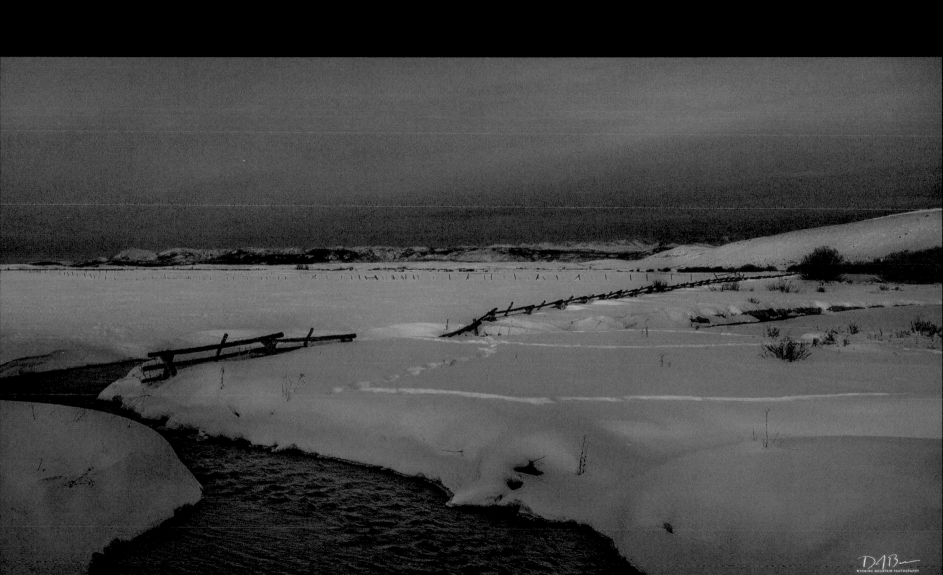

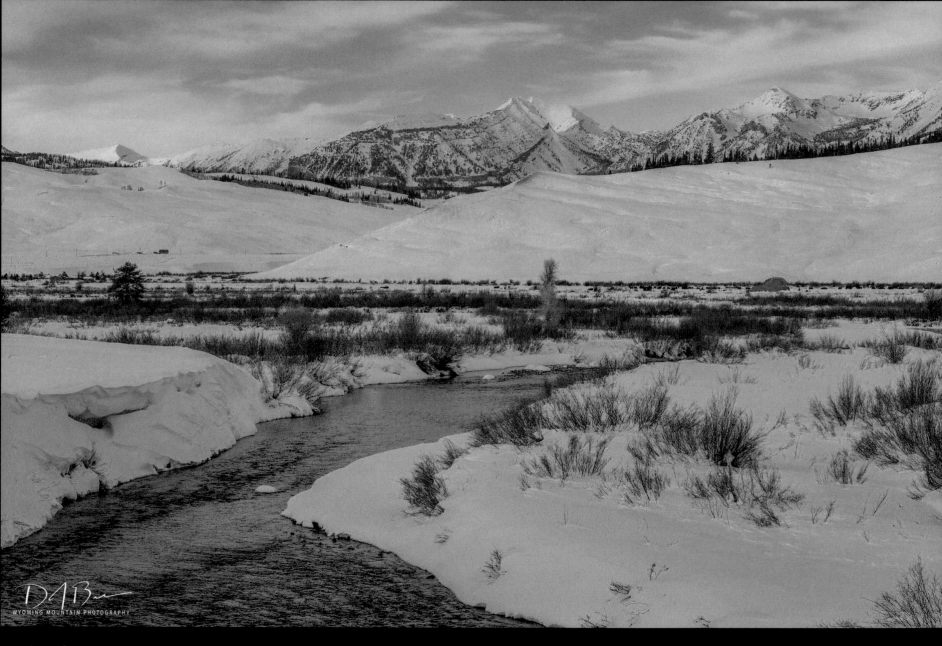

Hoback River and Gros Ventre Peaks

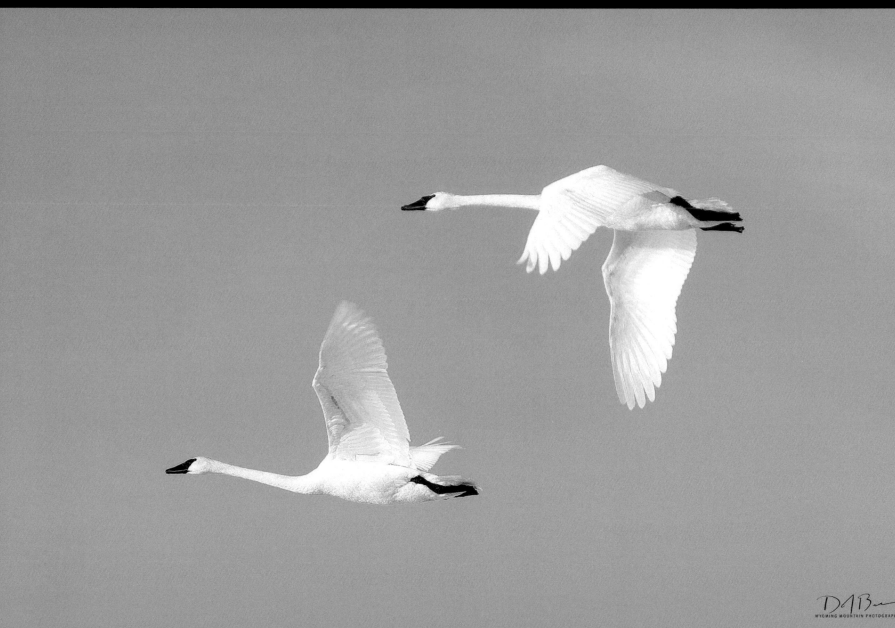

Honk When Passing

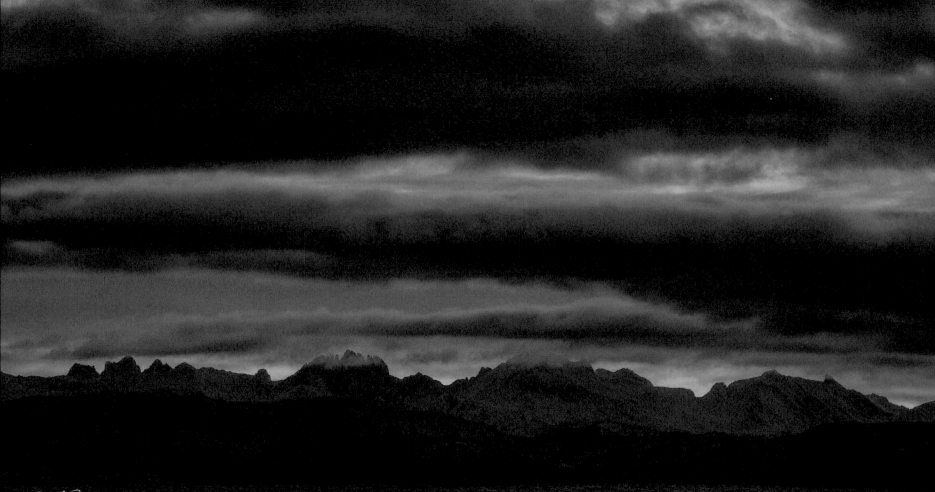

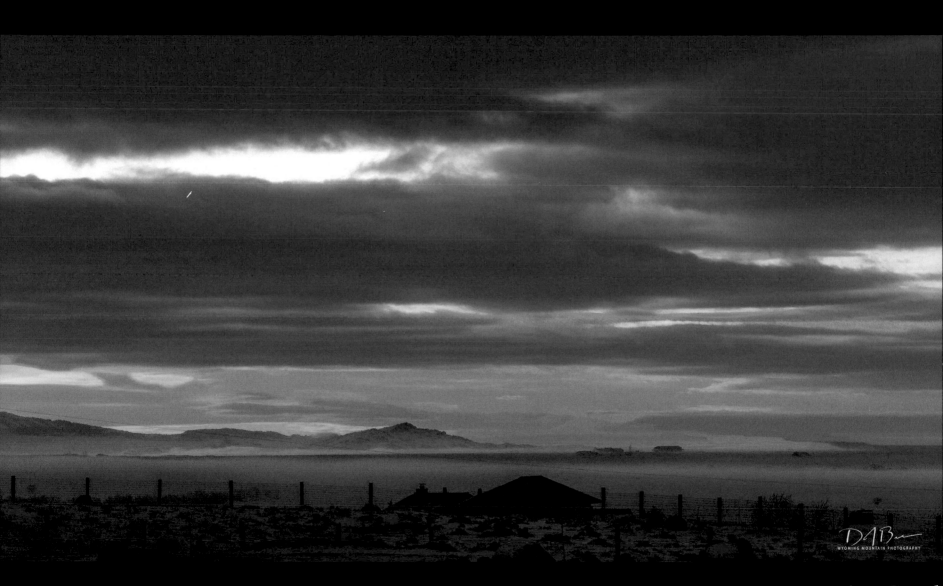

Foggy View South

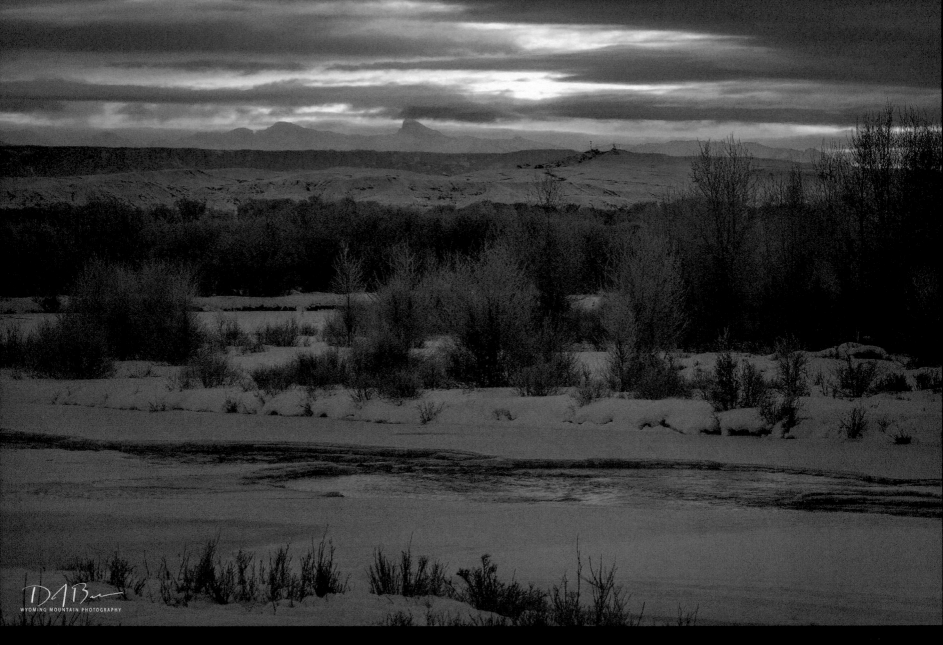

Temple Peak Dominates

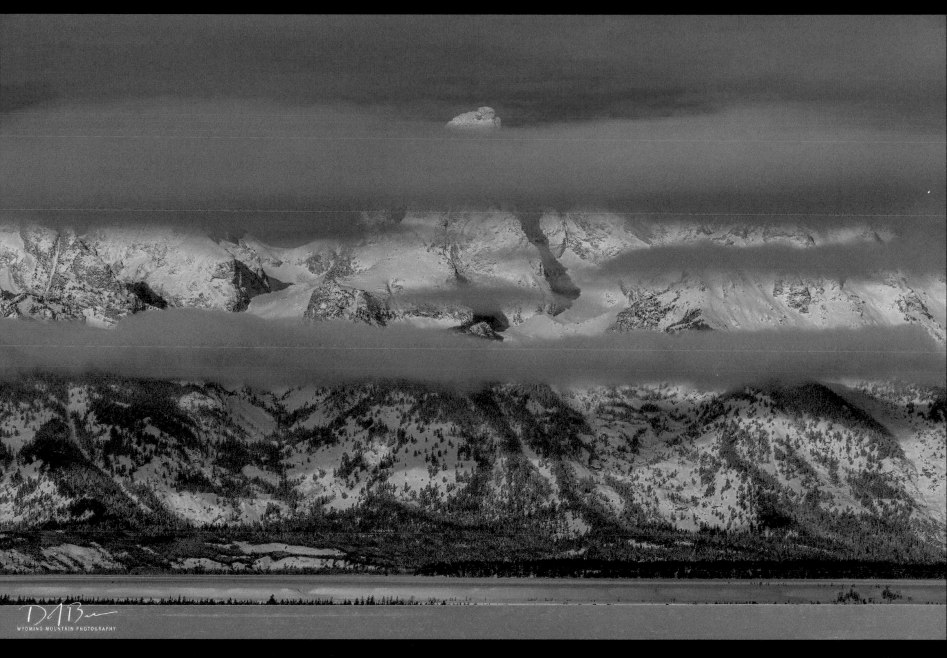

Layers

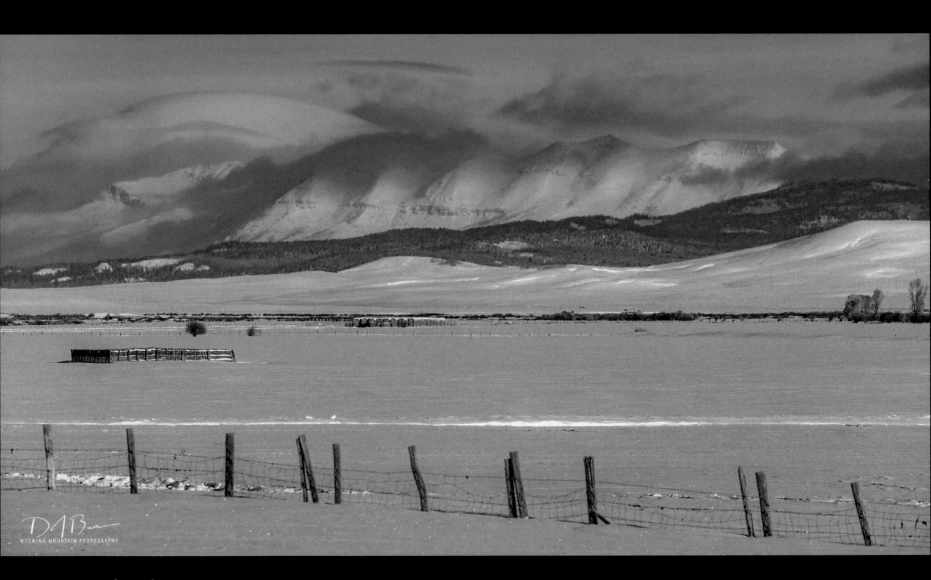

Awesome Cloud

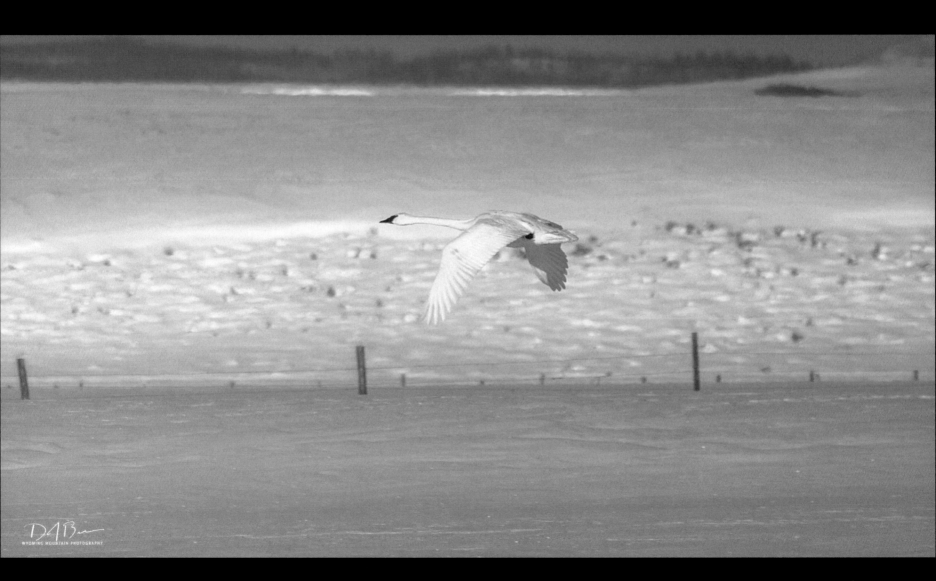

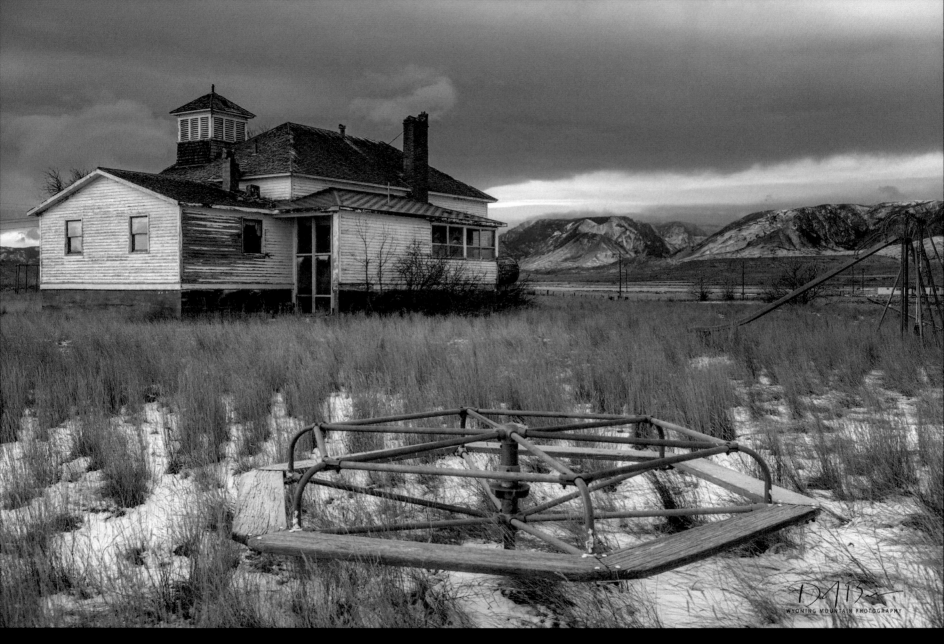

Merry Go Round

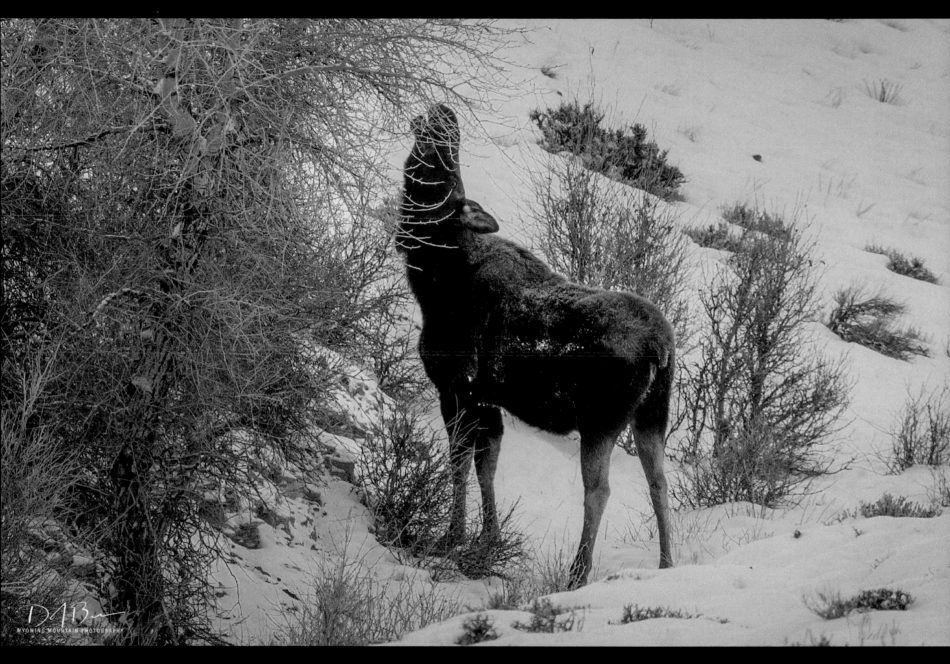

Stretching, Stretching

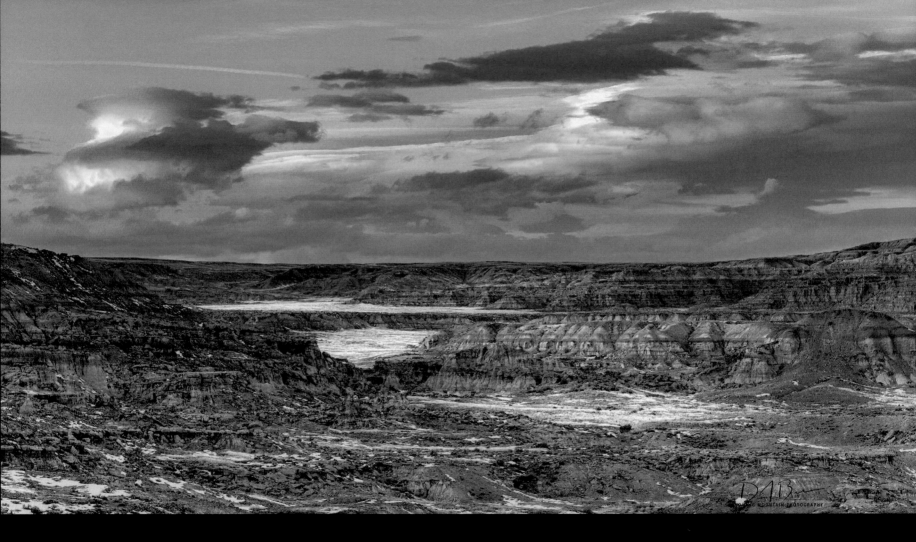

Gooseberry Badlands

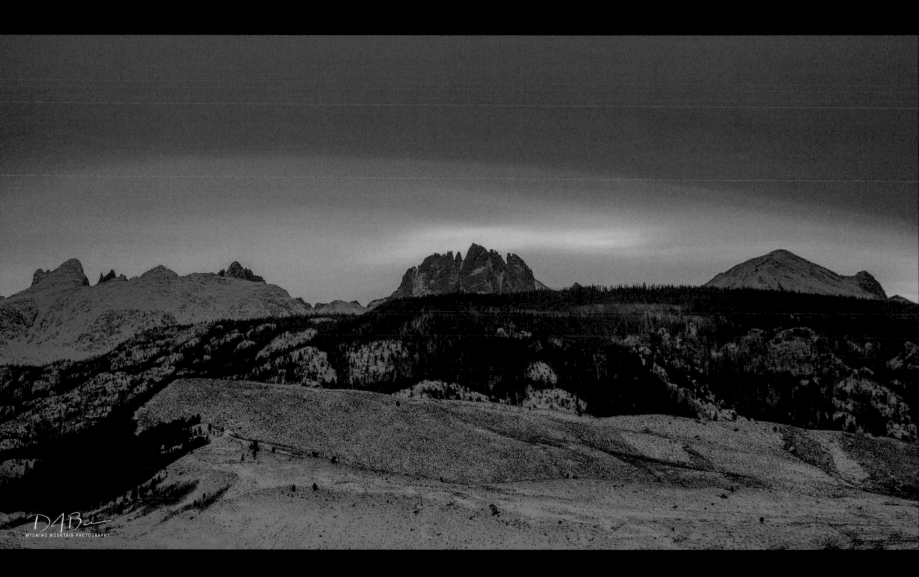

Orange Streak

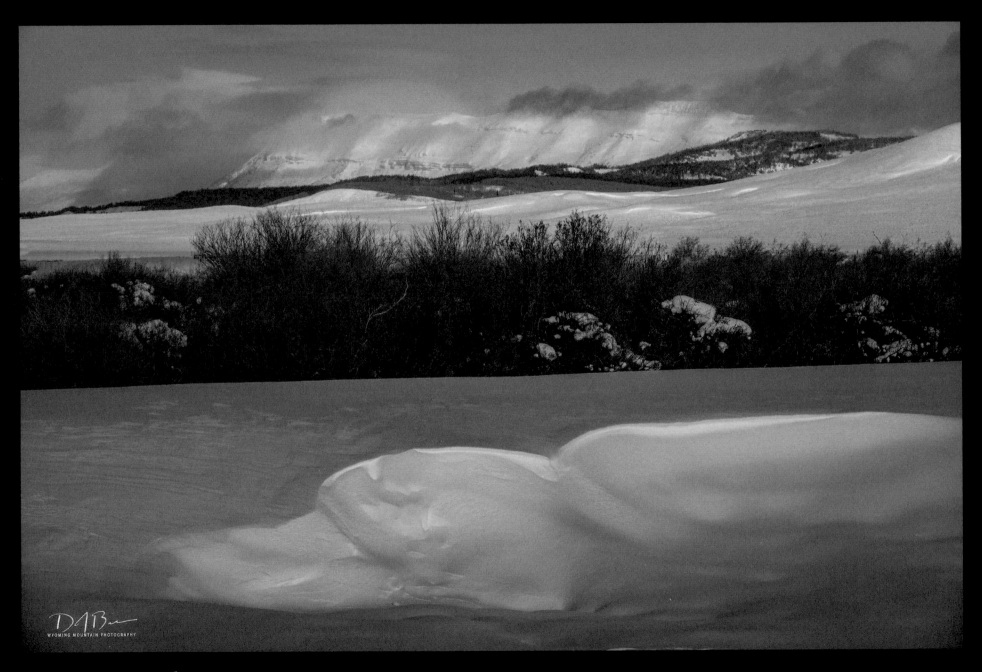

Snowy Sawtooth

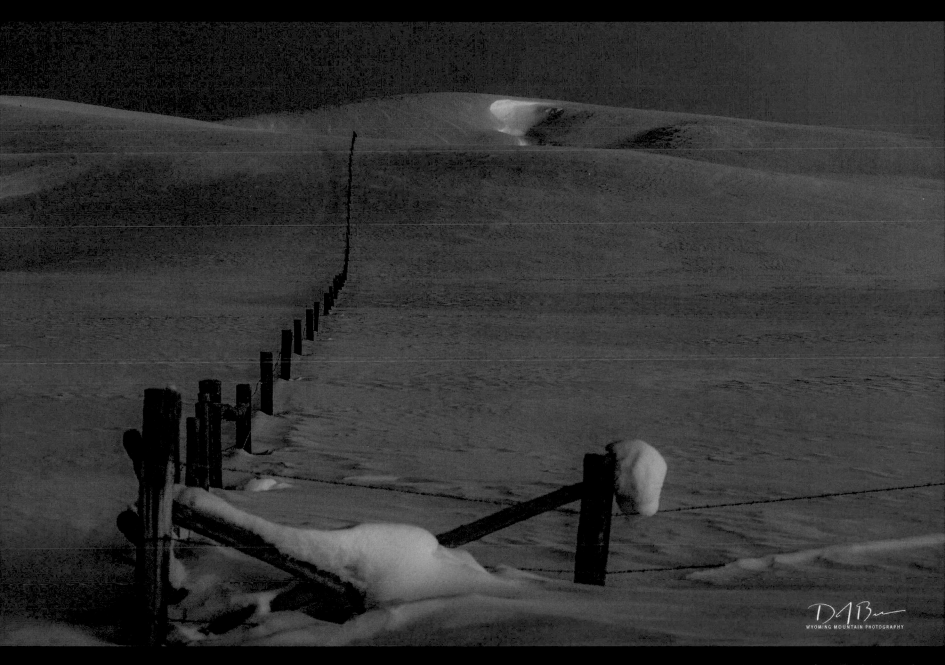

Untracked Fenceline

FEBRUARY

Something is Up

By the beginning of February it was apparent the COVID pandemic was coming to America. By the latter part of the month, it was uncertain where our future was headed. February was a snowy month with our mountains recording many feet of the white stuff. The photography was excellent. We also made a short trip to Florida, just before the COVID virus began to take hold.

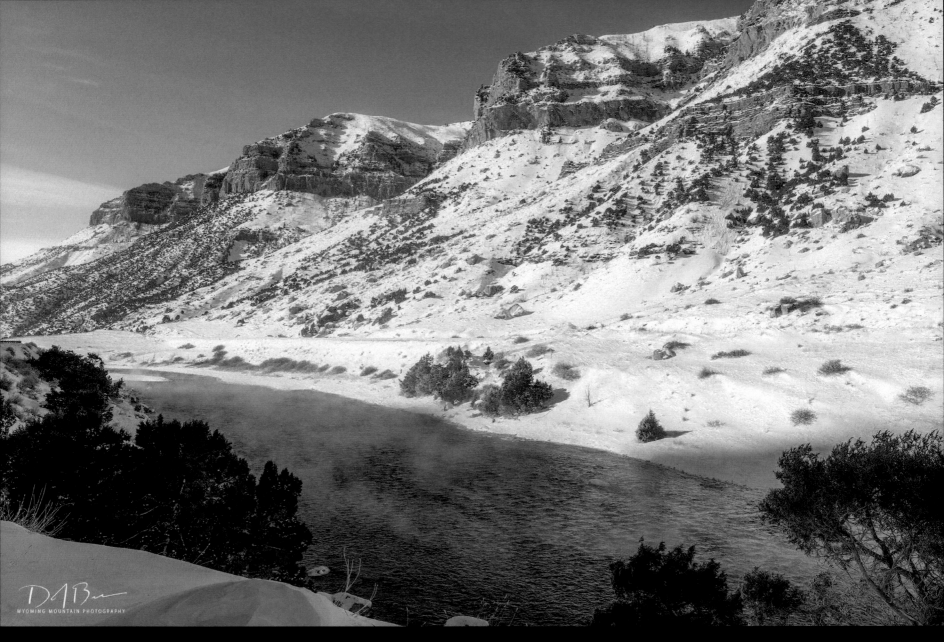

The Canyon

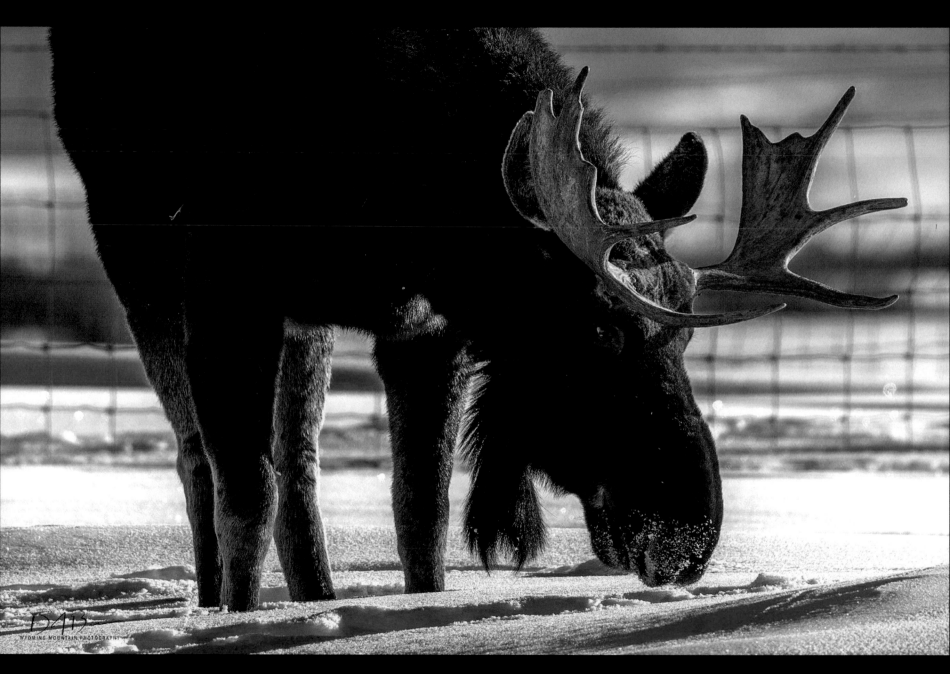

Snowy

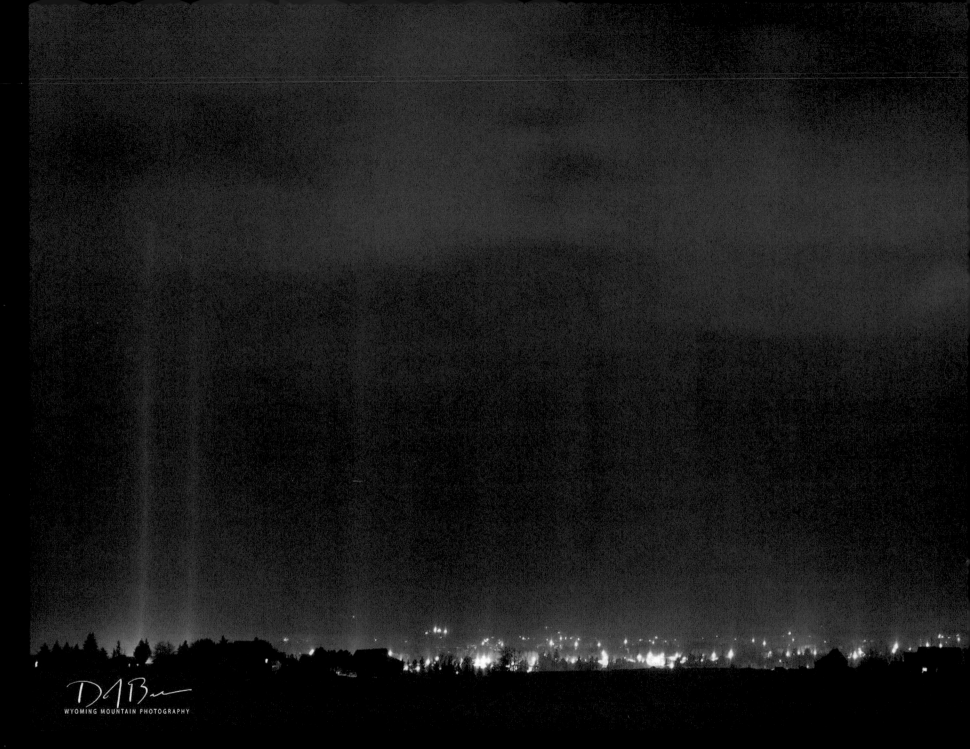

Light Pillars

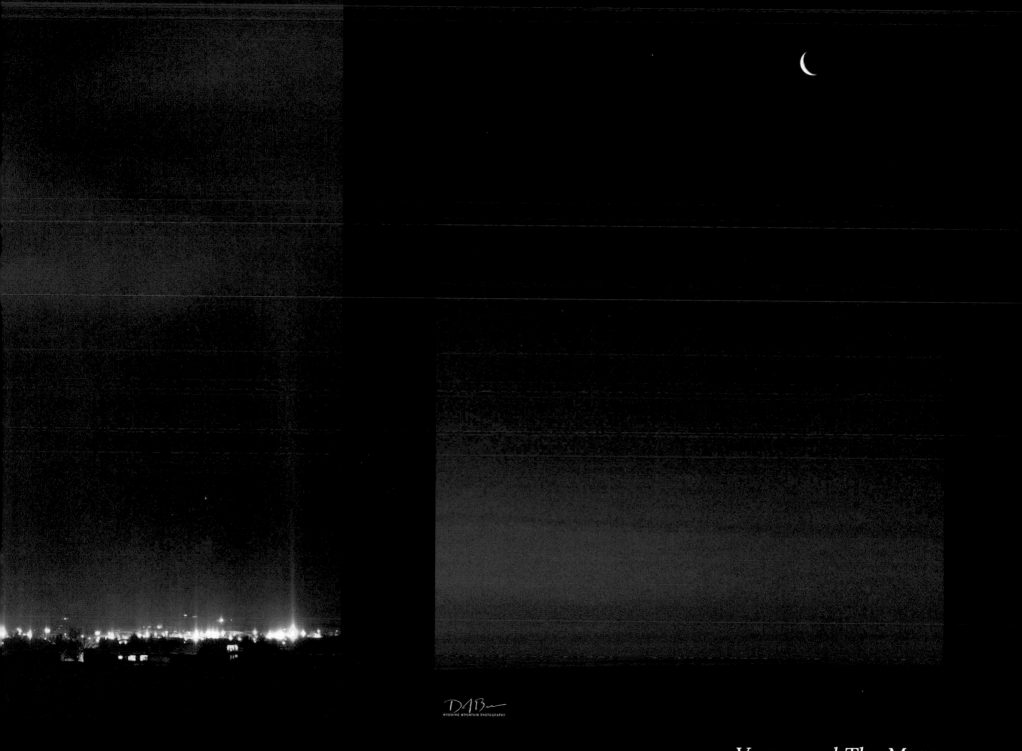

Venus and The Moon

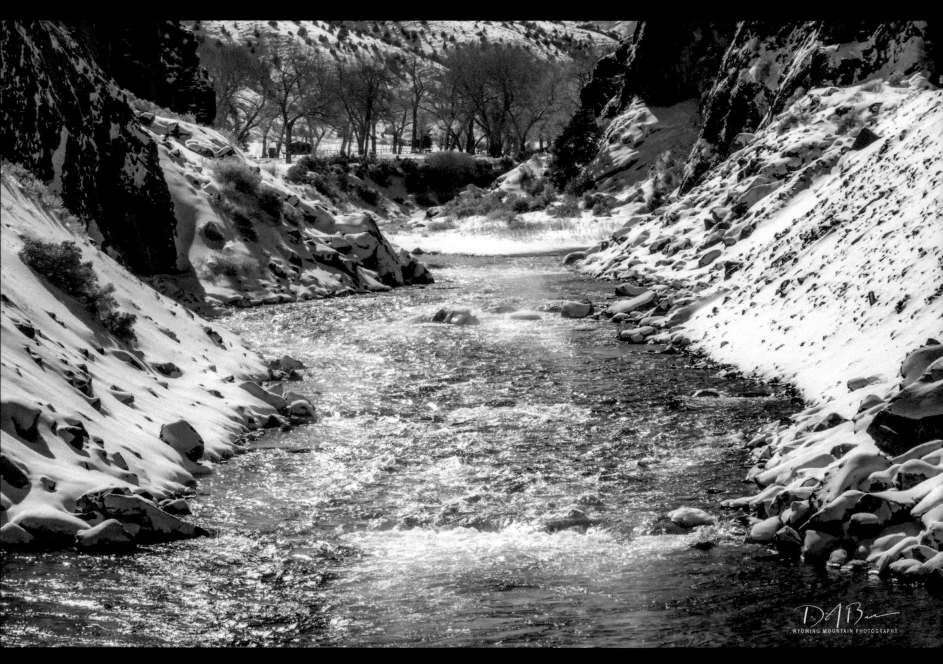

Head Of The Canyon

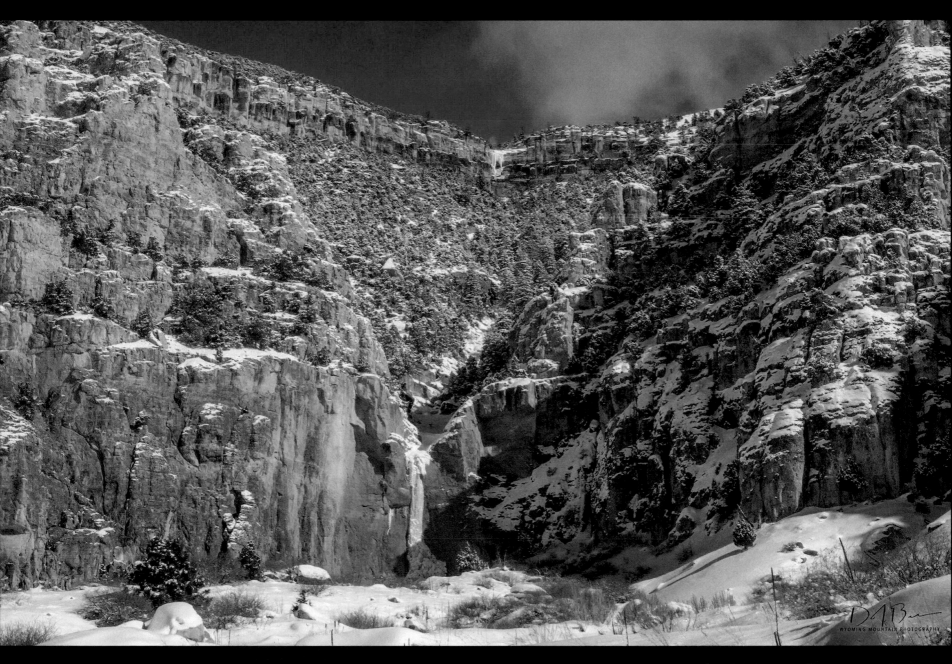

Wind River Canyon Beauty

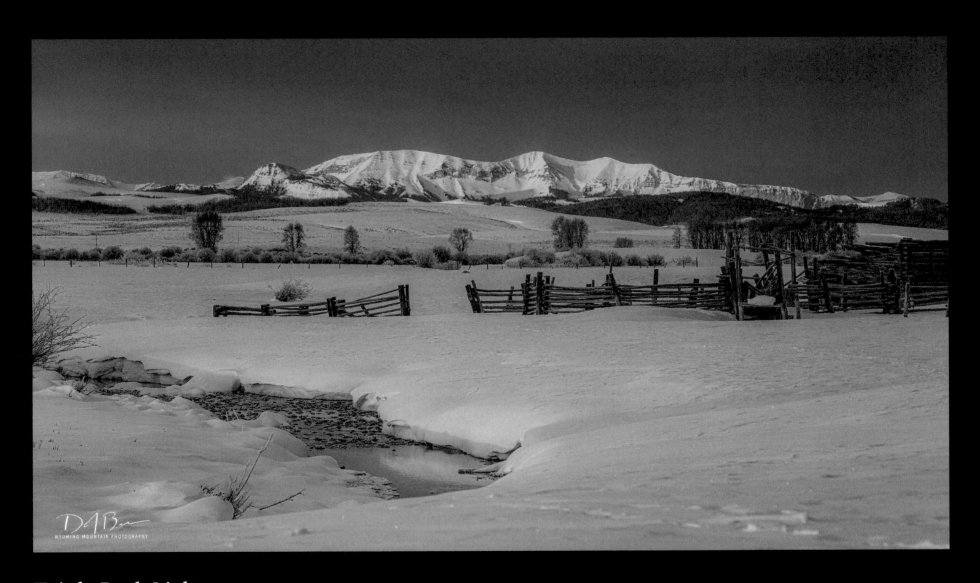

Triple Peak Light

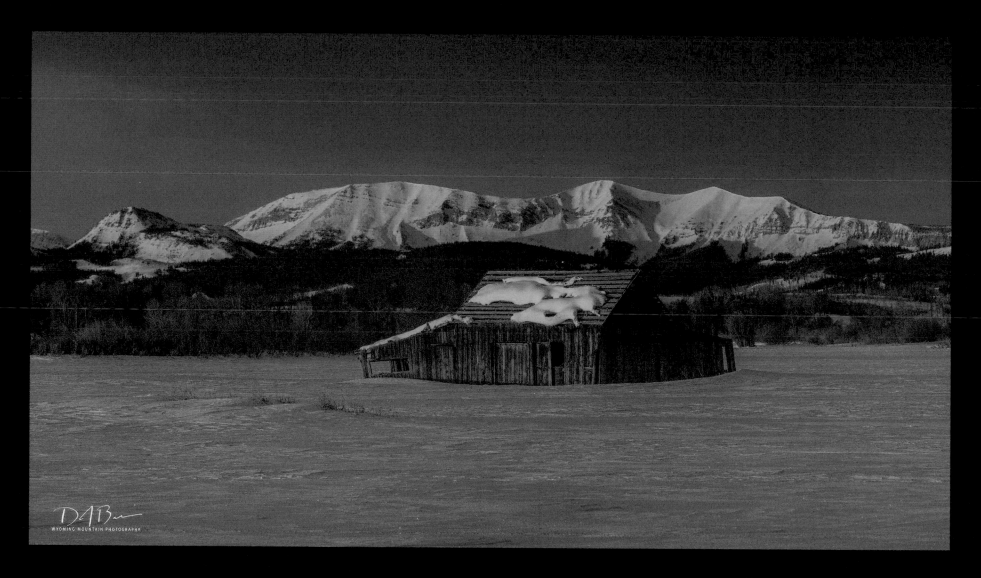

Triple Peak and Barn

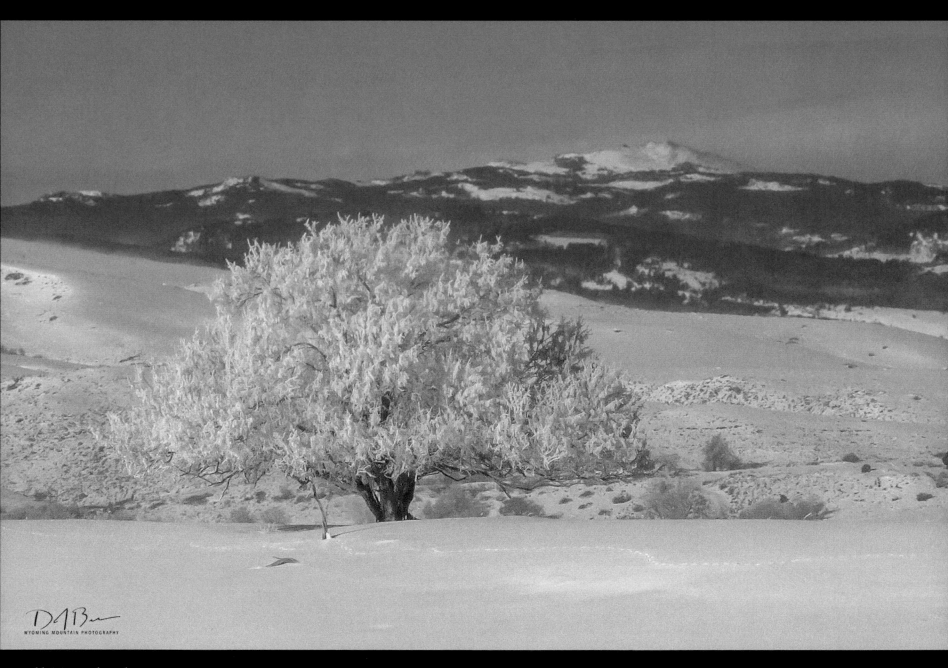

Well Frocked

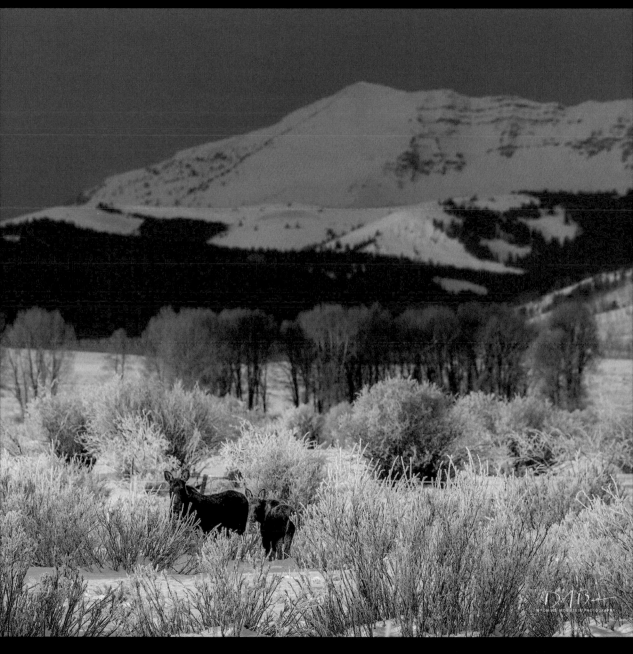

Mom and Calf

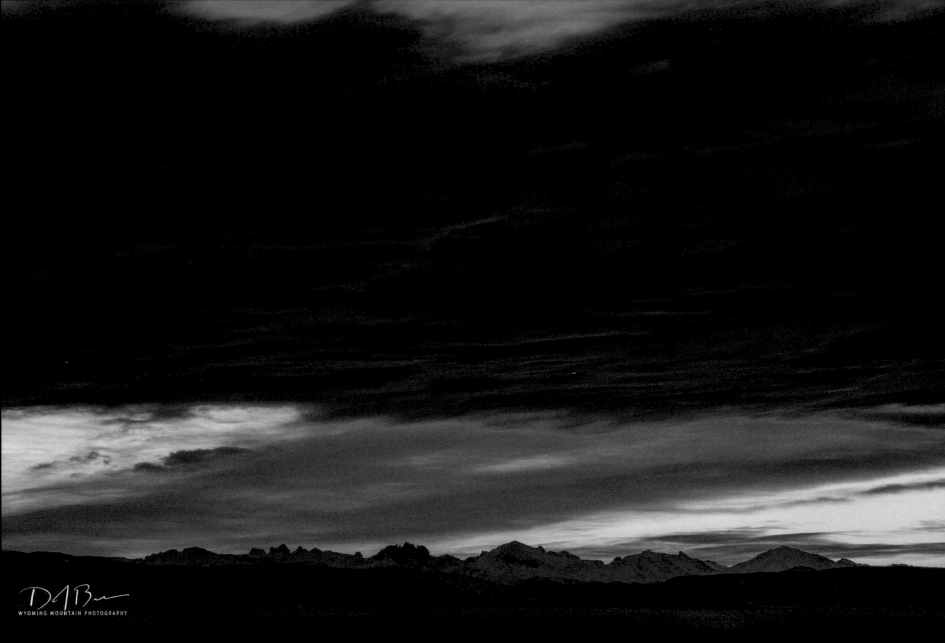

Before The Sun

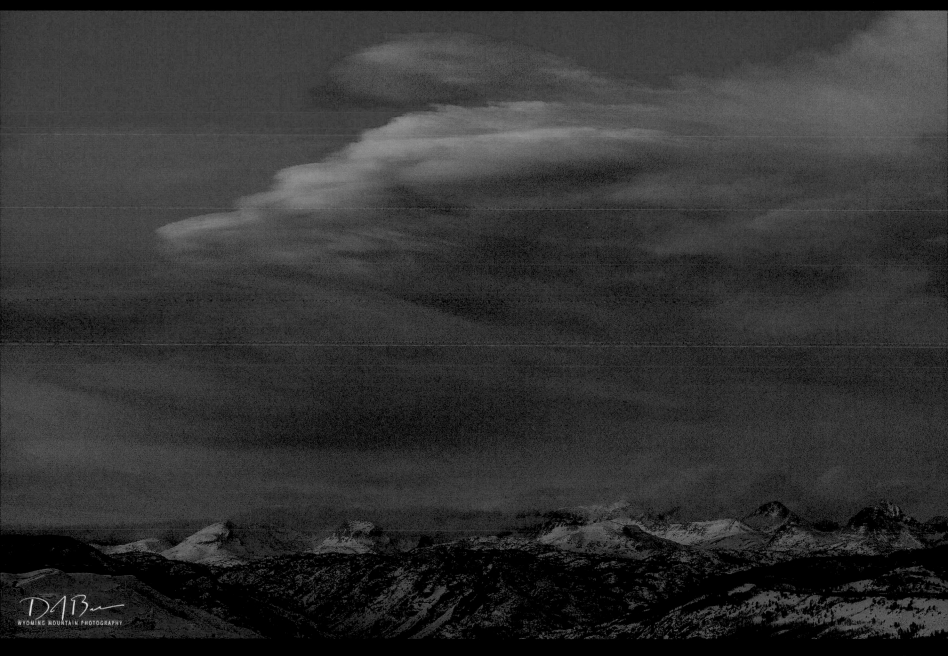

A Great Lightup

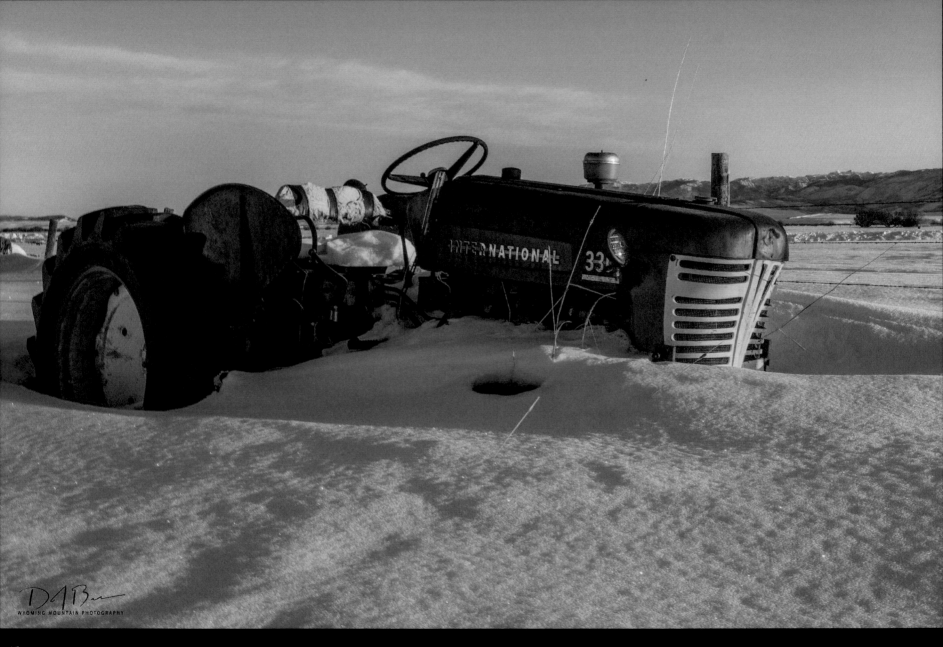

The Tractor

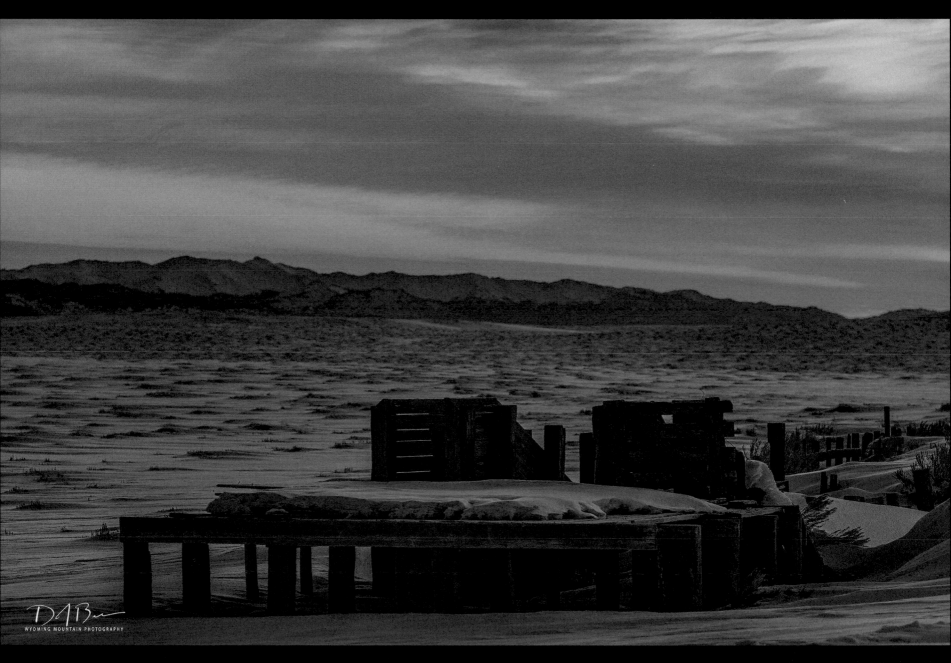

Amazing Morning Sky

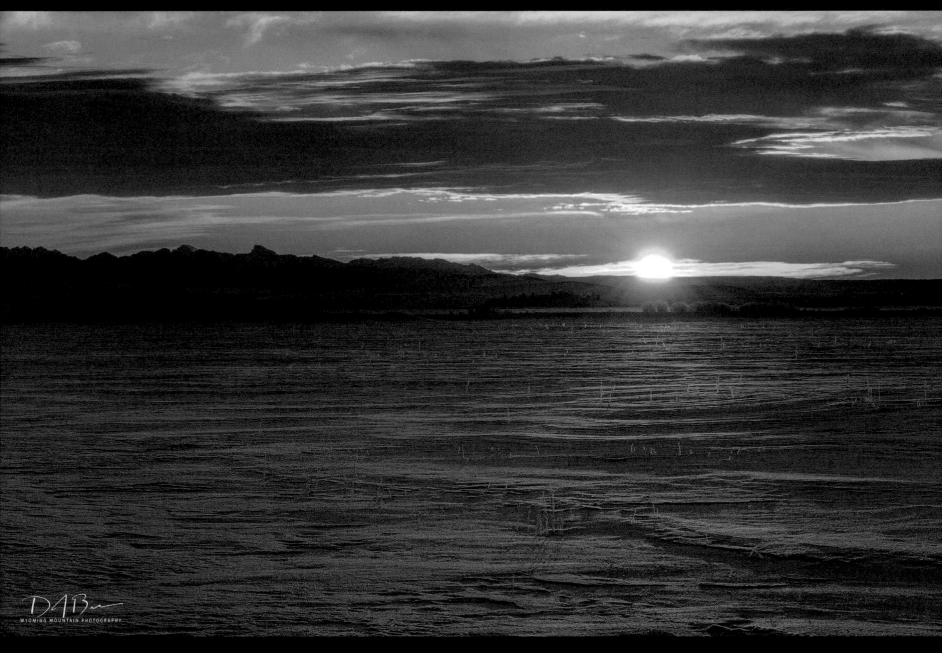

Good Morning

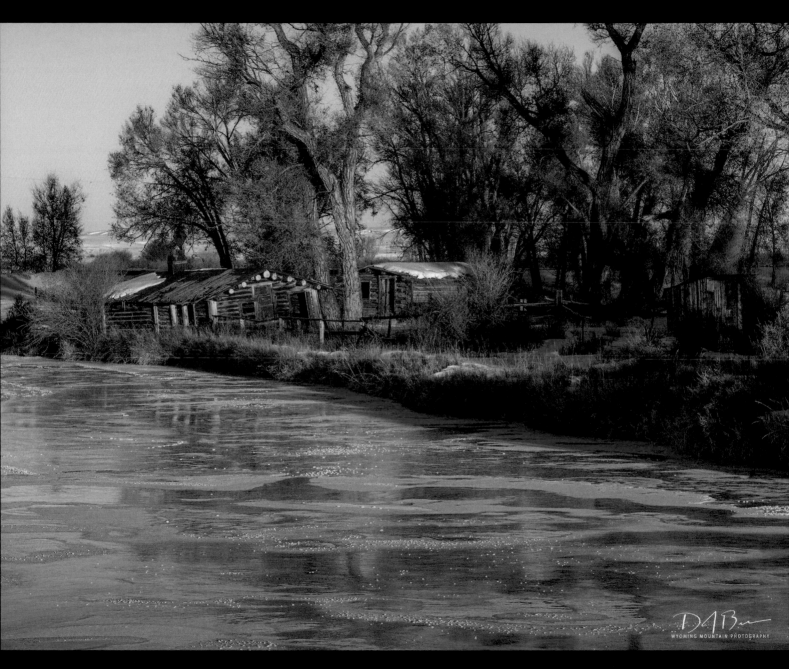

Failing Homestead

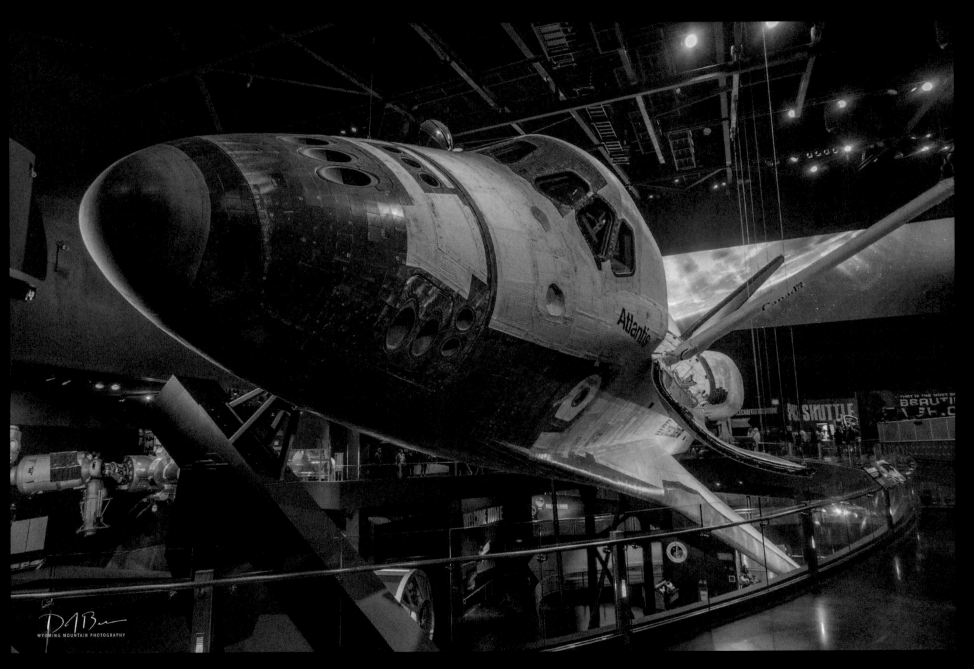

Atlantis

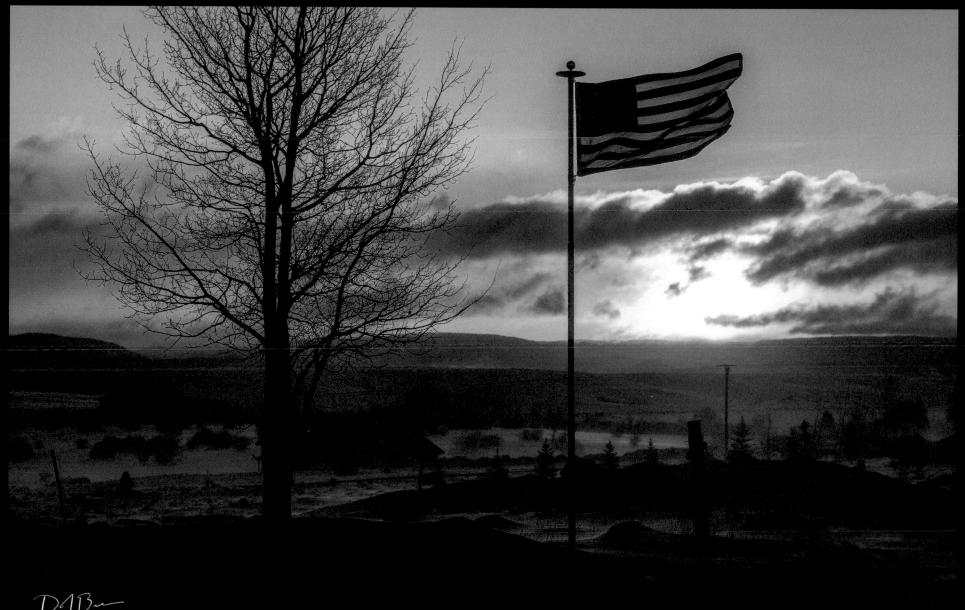

Miserable Morning

MARCH

Spring Break and Buckle Up

March is generally the month we enjoy spring break. This year we spent the beginning of the month with dear friends on the western slope of Colorado. I enjoyed seeing some country I had never seen before and the grandness of the Colorado 14'ers.

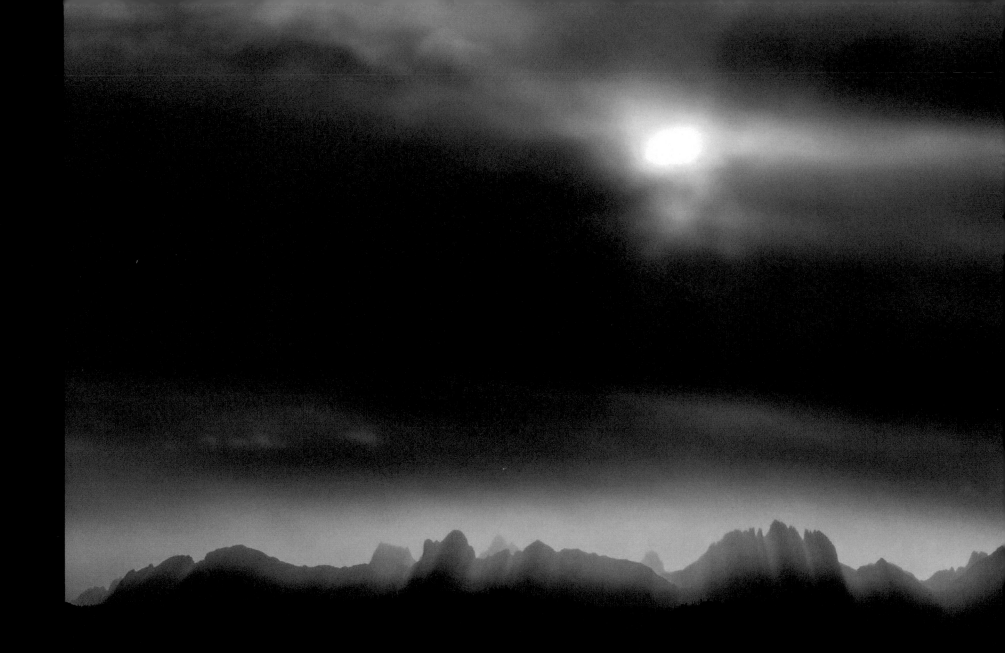

WYOMING MOUNTAIN PHOTOGRAPHY

Mountain Shadows

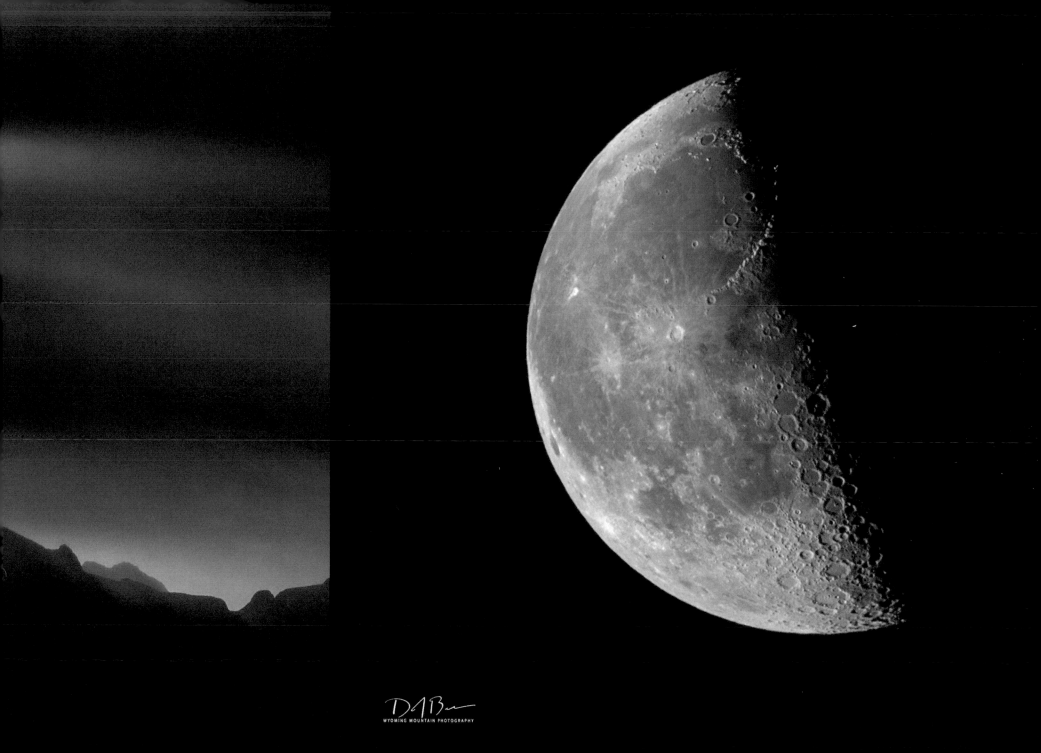

Say Good Morning To The Moon

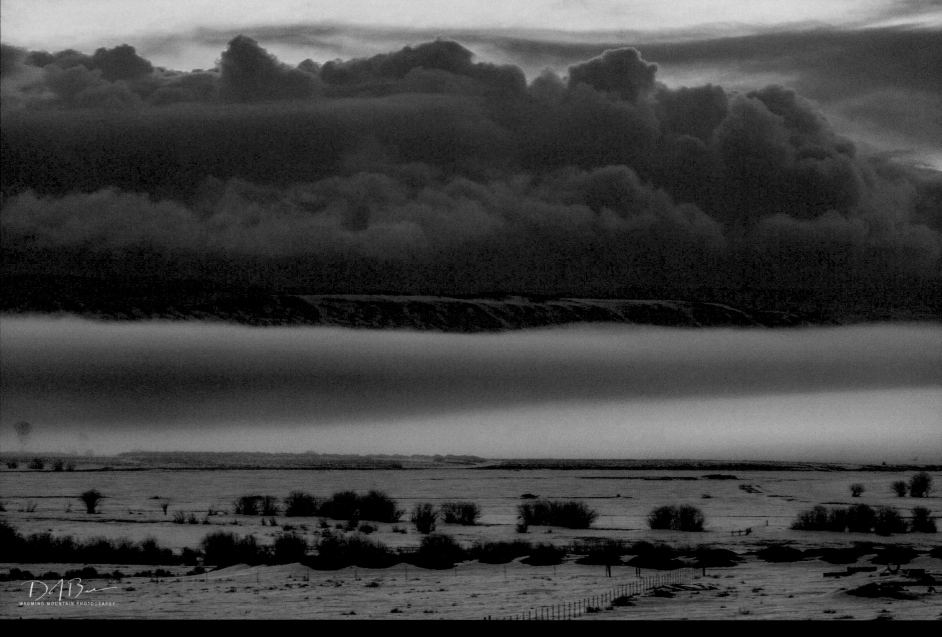

Morning Fog

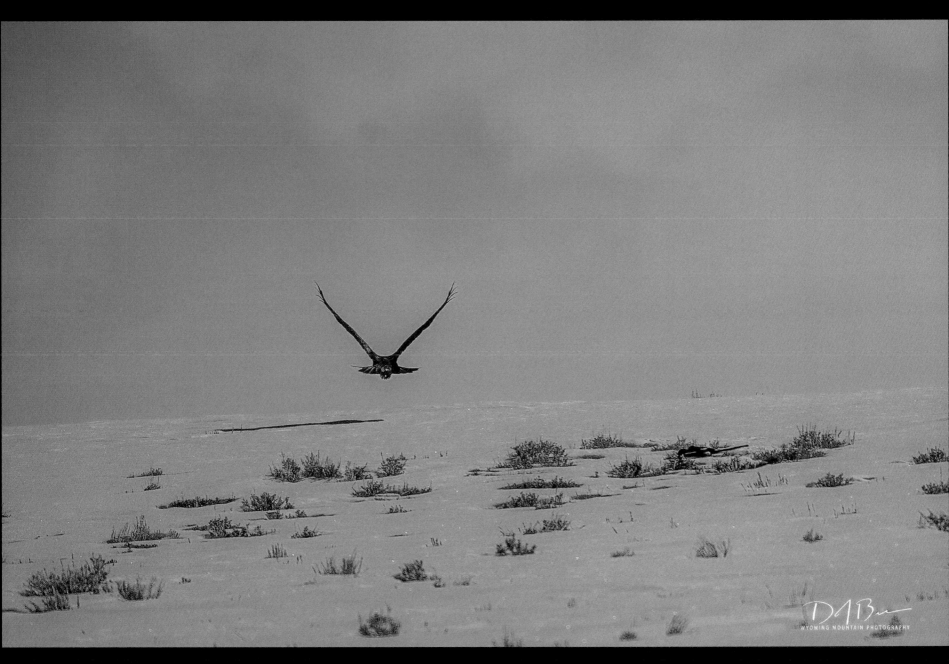

Up and Away

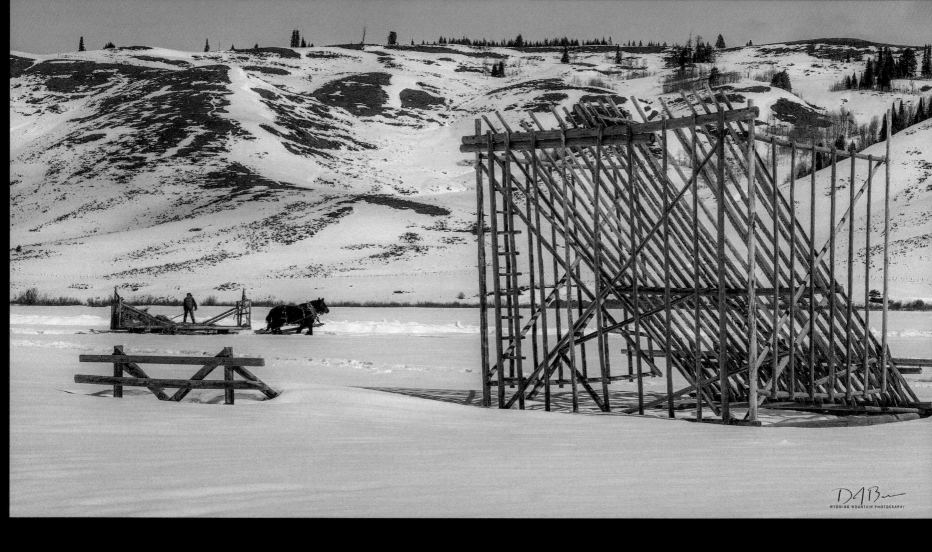

Horses-Sleigh-Beaver Slide

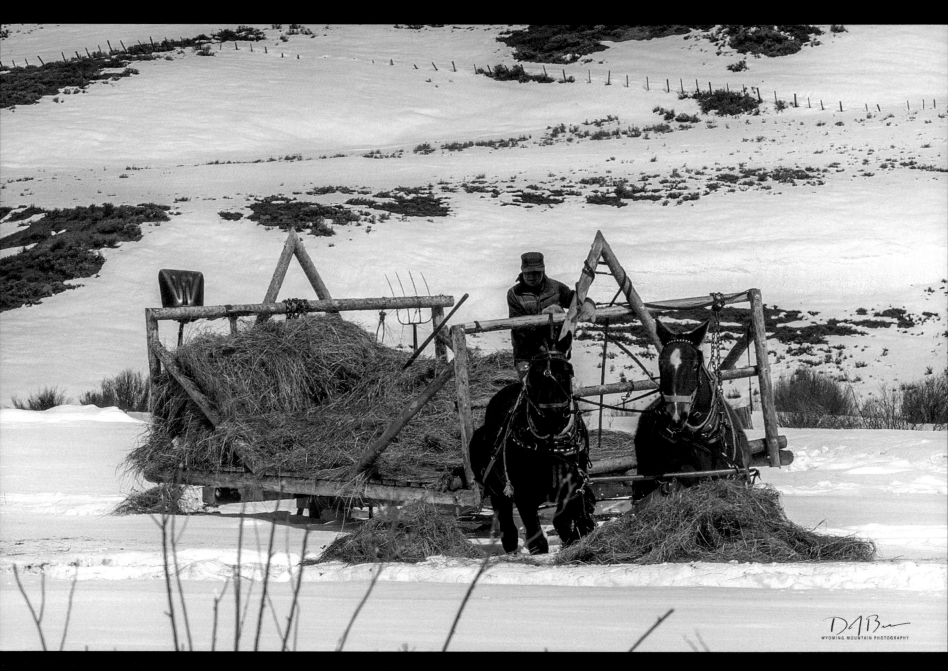

Guiding the Team

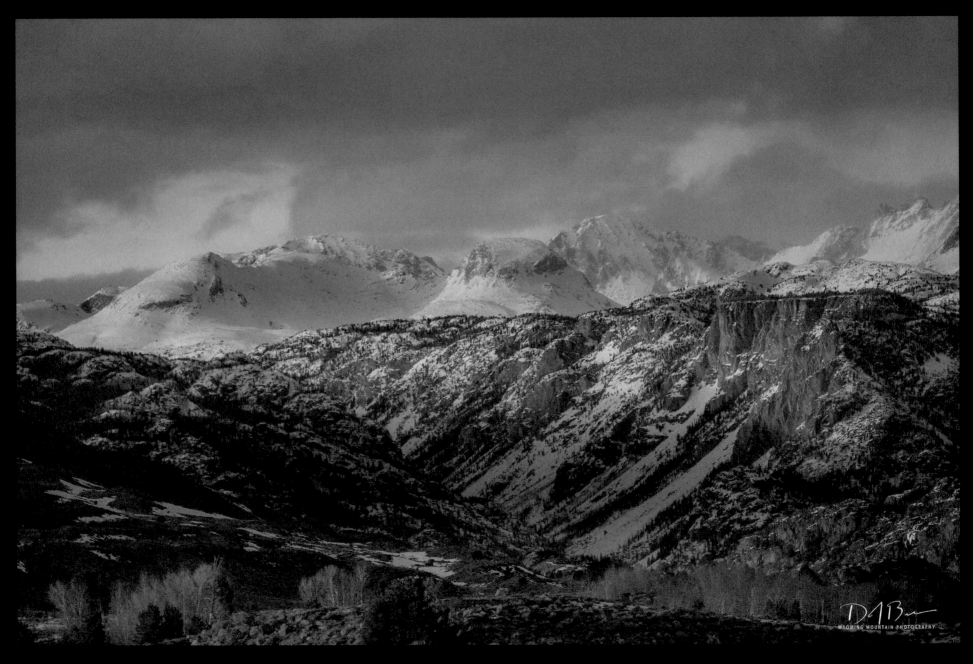

Sky Pilot Sunset

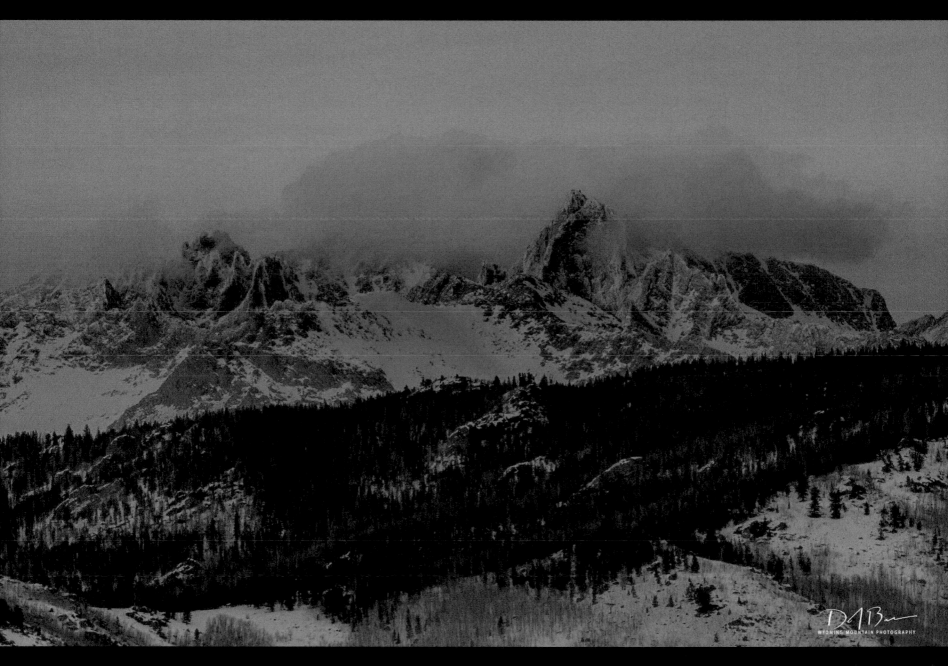

Helens Light

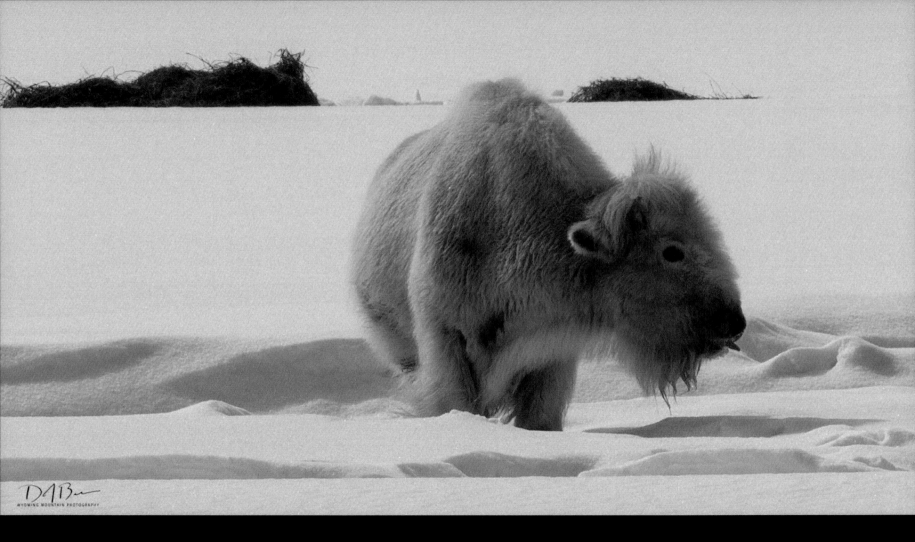

White Buffalo

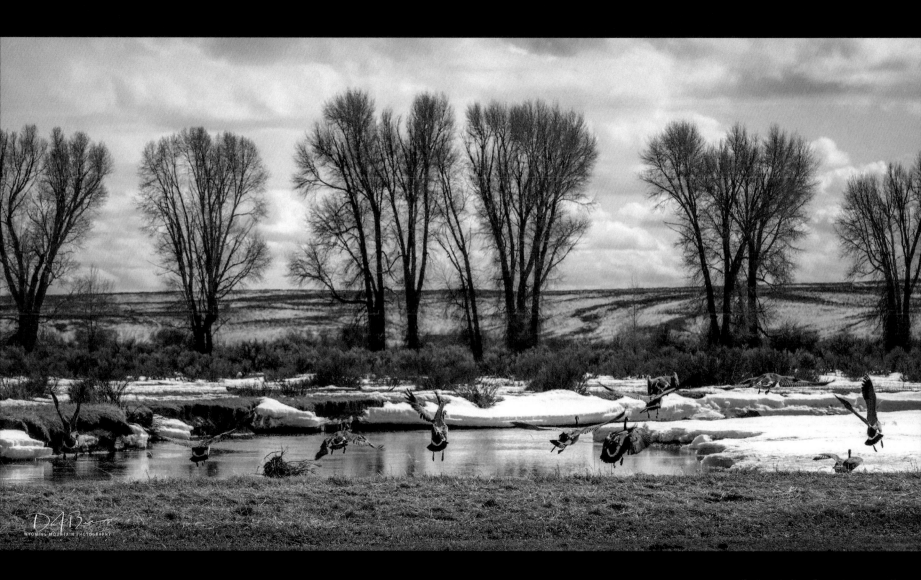

This Made A Racket

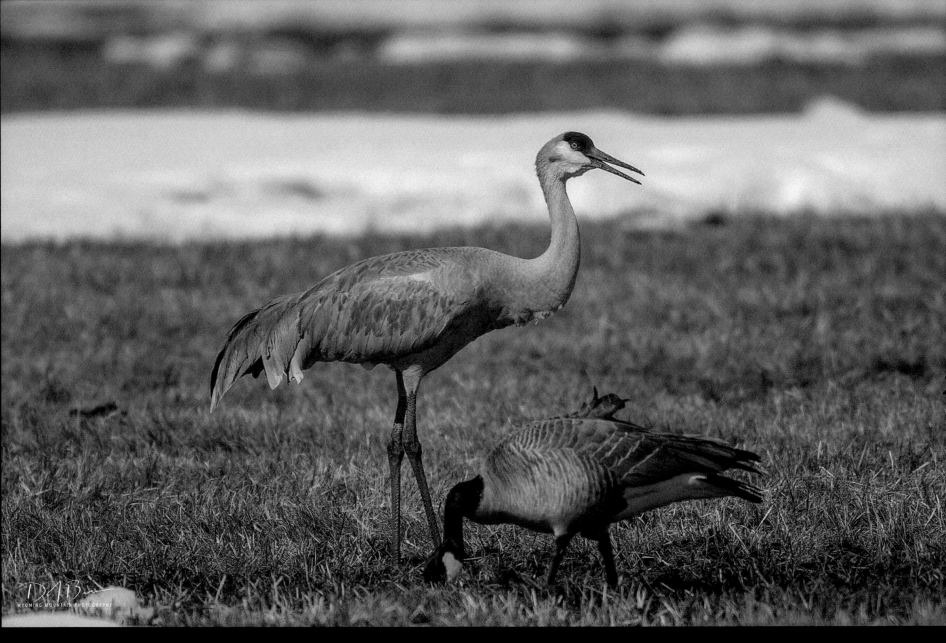

Sandhill Beauty

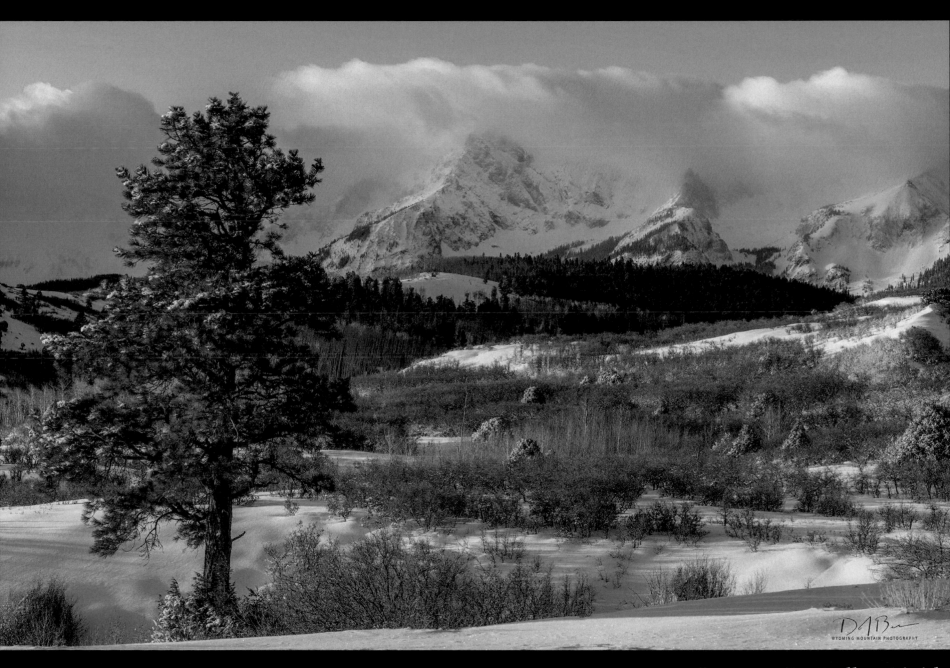

Scenery On Dallas Divide

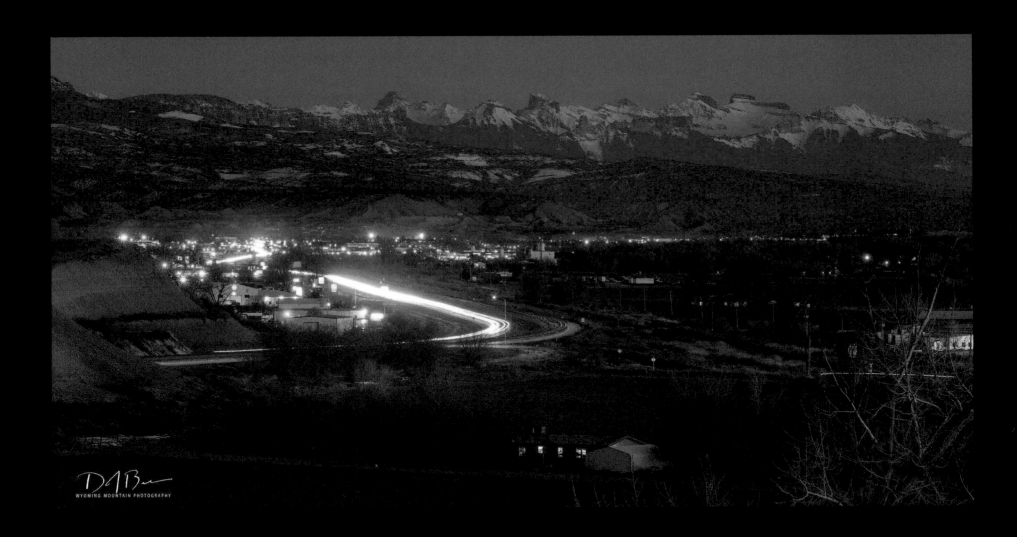

Lights Of Montrose

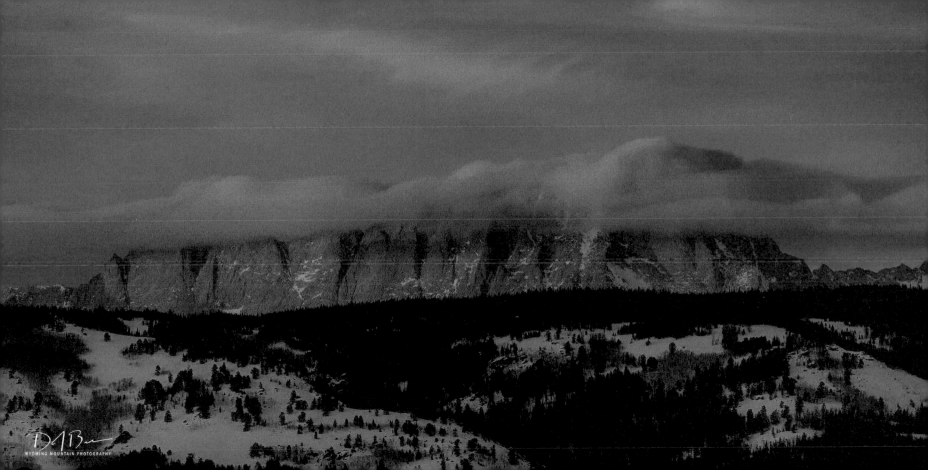

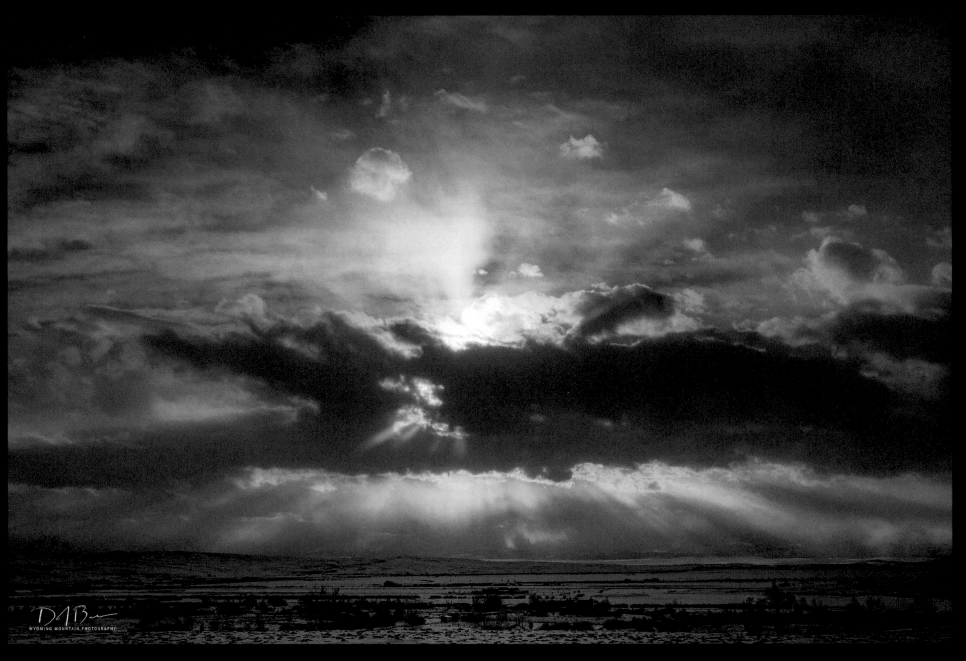

Solar Flare

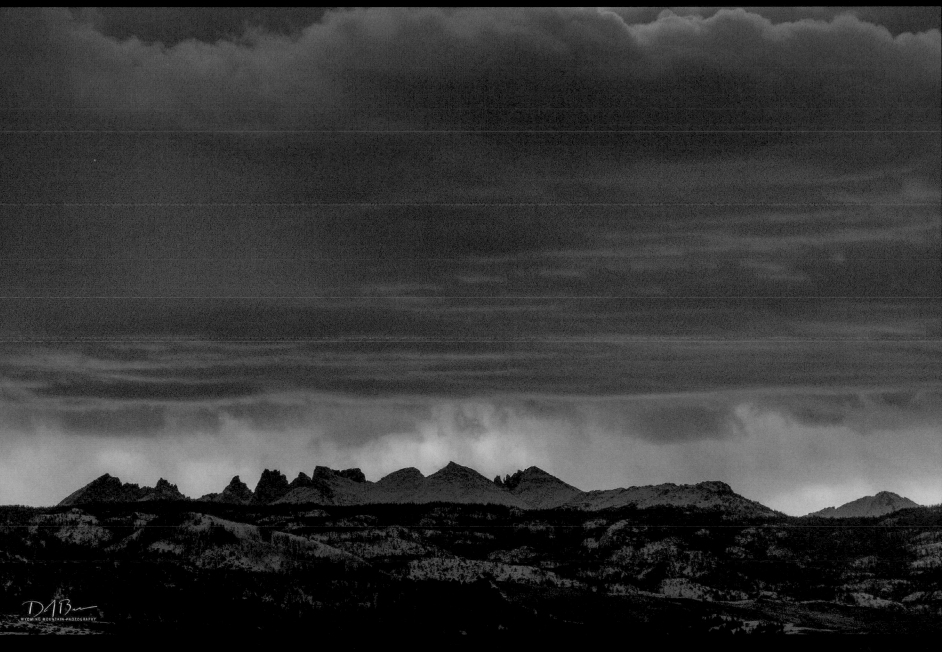

Cirque Silhouette

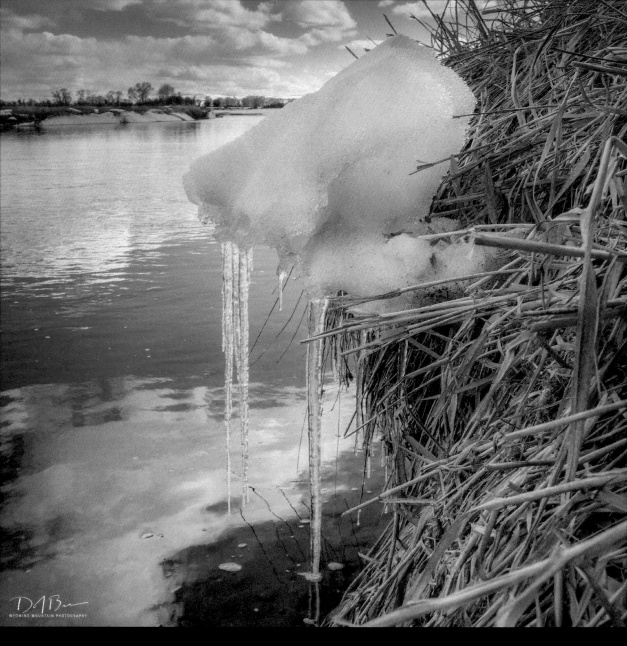

Winter Remains

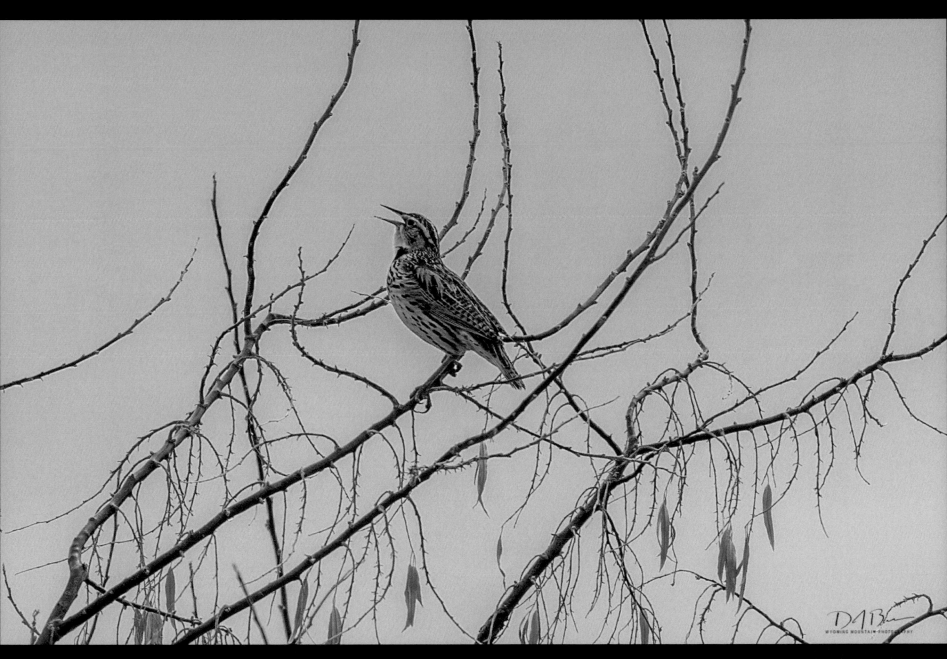

Sing Me A Song

APRIL

Quarantines

The quarantines began across the country in April. We recorded literally six weeks where things were mostly at a standstill across this great land of ours. This was uncharted territory for the USA, and the world, in a modern, instant communication world of 24-hour news and social media. But, I enjoyed some incredible photo safaris with my wife out in our rural countryside with the Wyoming landscapes and wildlife.

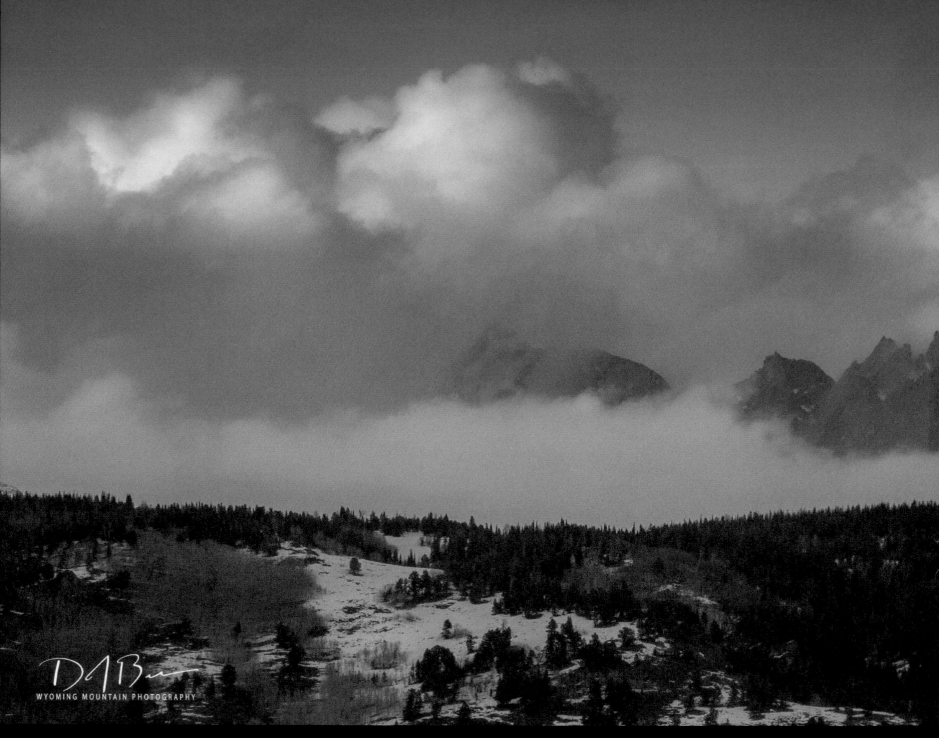

Clearing

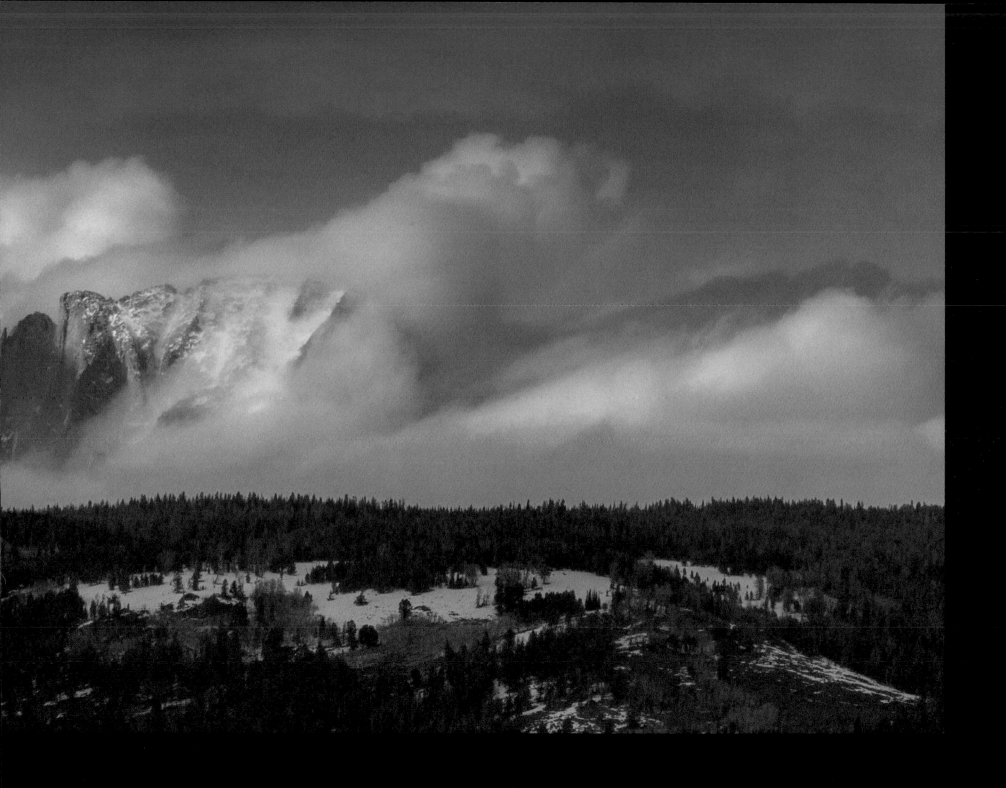

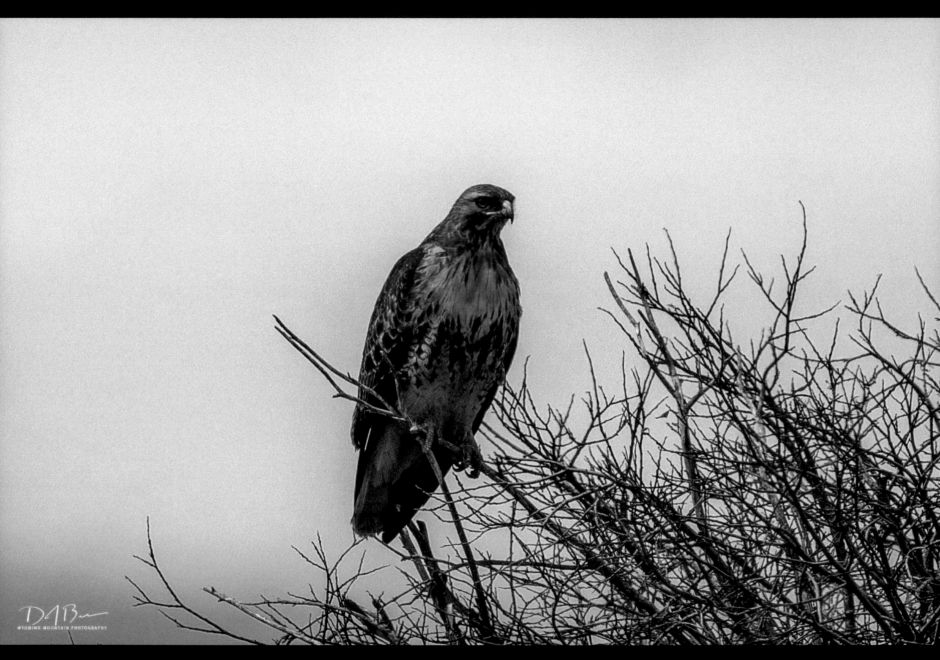

Red Tail

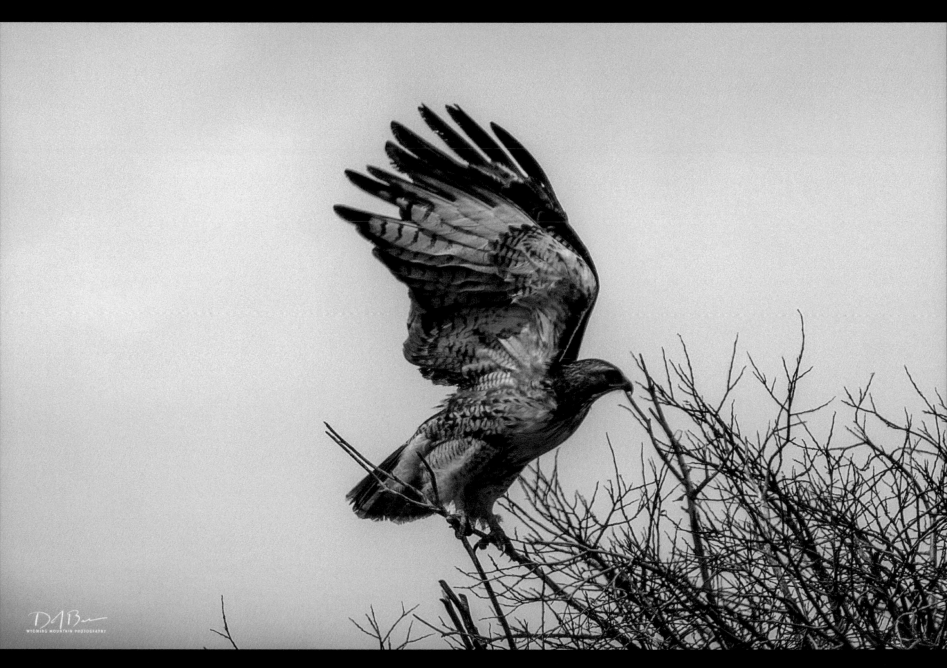

Launch

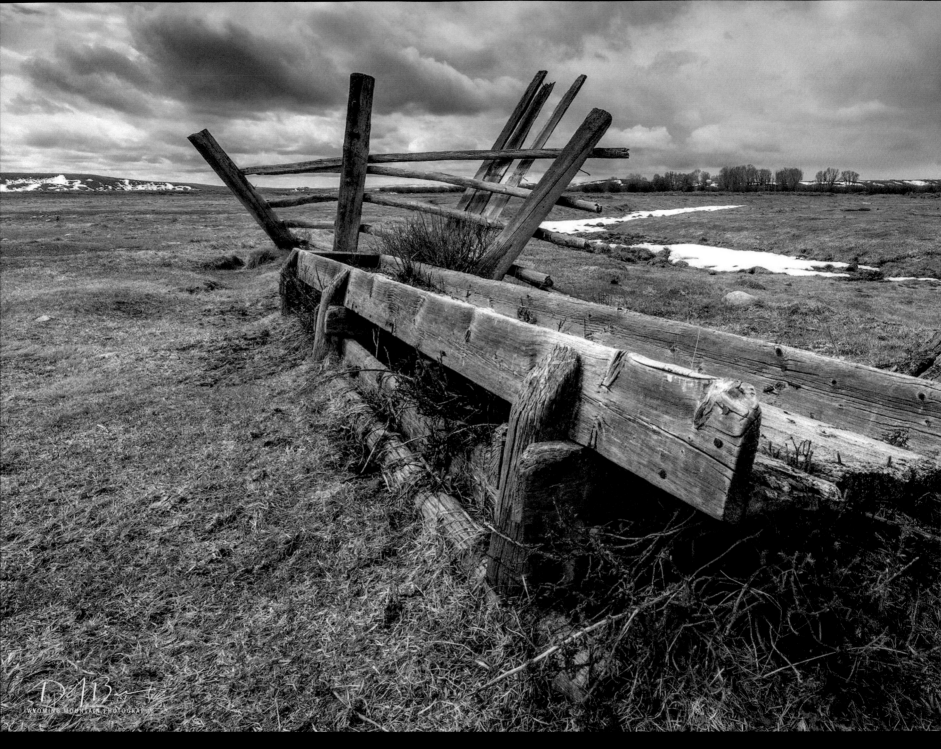

Feed Trough

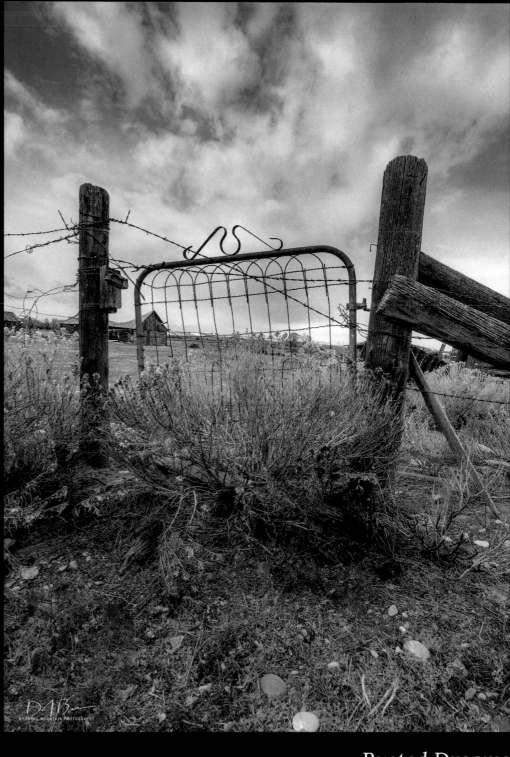

Busted Dreams

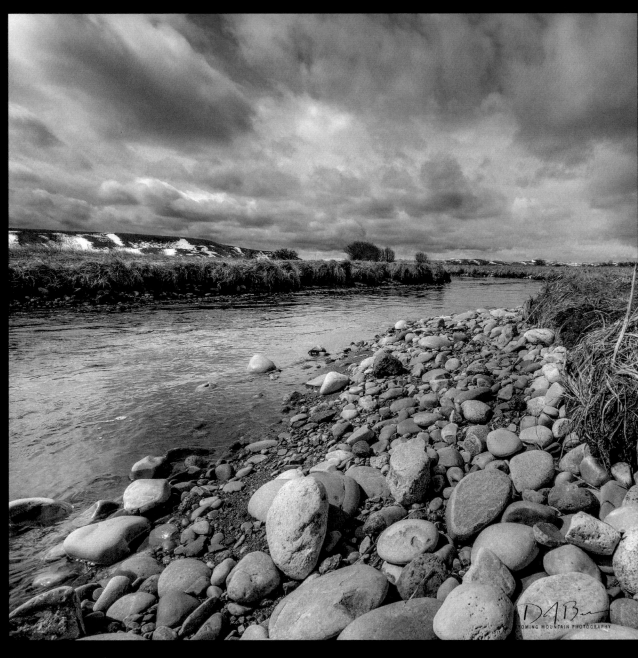

River Rock

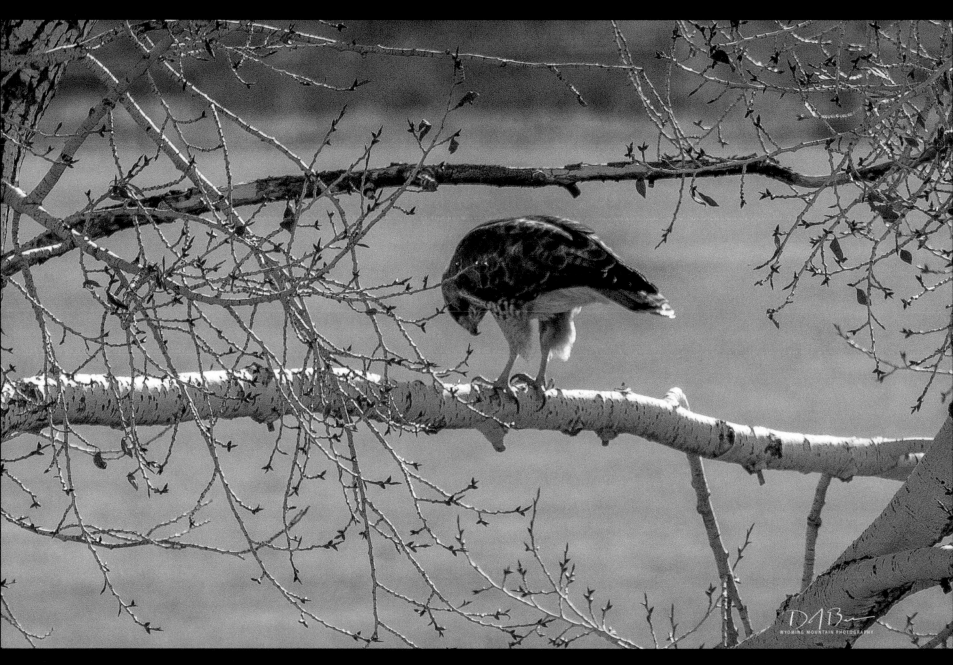

Finishing Breakfast

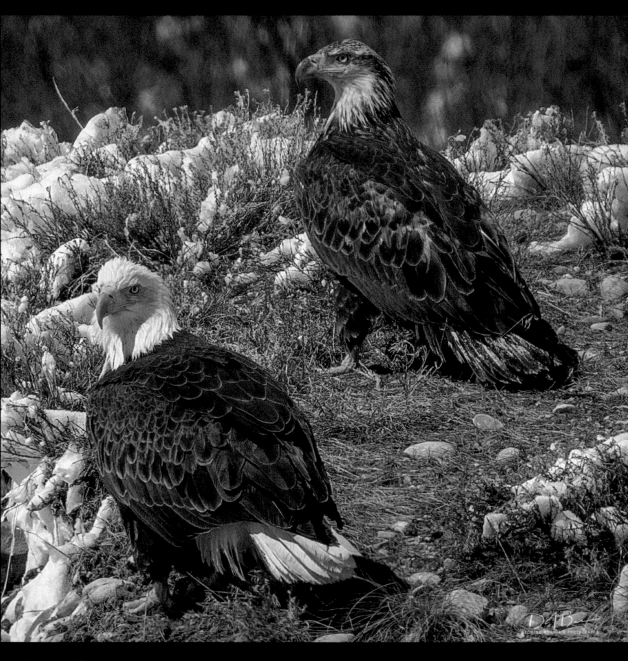

Irritated

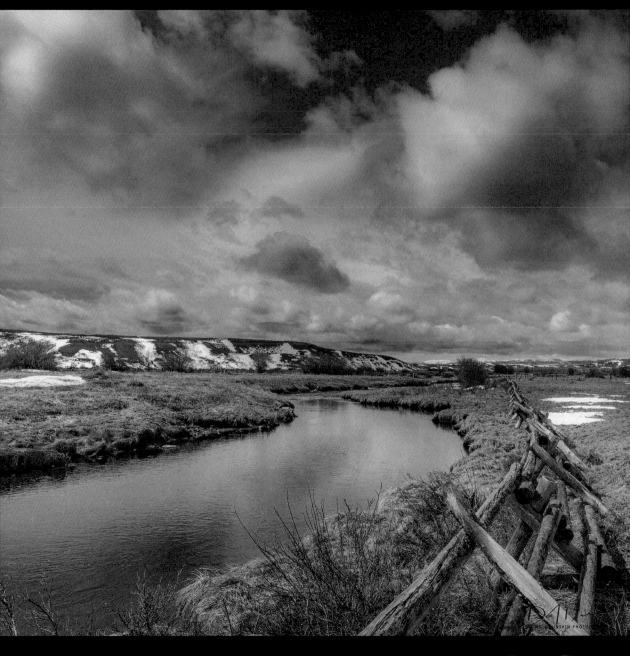

Lazy Stream

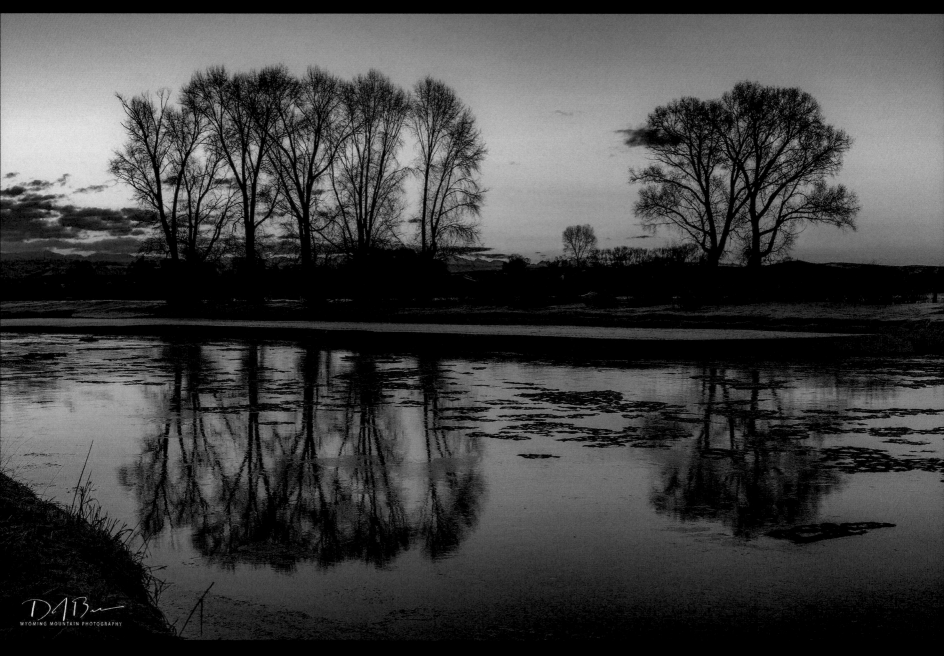

Sunrise Glow

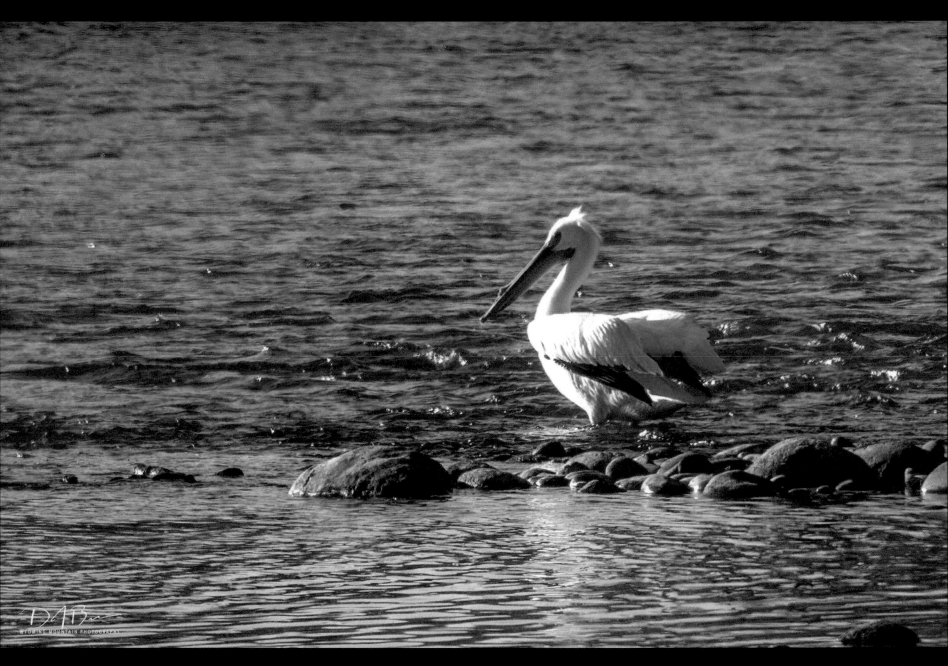

New Fork Pelican

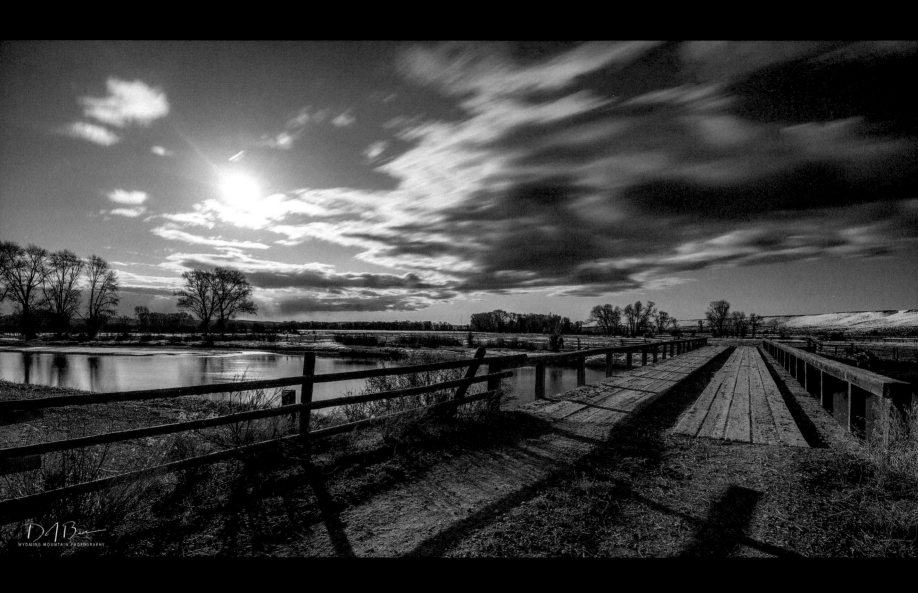

Moonlit Scene

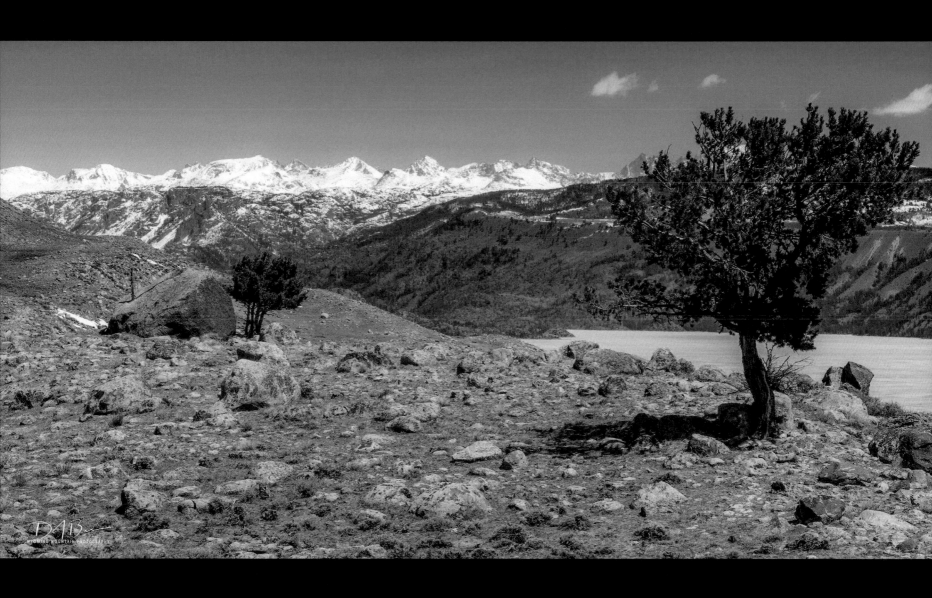

Springtime

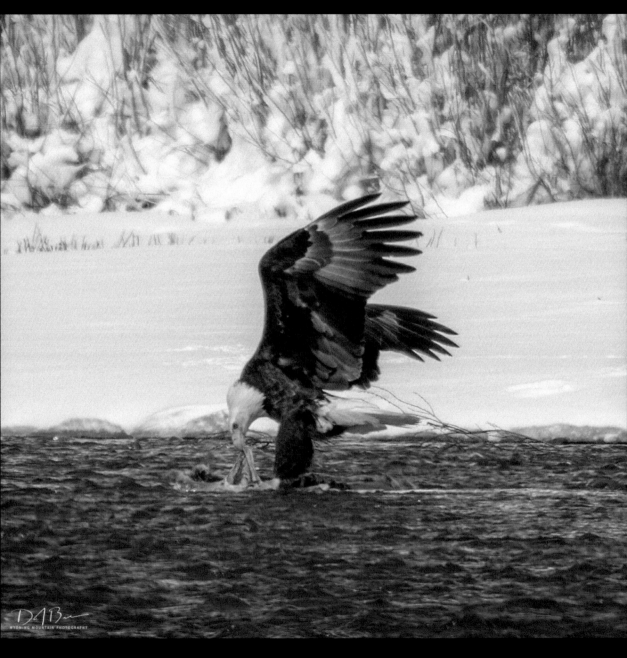

Ripping

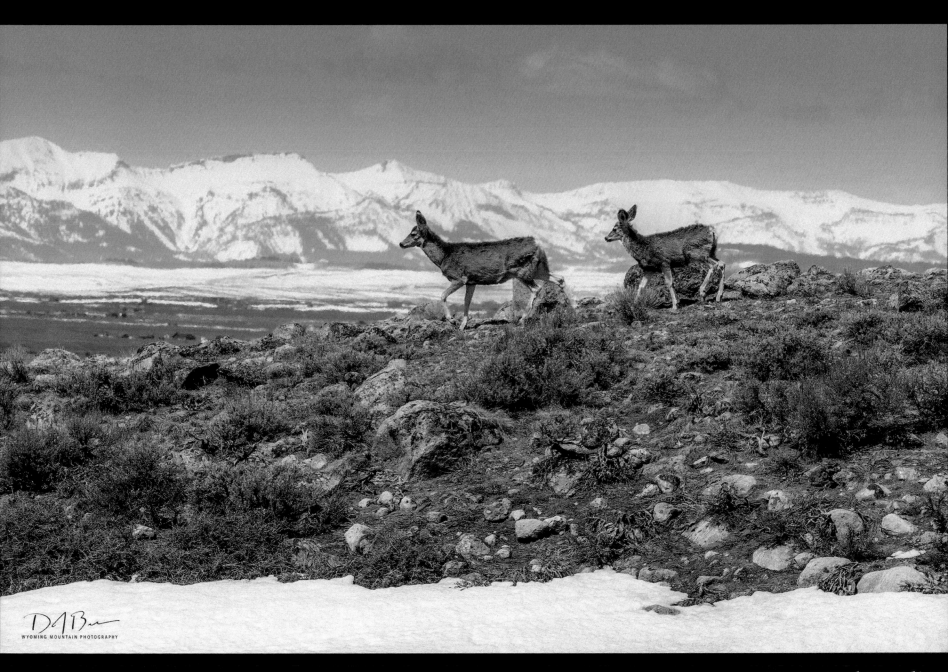

WYOMING MOUNTAIN PHOTOGRAPHY

Mom And Yearling

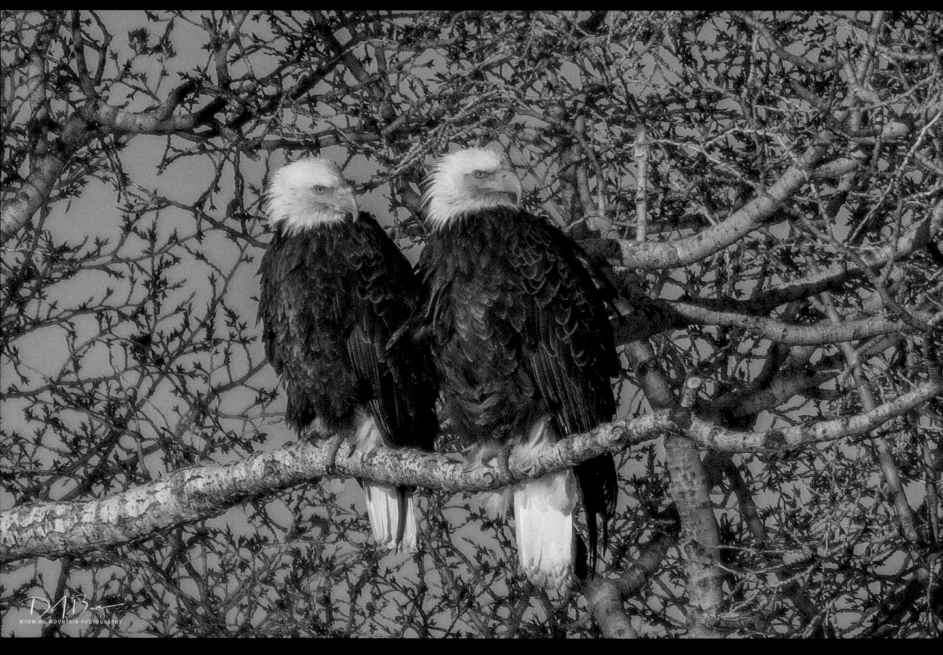

Together

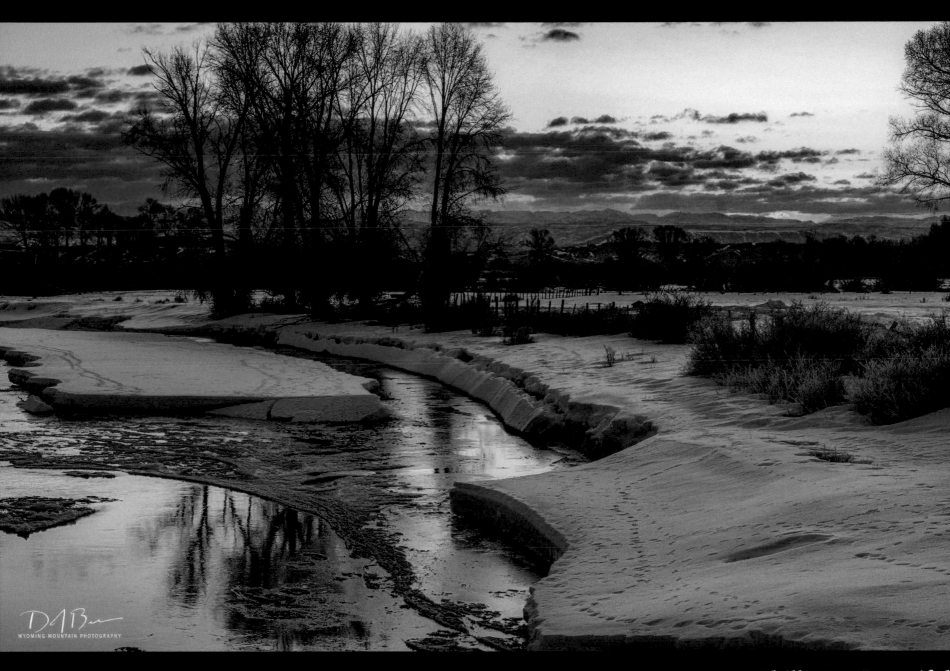

Chilly But Beautiful

MAY

Spring Hope

May usually brings great hope after long Wyoming winters. This May brought more uncertainty but the spirit of the American people was beginning to show. Even though groups were rioting and terrorizing cities in the USA, most of the populace, particularly in Wyoming, were optimistic for better times ahead with approaching summer. With my friends, Tim and Peggy, I was able to enjoy opening weekend in Yellowstone. It was spectacular. I was given an opportunity to photograph an eagle hunting rabbits (legally kept) with a skilled "falconer".

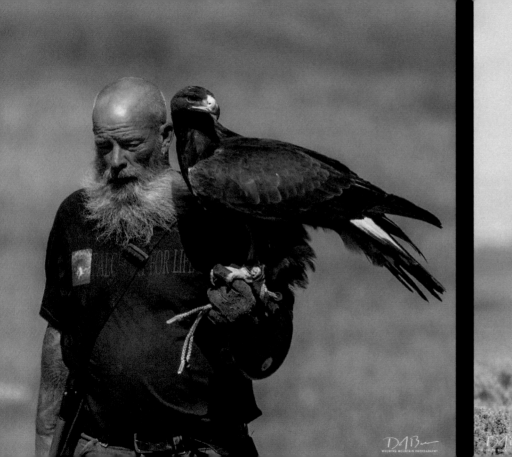
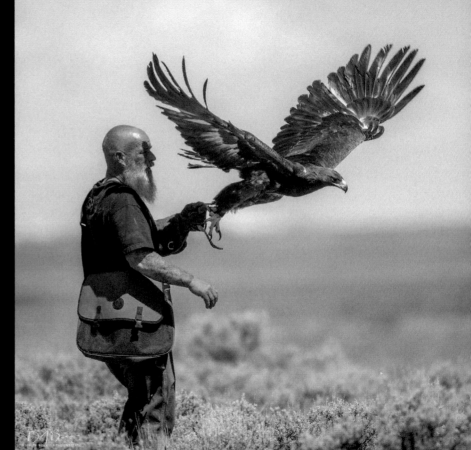

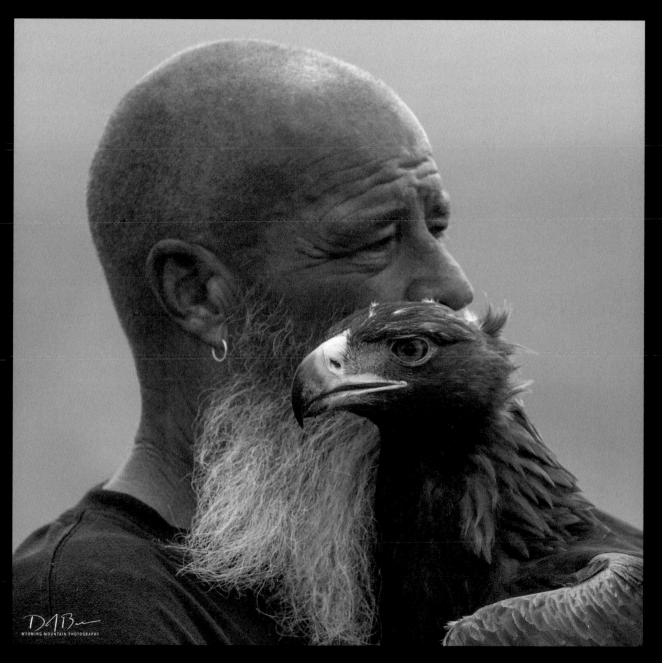

Beautiful Eyes

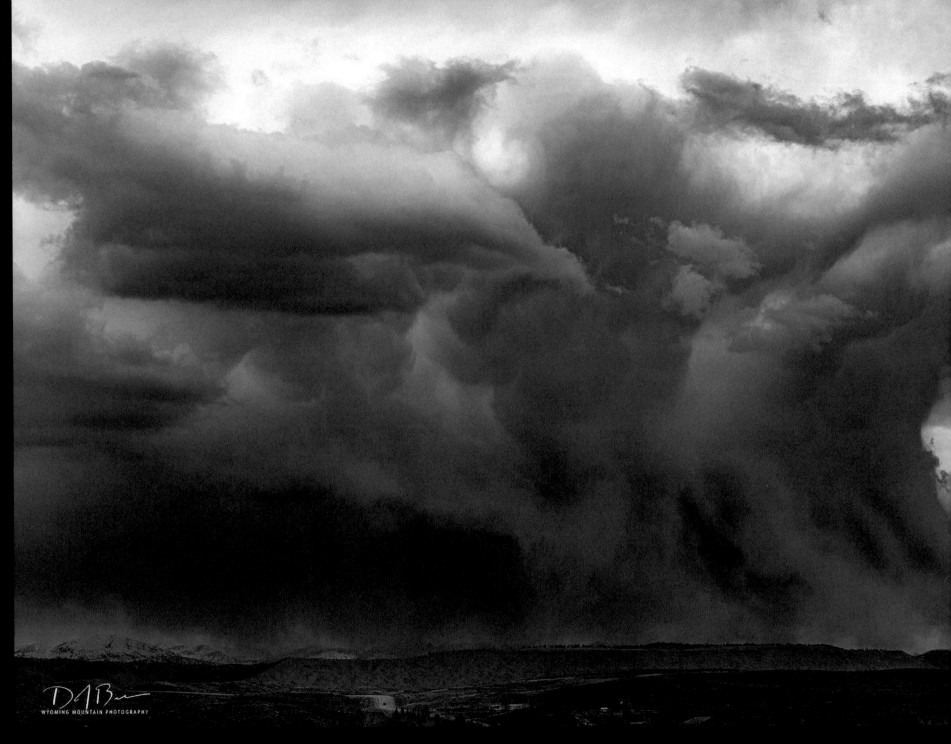

Gnarly Bitch

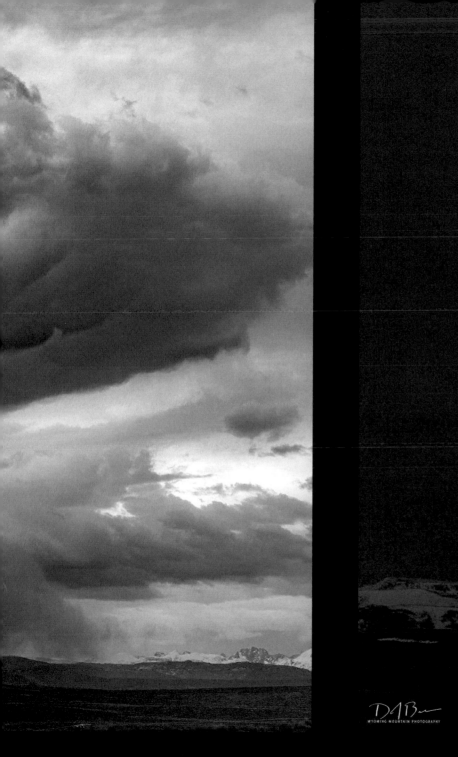
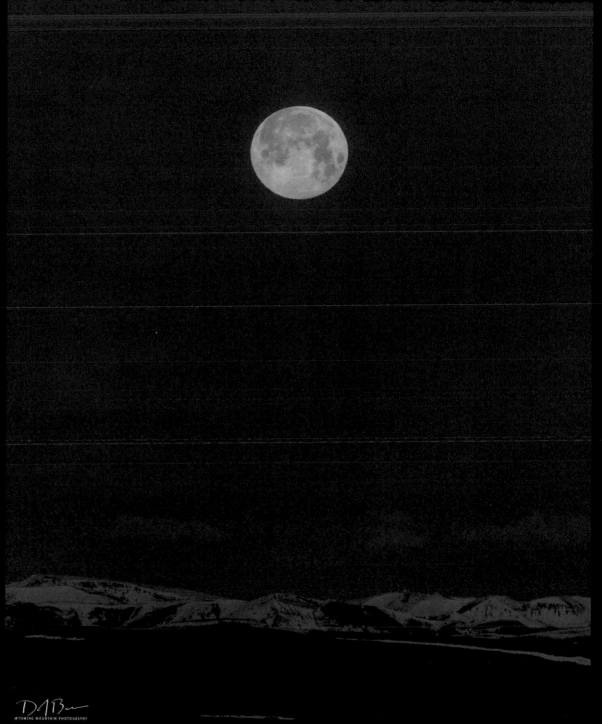

Full Moon and Belt of Venus

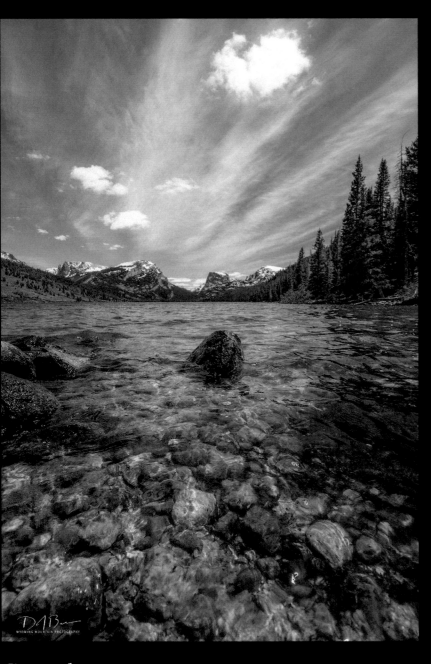

Crystal

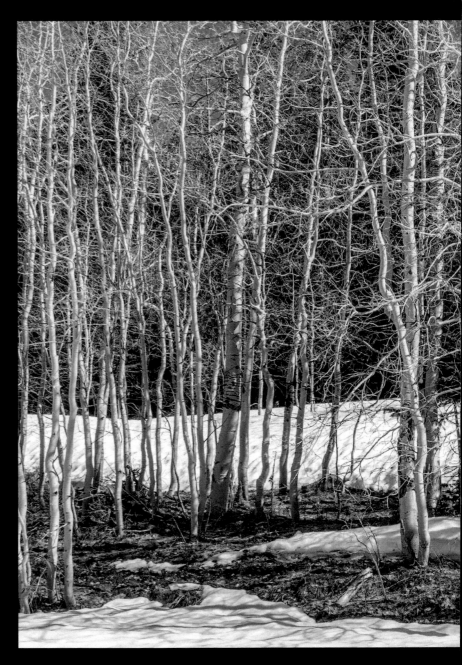

Spring Aspen Grove

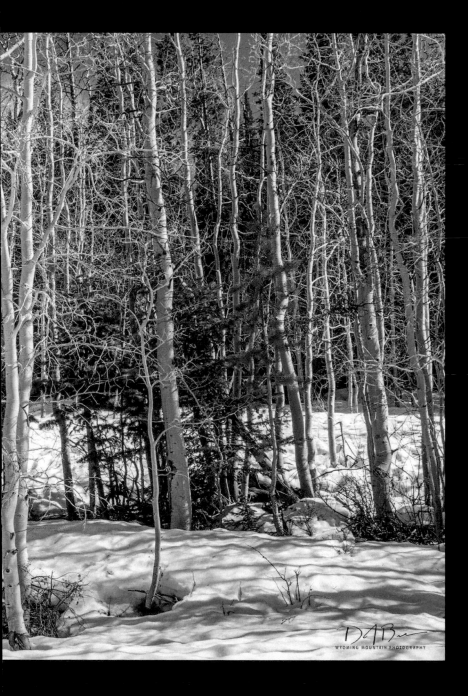

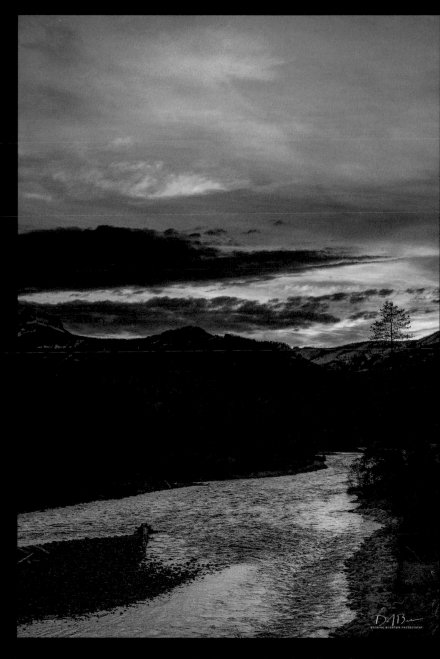

North Fork End Of The Day

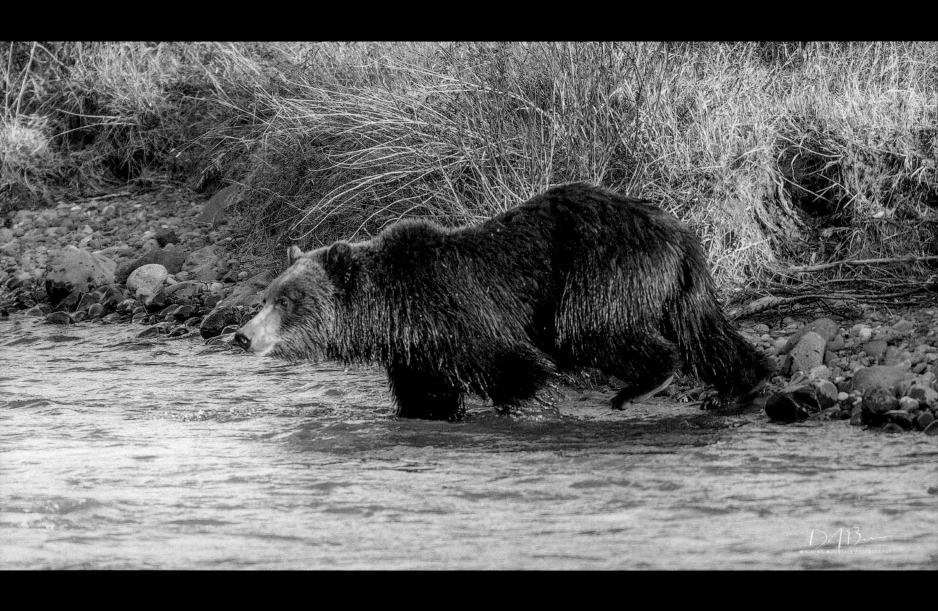

Into The River

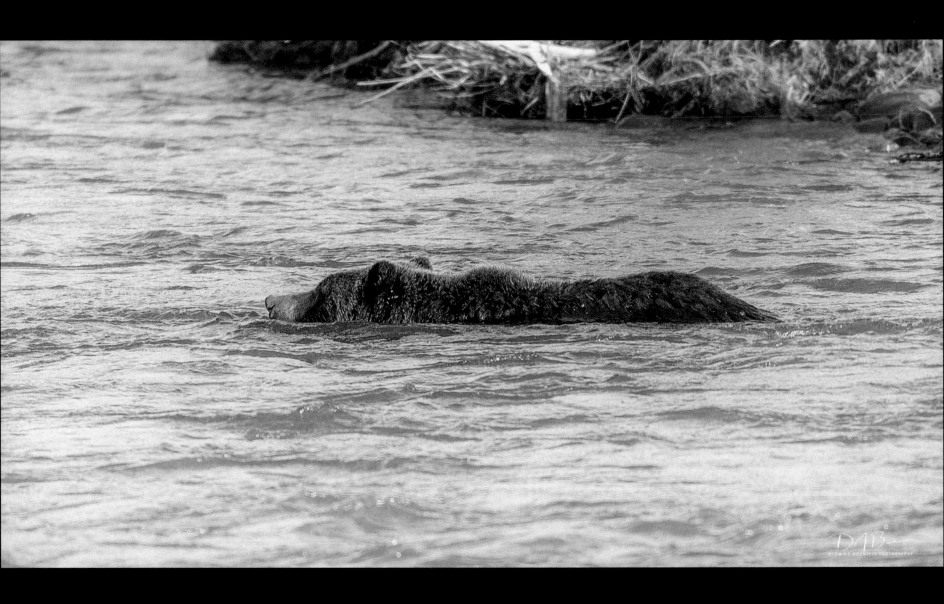

Bears Swim Quite Well

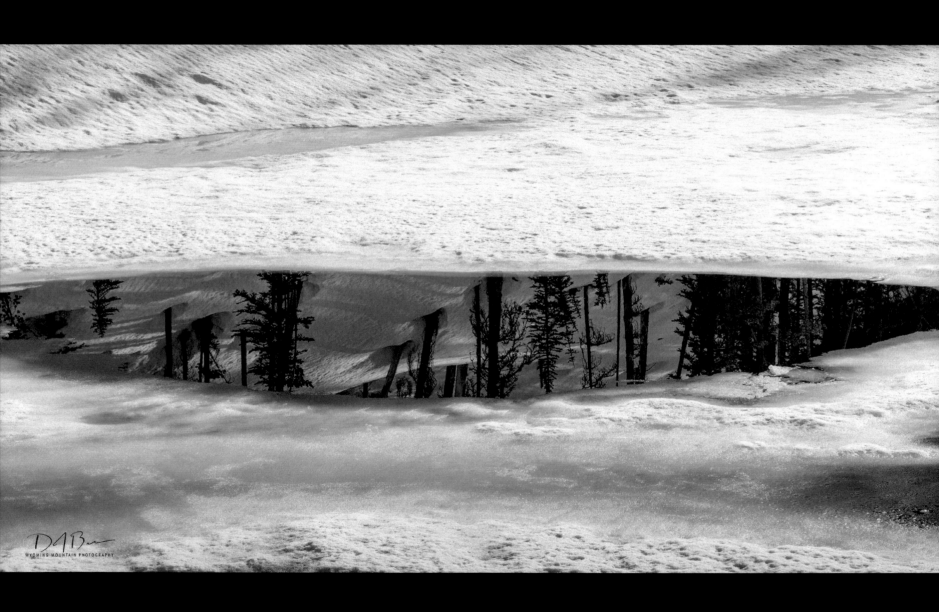

A Reflection From Above

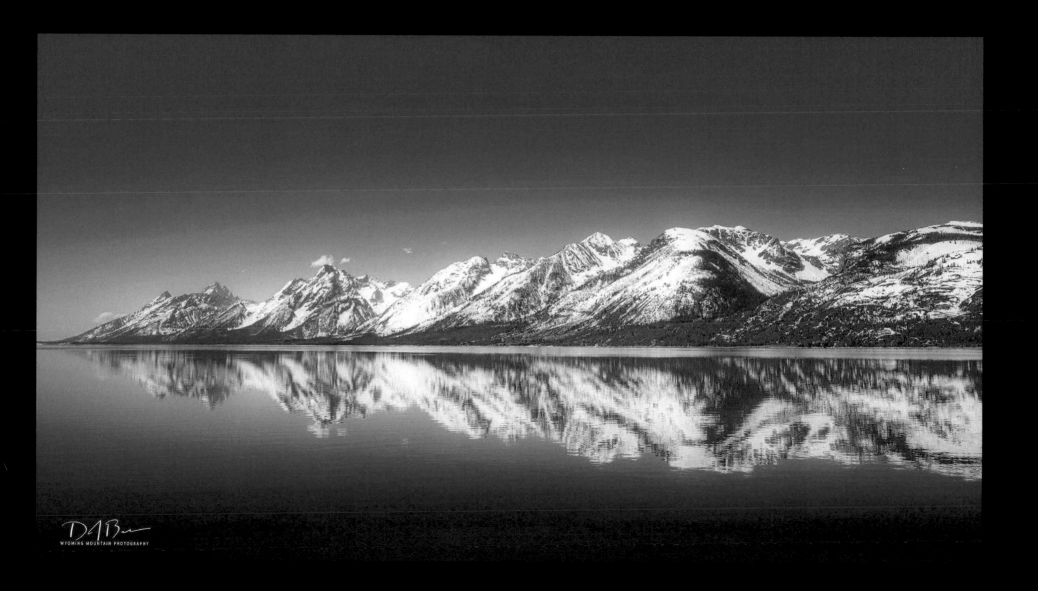

Calmness

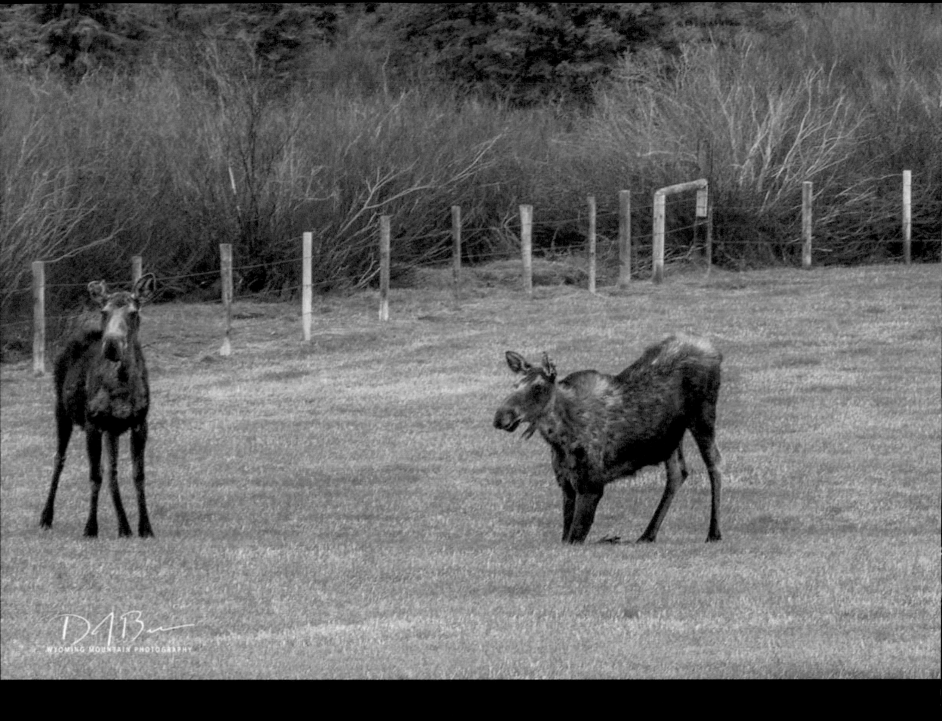

Spring Grass

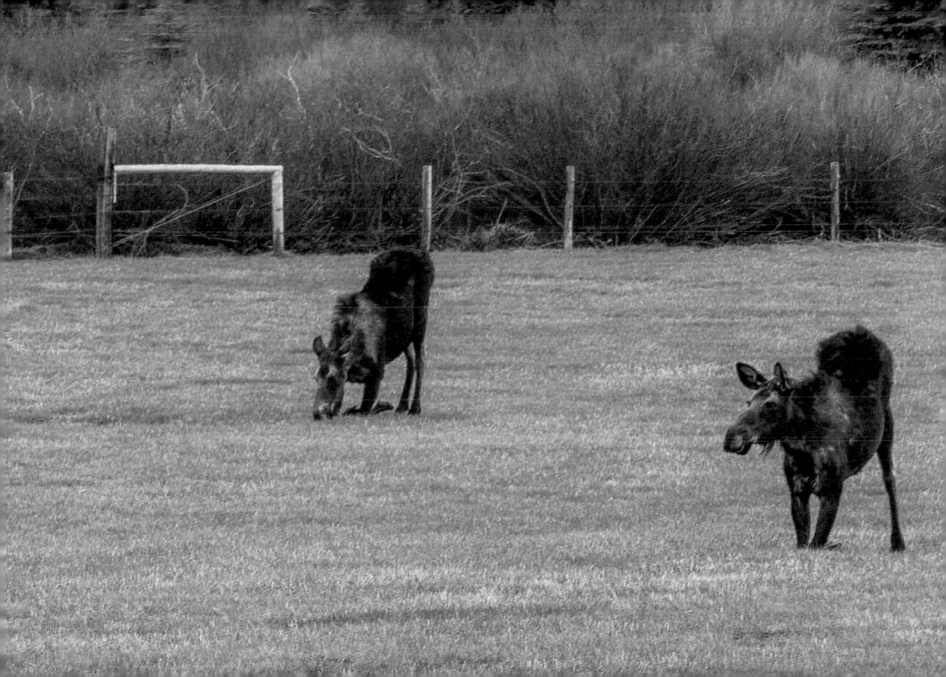

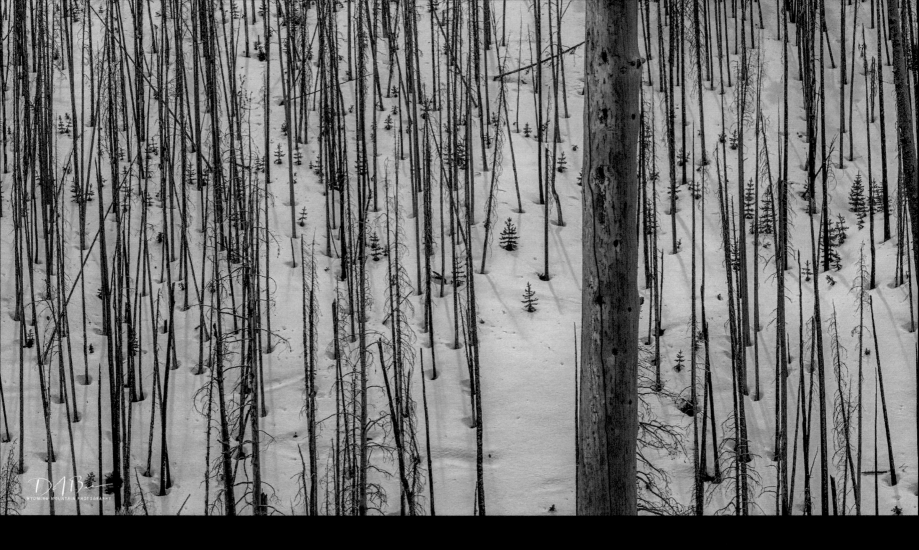

Rebirth

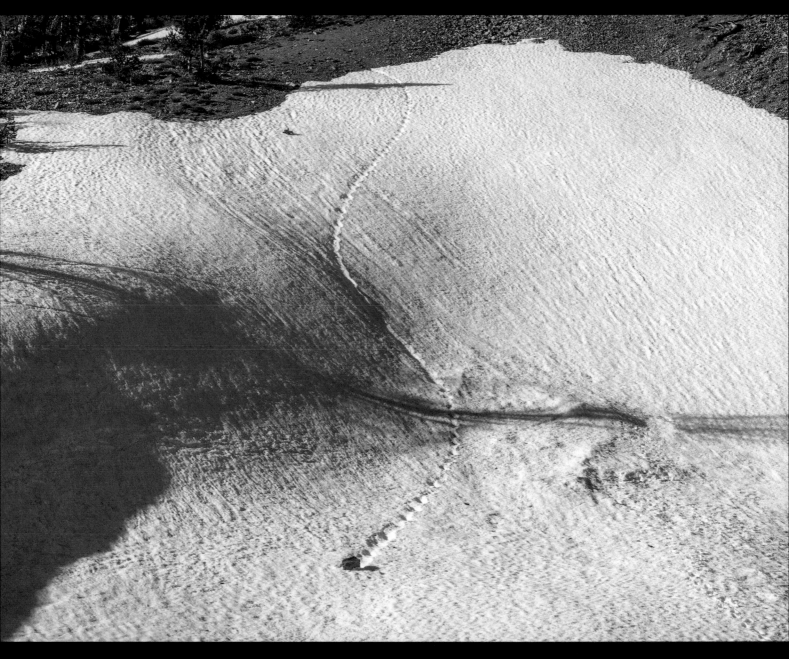

Stem Christie

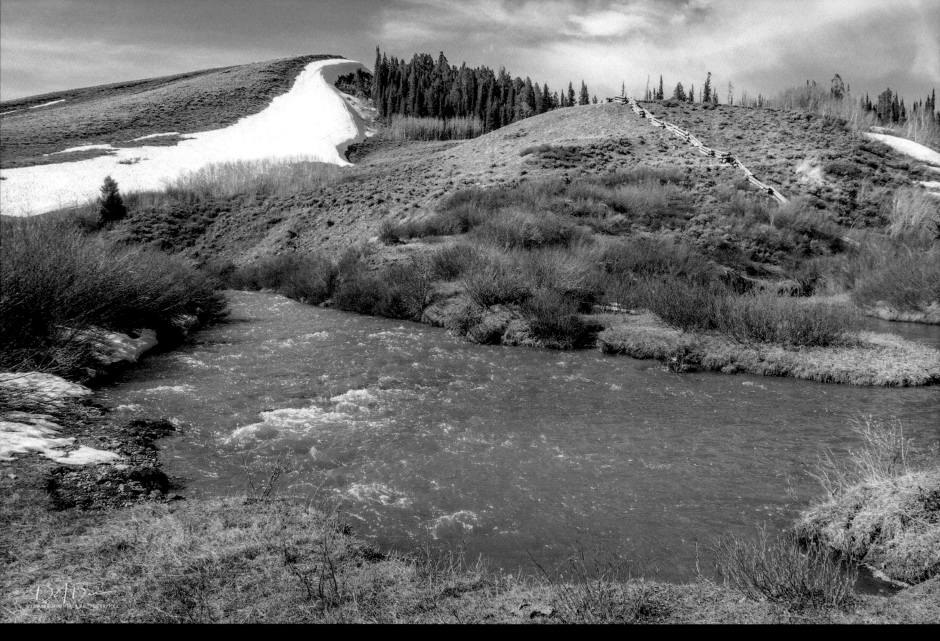

Beautiful North Cottonwood Creek

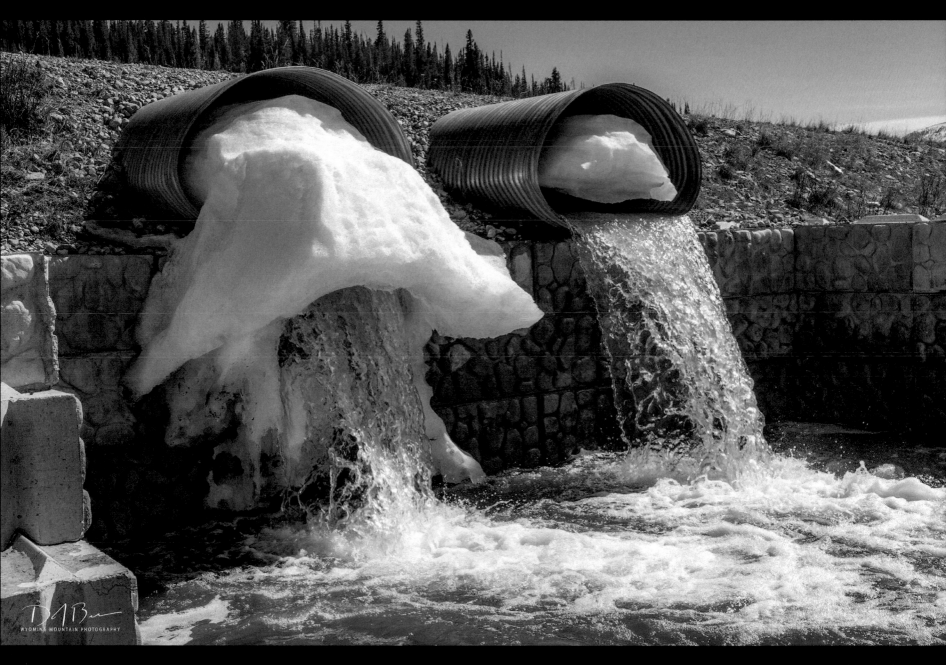

Bare Creek Culverts

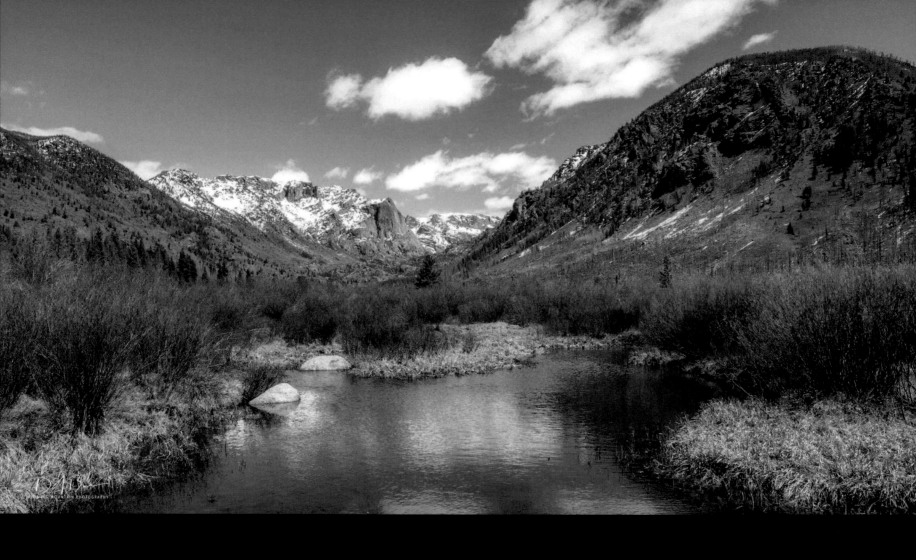

Beautiful Scenery

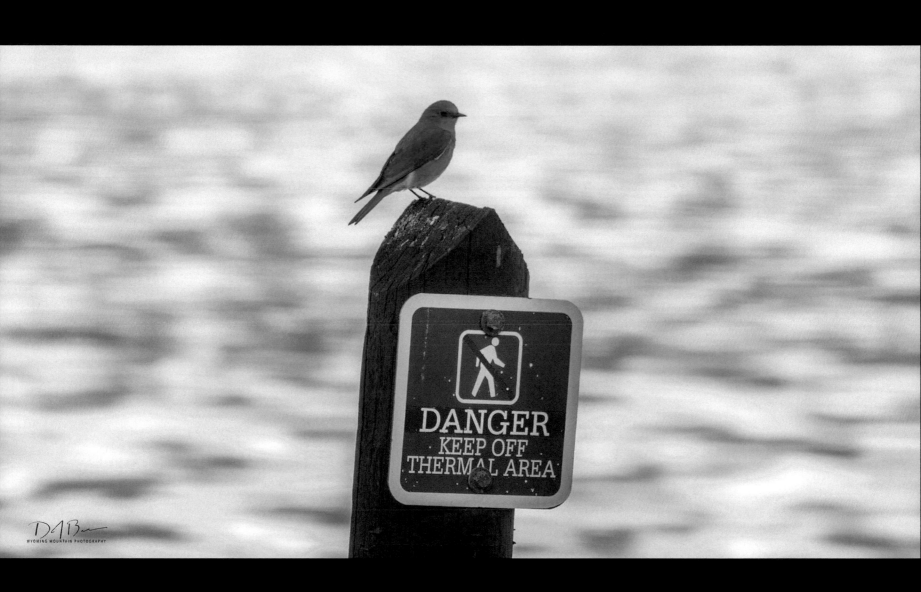

Obeying the Rules

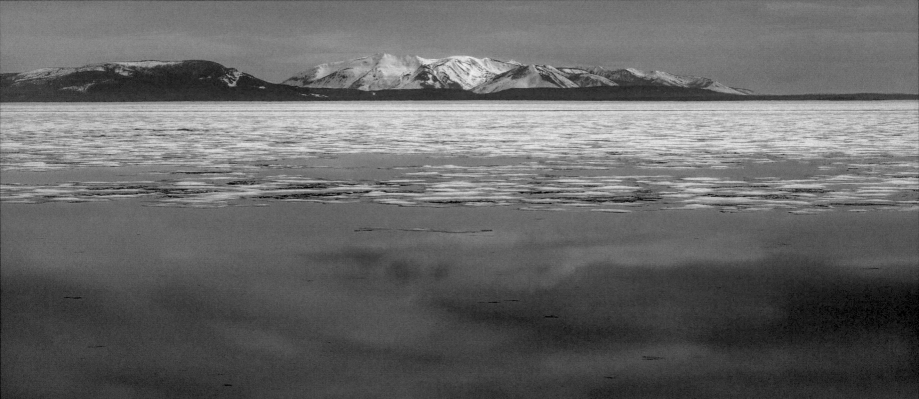

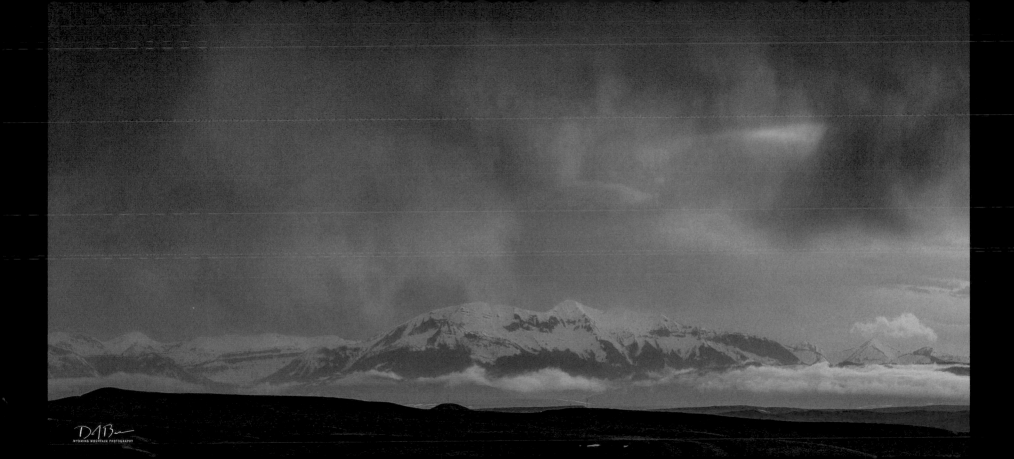

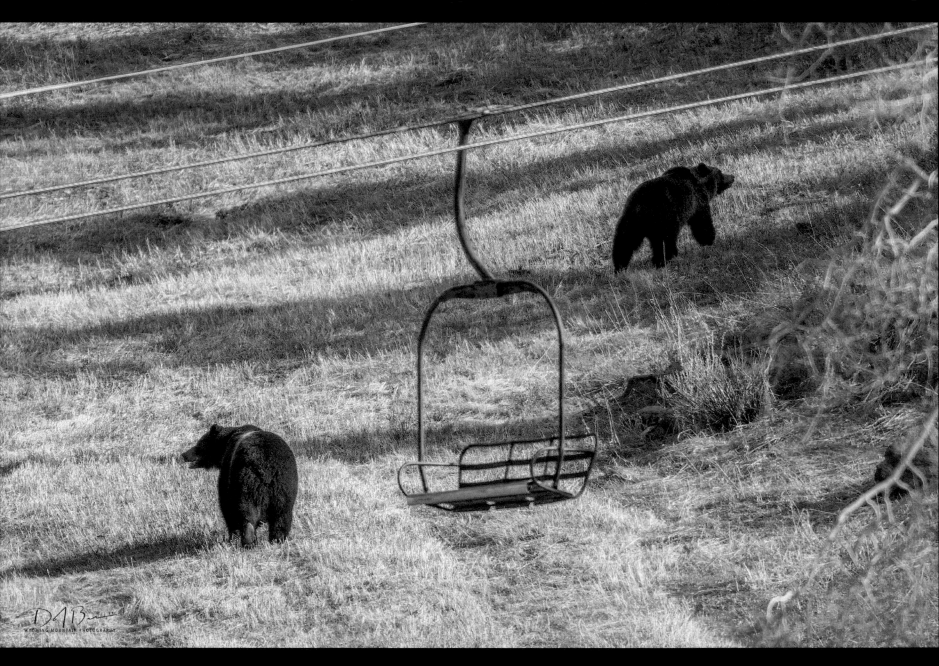

Catch the Lift

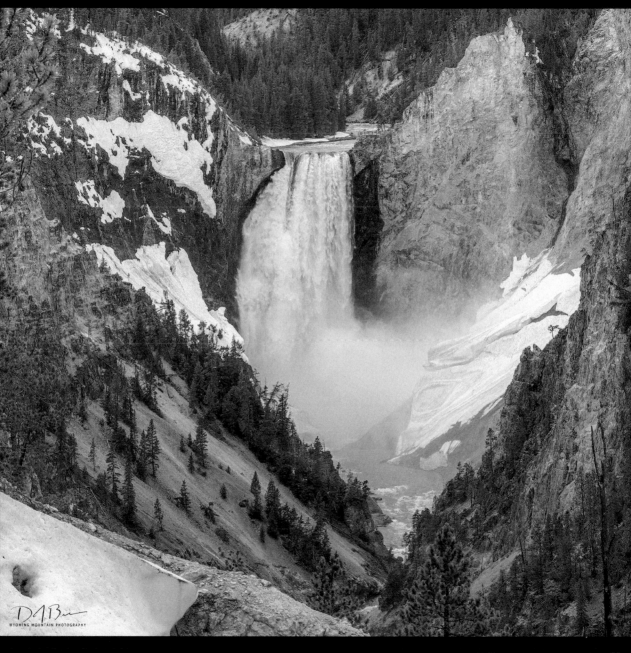

The Lower Falls

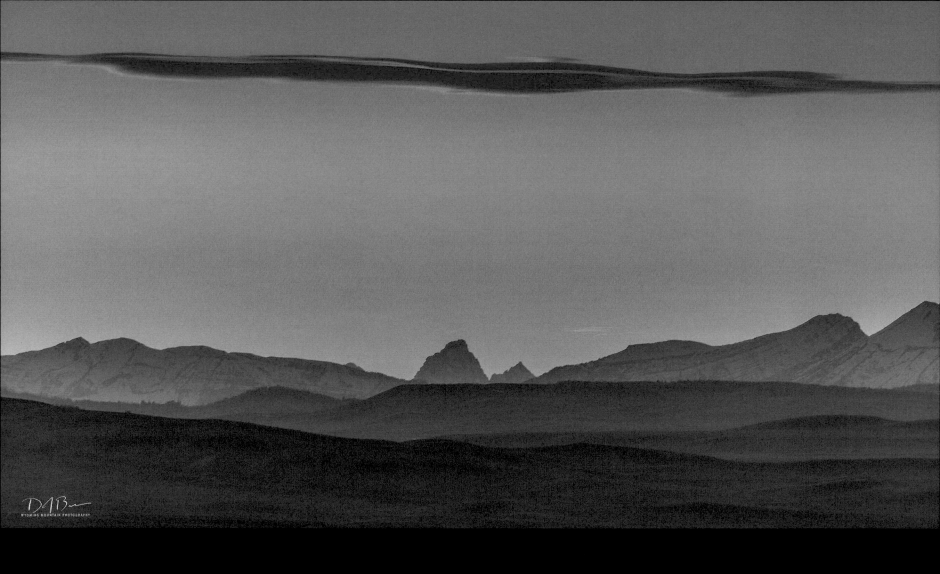

Yonder Lies Jackson Hole

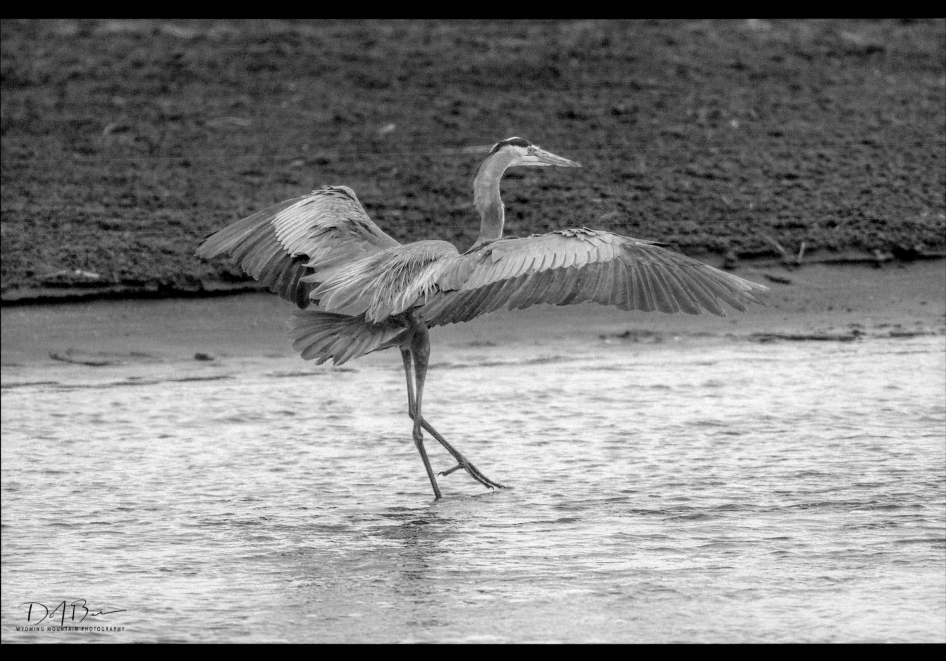

Beauty

JUNE

The Beauty Of Spring

Our spring arrives late at 7,400 feet. It is just the way it is. But, by the first of June, our leaves have burst forth and the flowers are blooming. It is the warmer weather and long days which drive optimism and hope. We had some incredible photography in June; terrific sunsets and sunrises, and green, green landscapes.

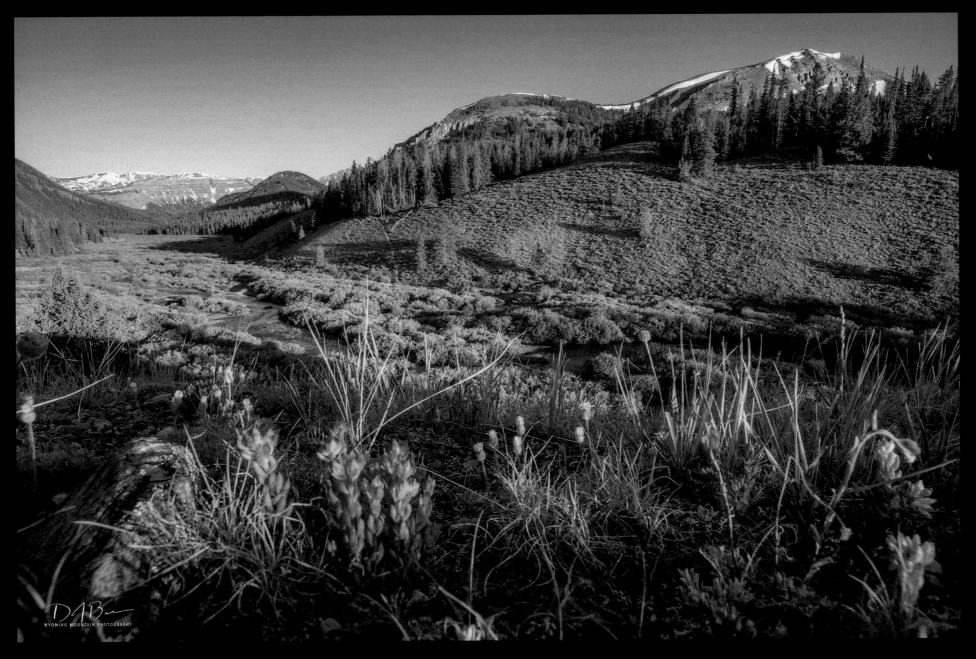

Gorgeous

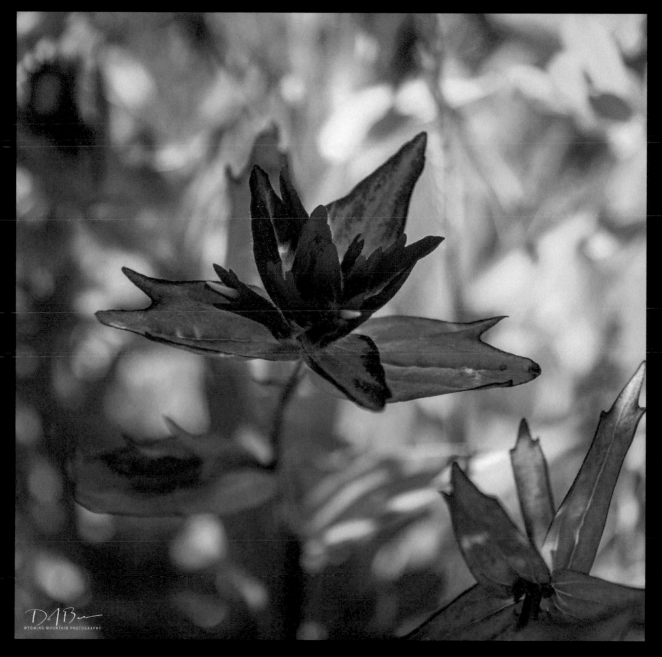

Infinite Beauty

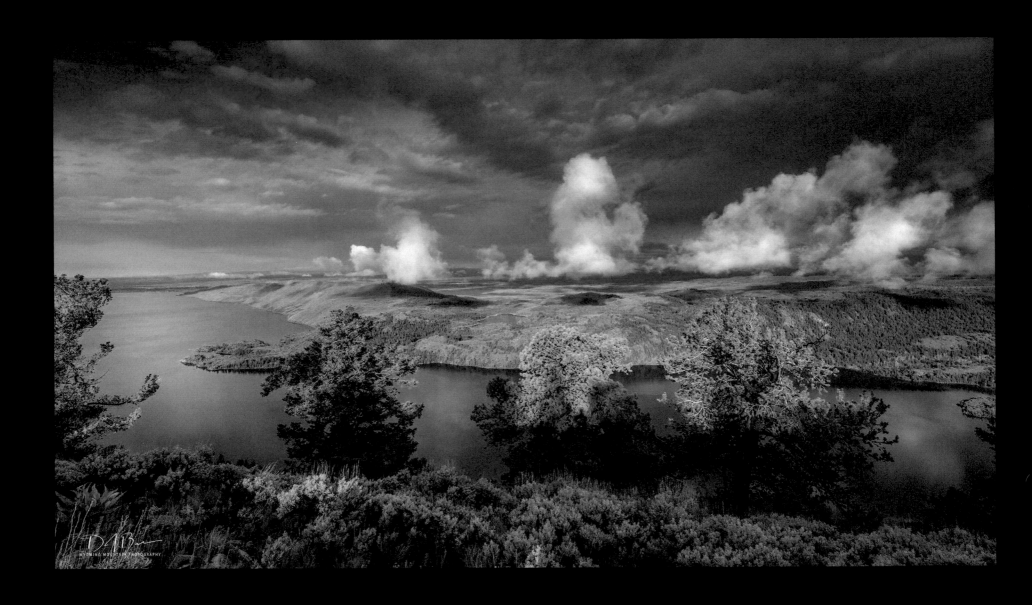

Is This Paradise

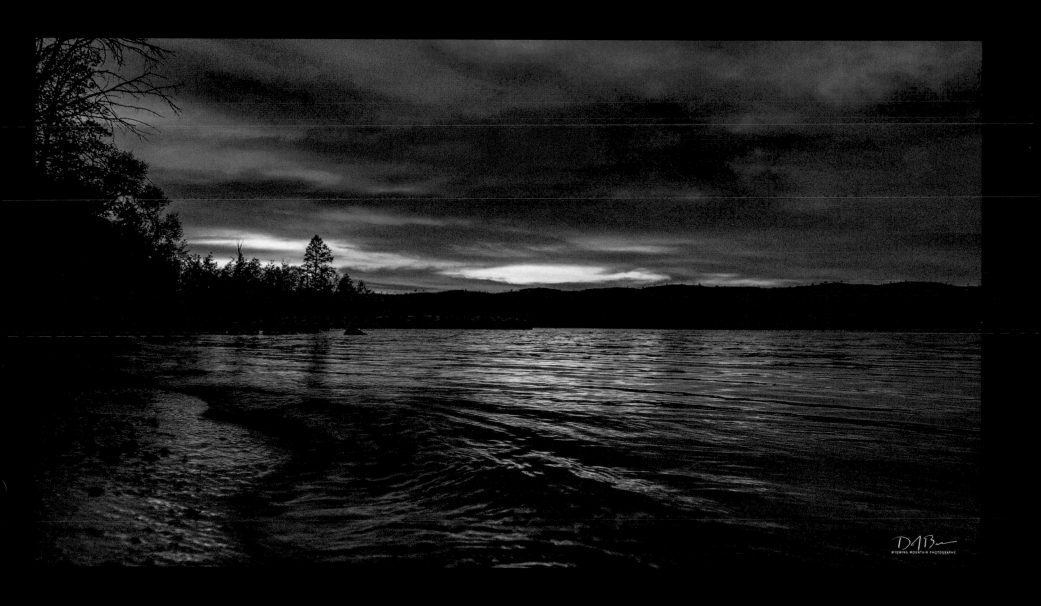

Wave Movement

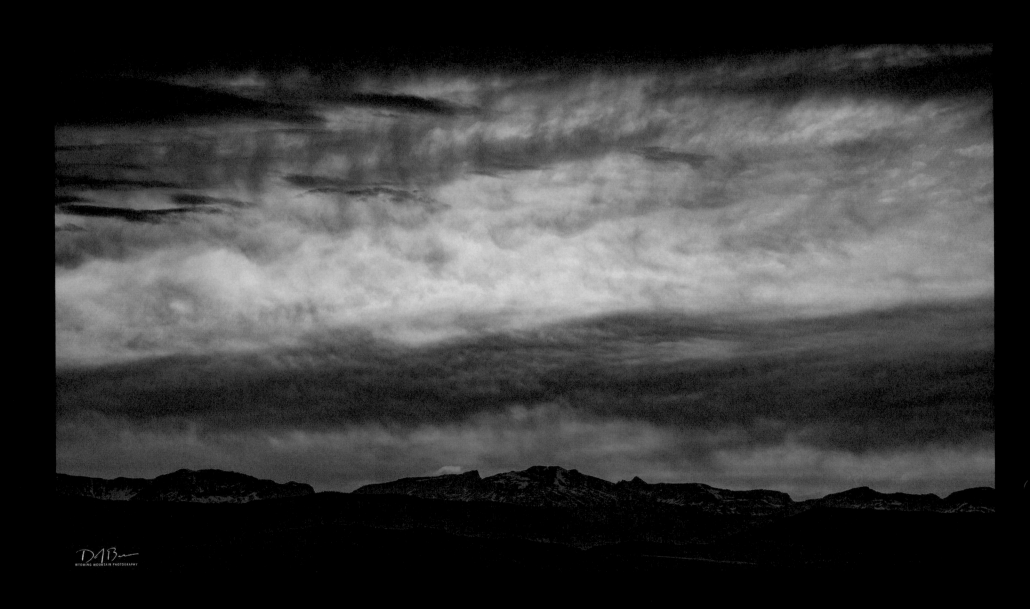

Incredible Sunrise

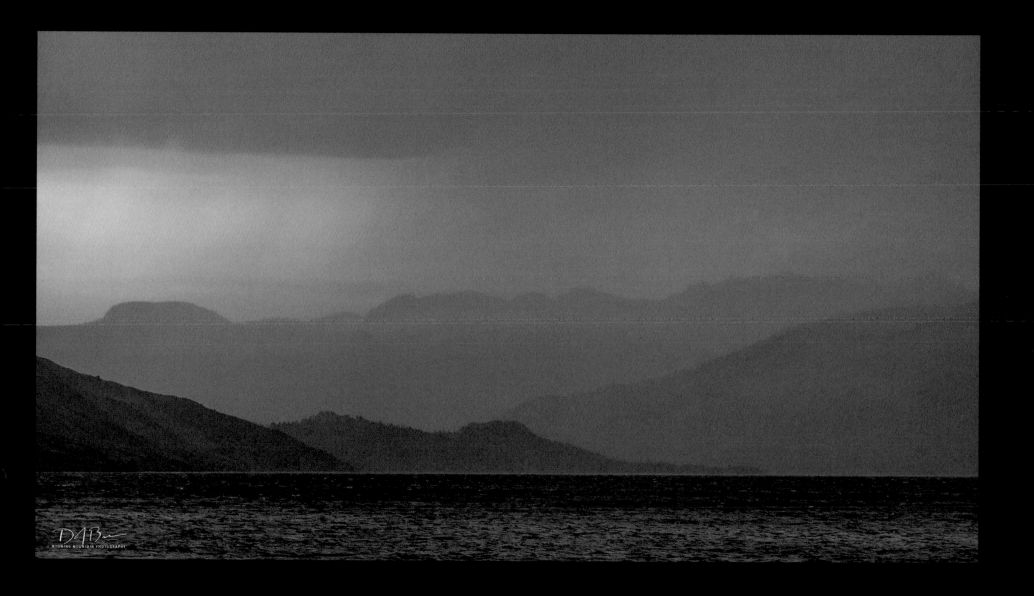

Rain Curtain

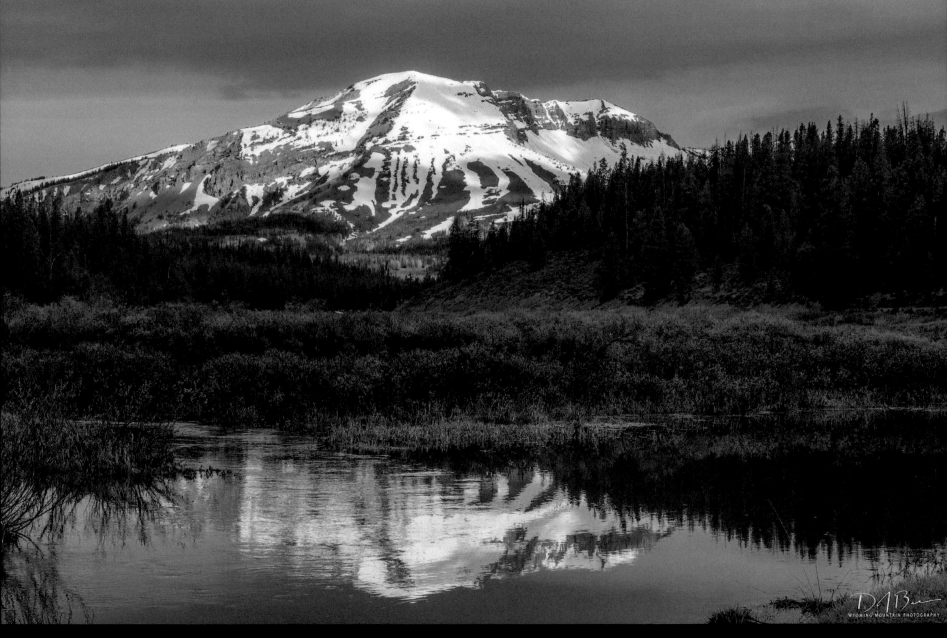

McDougall Reflections

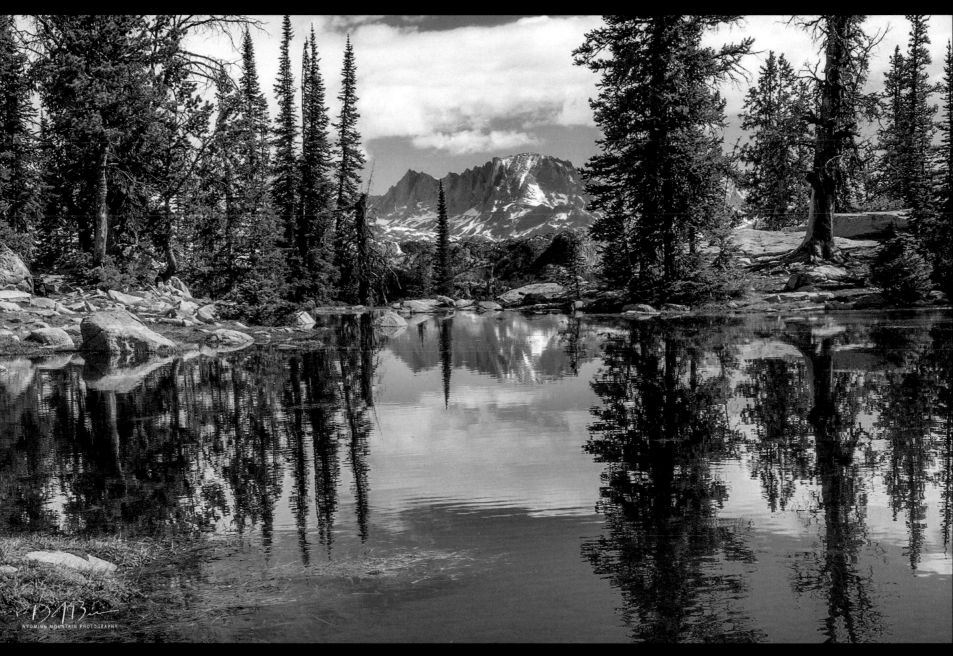

Reflecting Pond

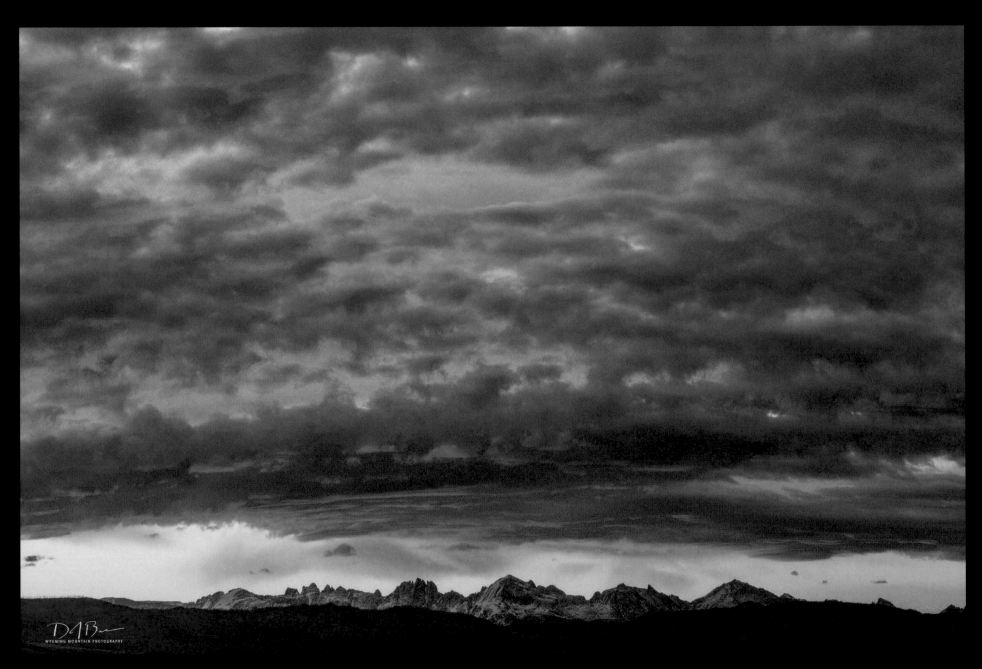

Saturday Sunrise

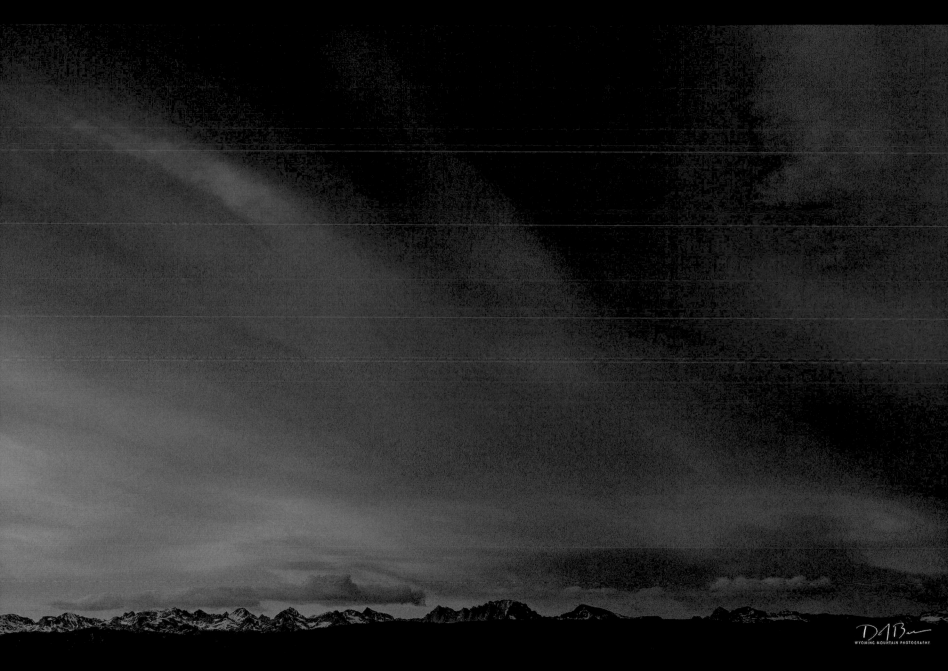

Spectacular Alpenglow

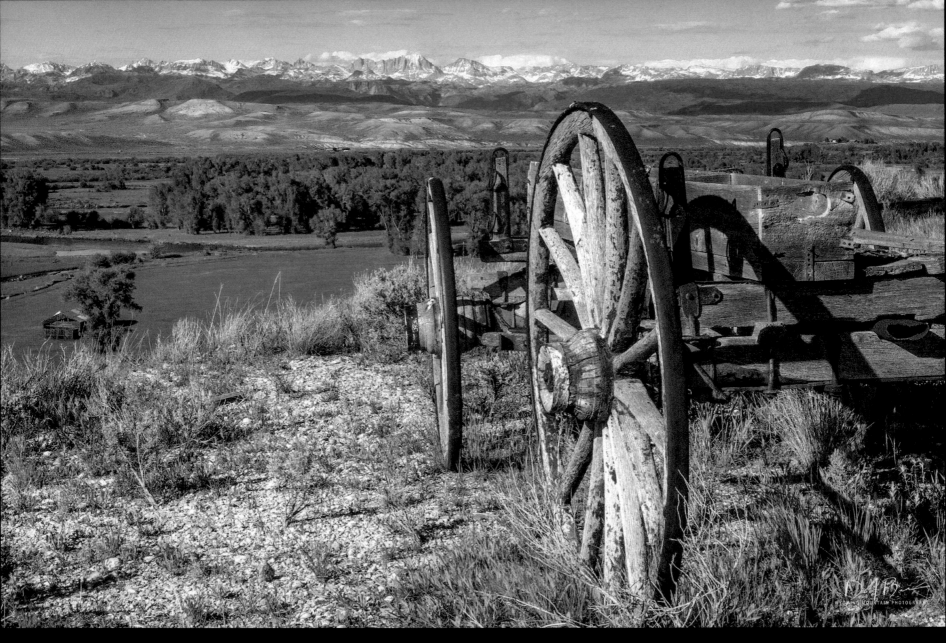

Such Beauty

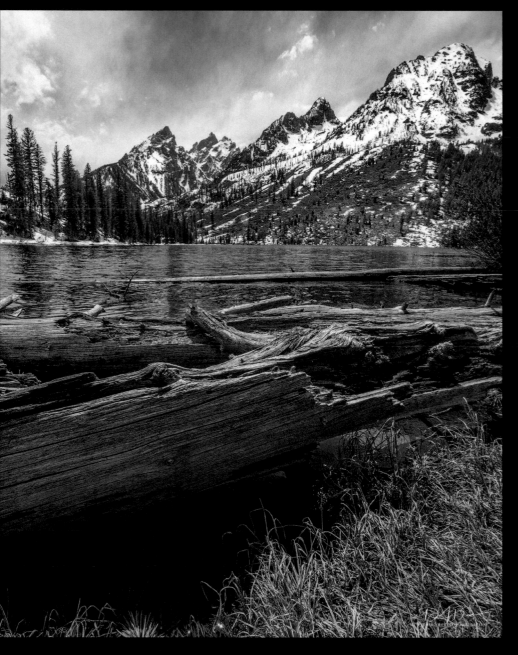

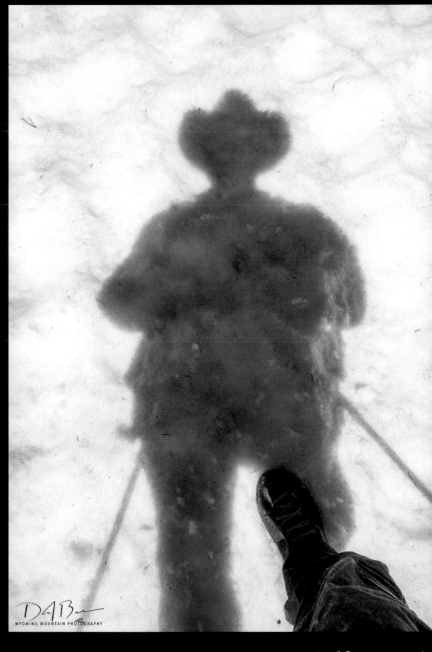

Gorgeous Scene at String Lake

Self Portrait

JULY

Beautiful Summer Month
and Epic Rendezvous Event

July is our month of wonderful summer. The landscape is still beautifully green, the hay fields are growing and the mountains are still mostly or partially snow-capped. But, the highlight of the month was an epic photo shoot of the re-enactment of the original Mountain Man Rendezvous along the Green River, with men dressed in 100 percent accurate period garb. I have included a large section in the book on this event.

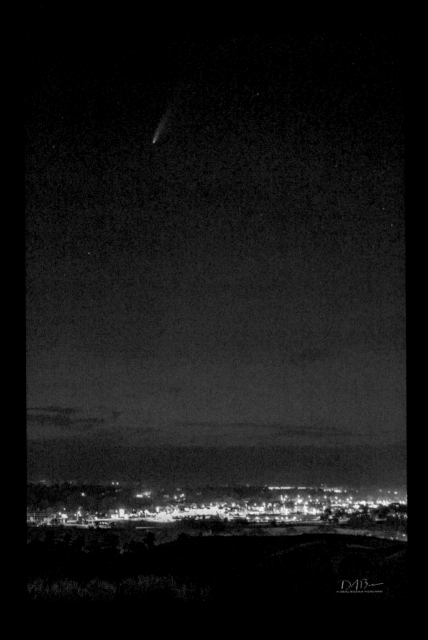

Comet Neowise

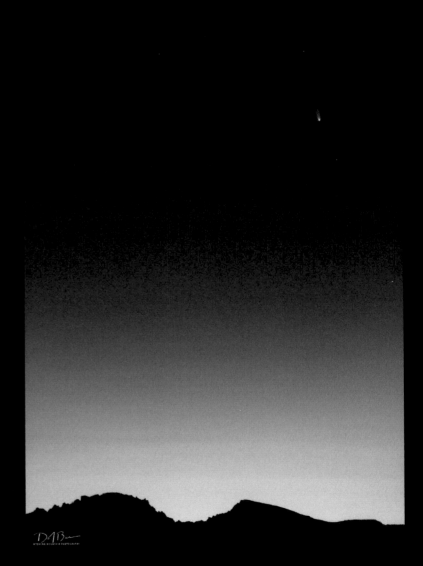

Comet Neowise

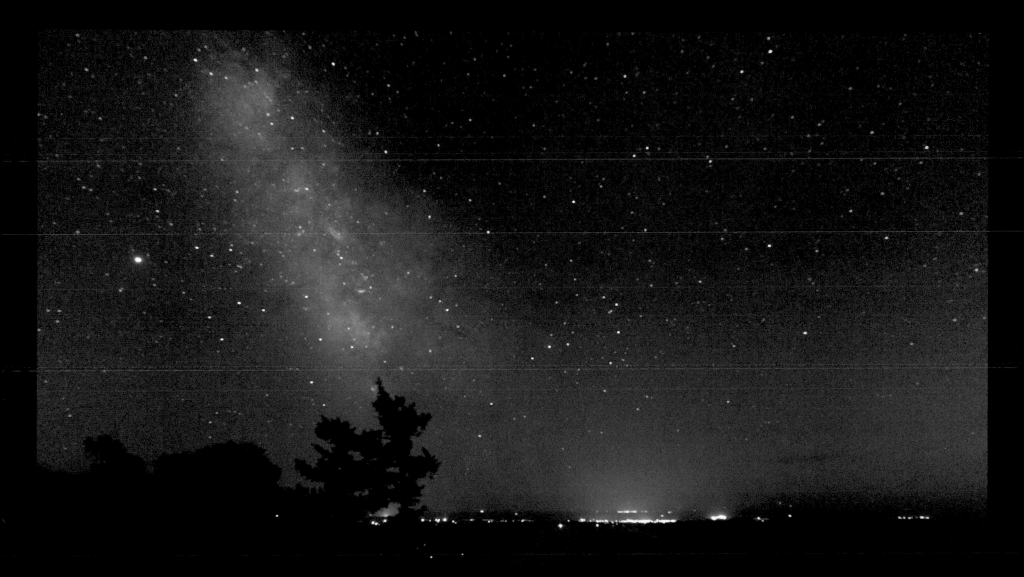

Pinedale Night Sky

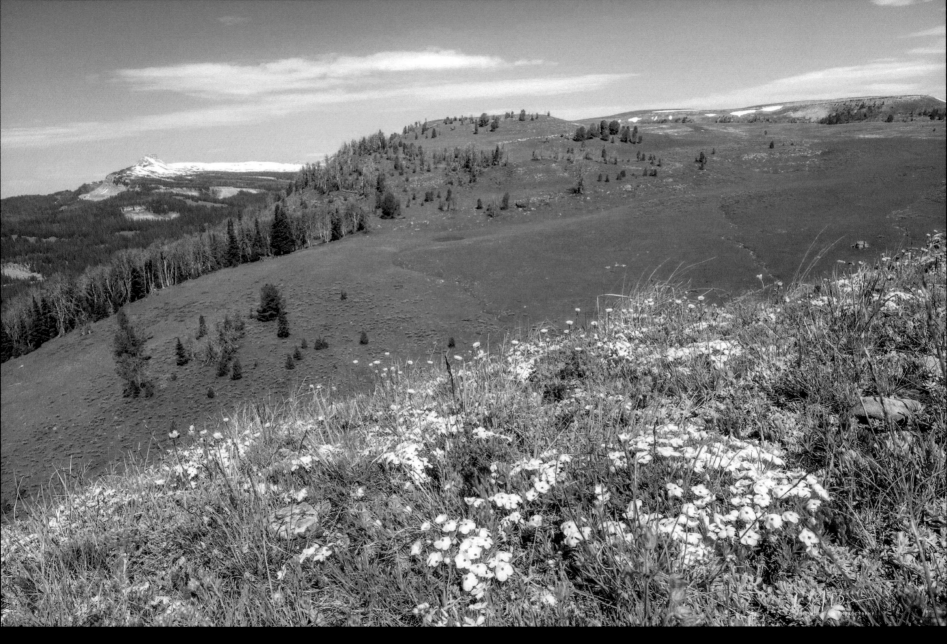

The Many Colors Of Early Summer

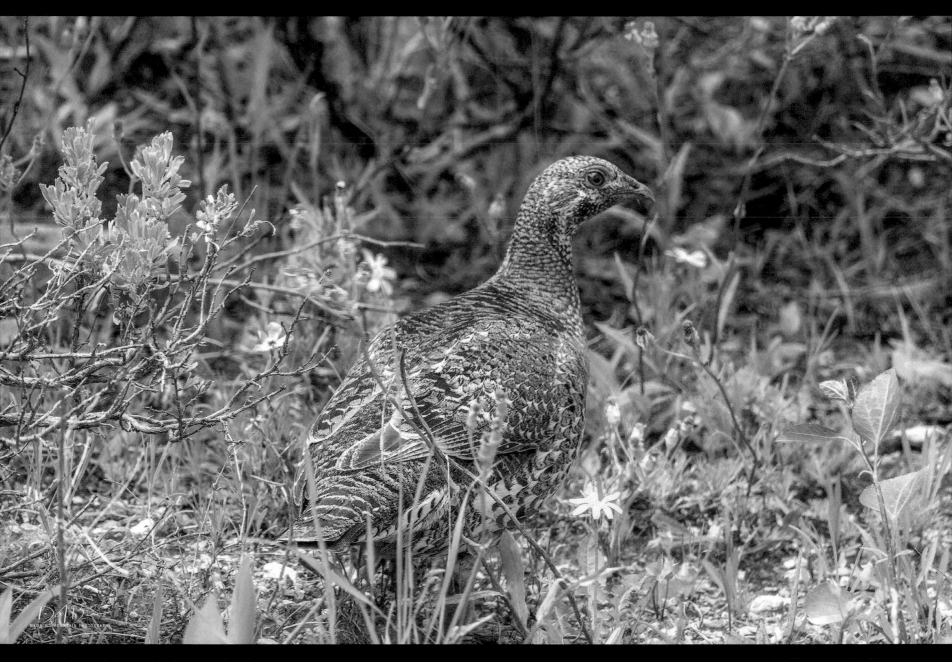

Beautiful Grouse

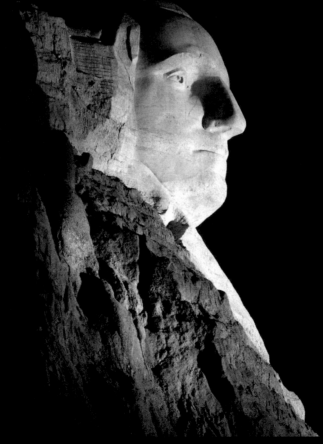

George

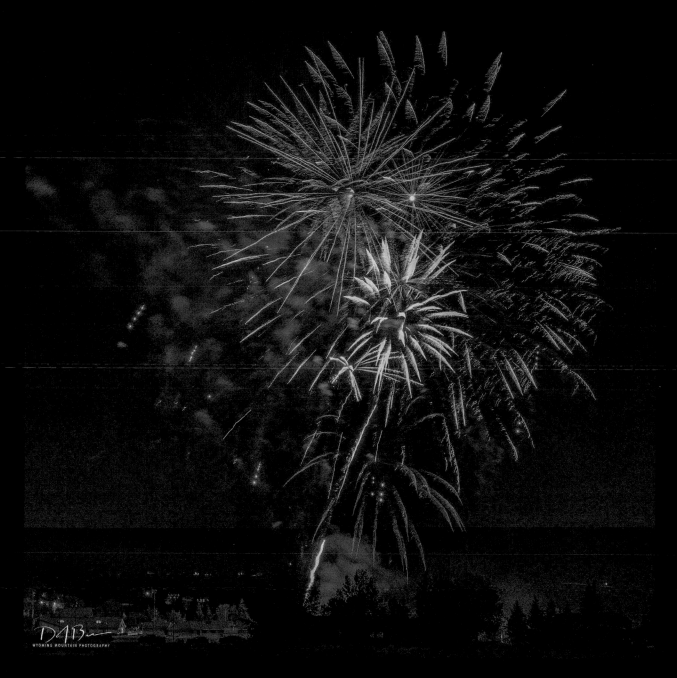

Fireworks

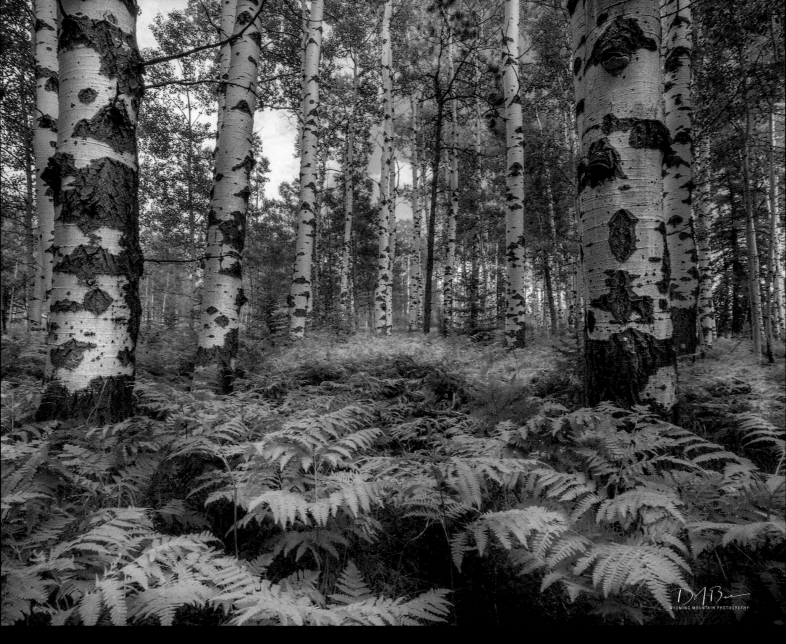

Primal Forest

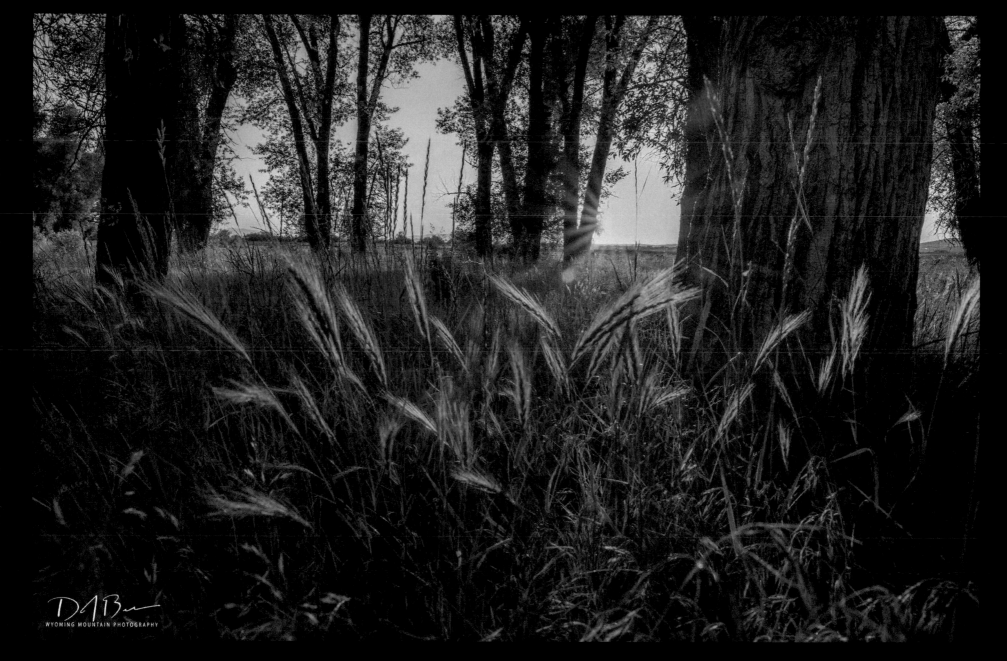

Sunlit Grasses

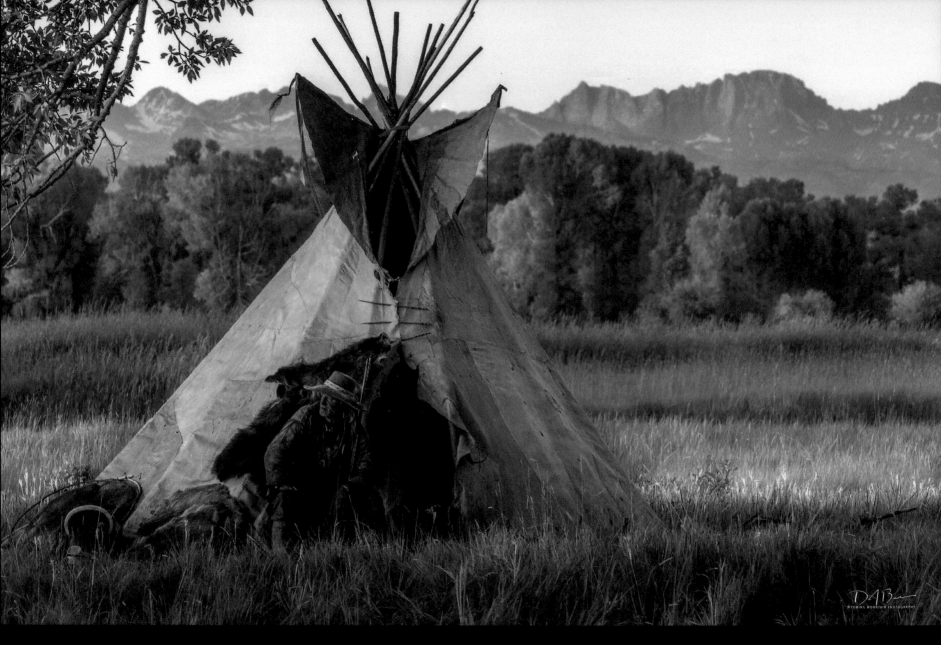

Doc at Sunset at Teepee

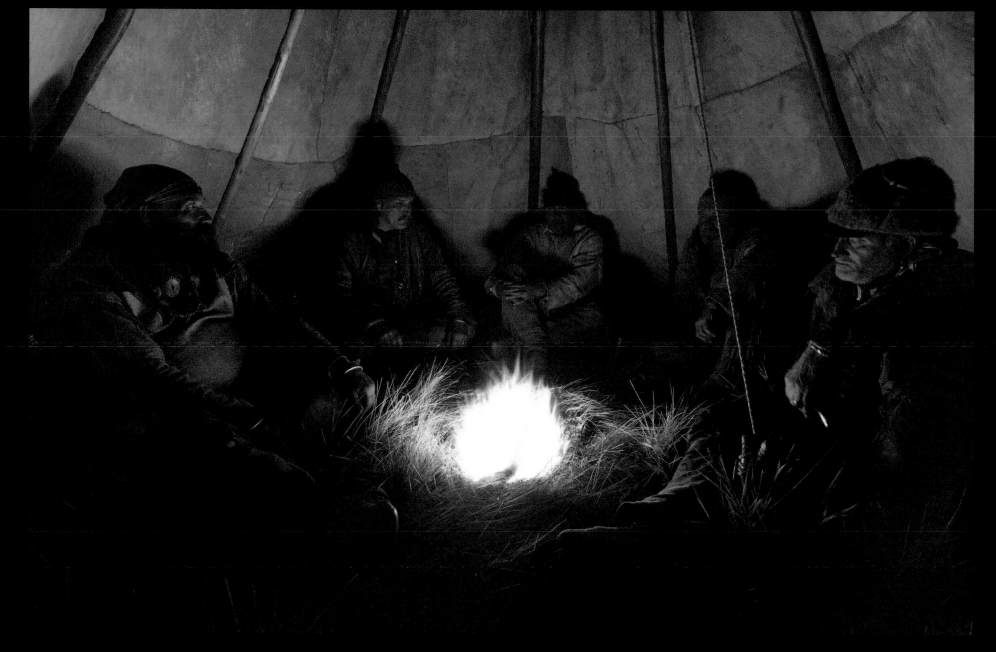

Fire, Lies and Eyes

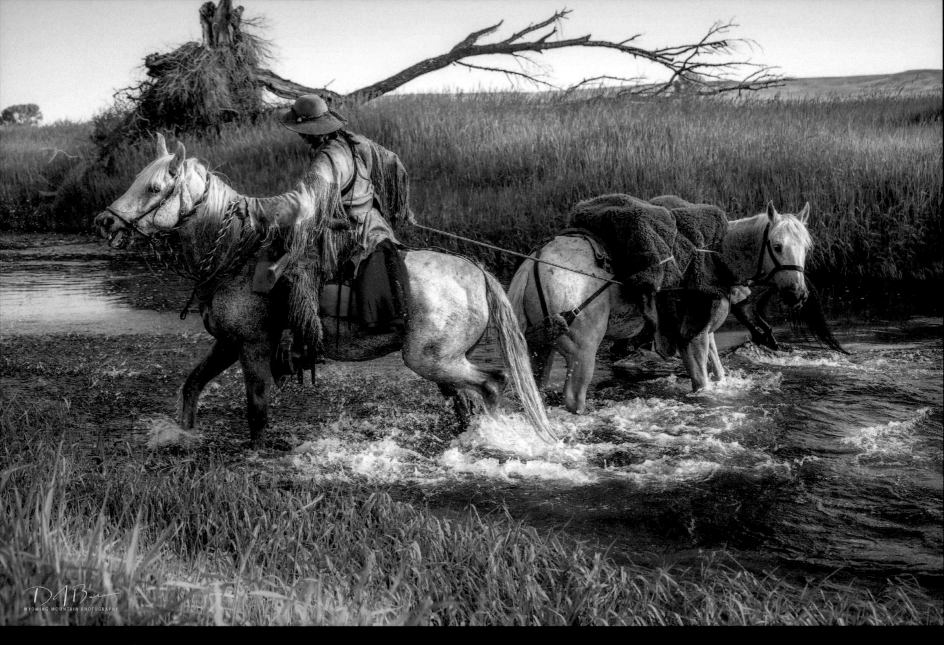

Tugging Hard

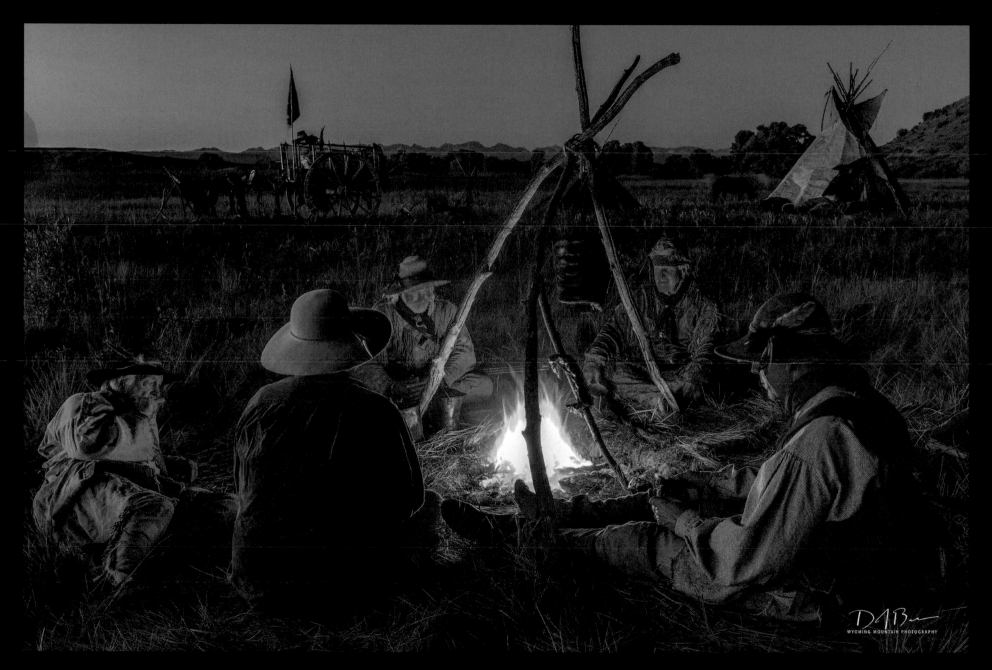

Finishing Dinner

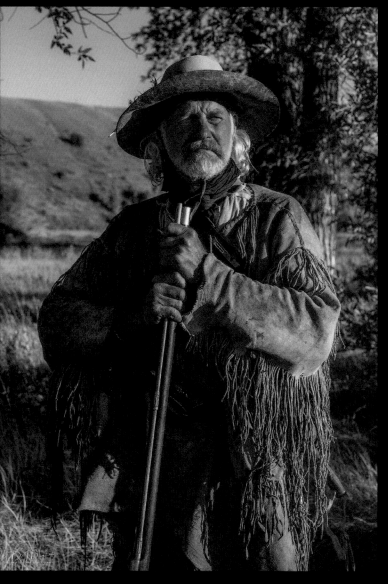

Bob

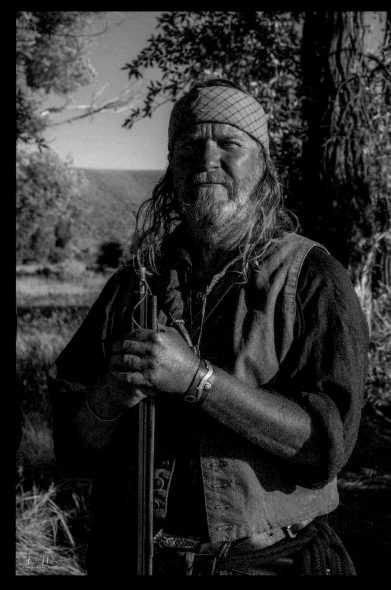

James

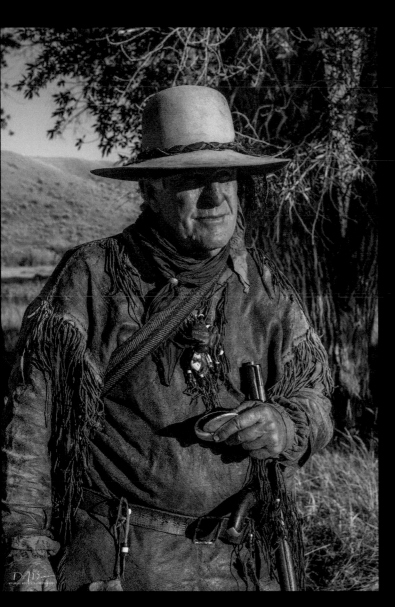

Richard

Trapper

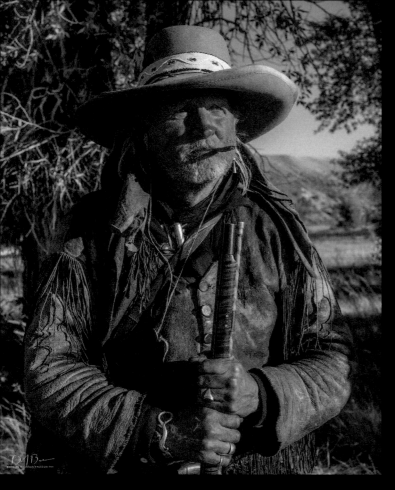

Doc

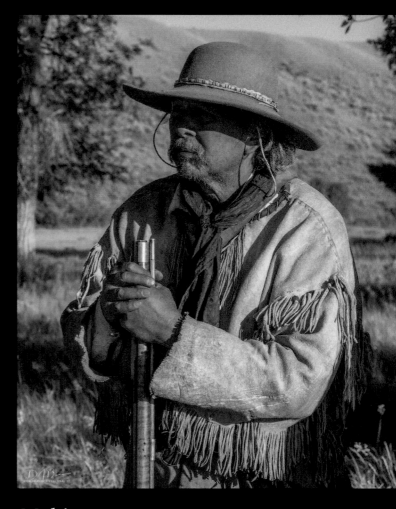

Moki

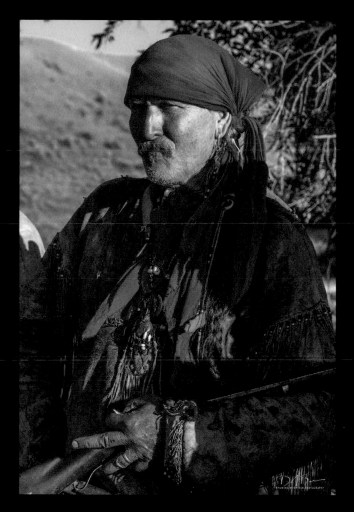

Hawk

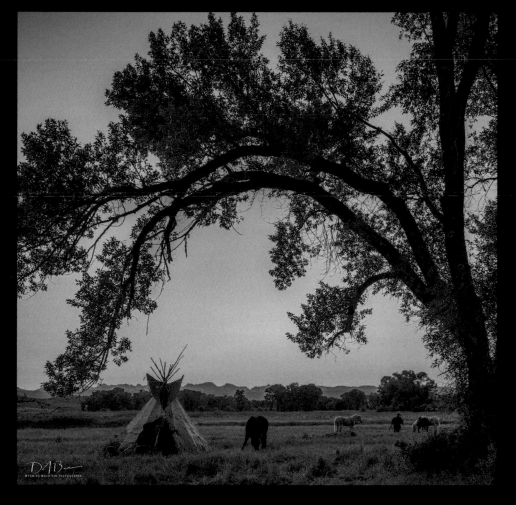

Morning at Camp

AUGUST

Return To Brewster

In August, for the past 38 years I have mounted an expedition of some sort or other into the mountains of the west. I have seen high places and alpine lakes in Idaho, Montana, Wyoming, Utah, Colorado, South Dakota and New Mexico. This year, I was able to return to a Wyoming lake – Brewster Lake in the Gros Ventre Mountains – a lake I once visited fifteen years ago. This incredible turquoise colored gem was just as I remembered it–spectacular.

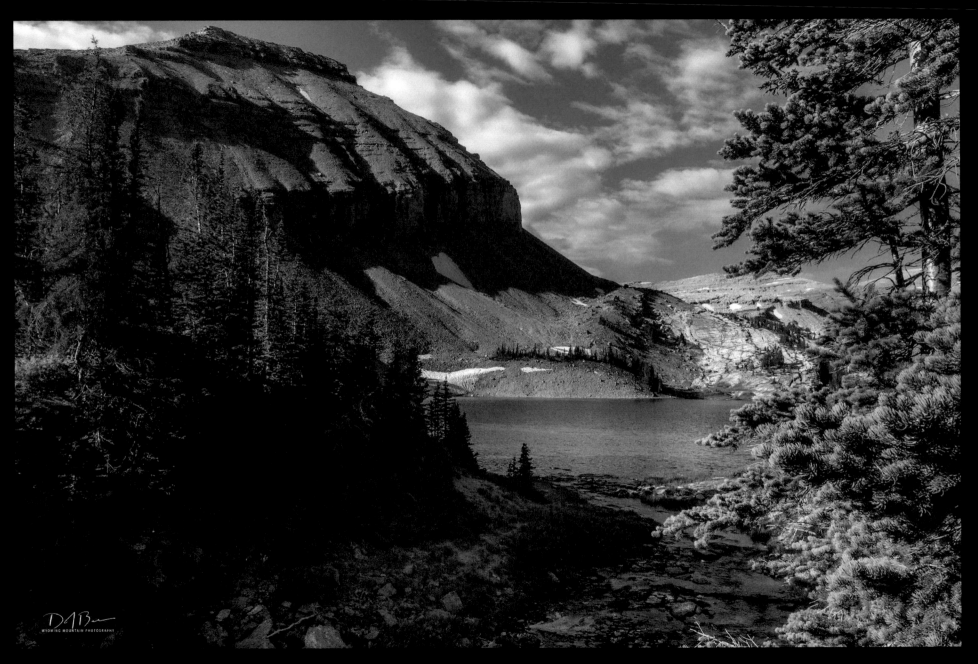

Brewster Lake and Triangle Peak

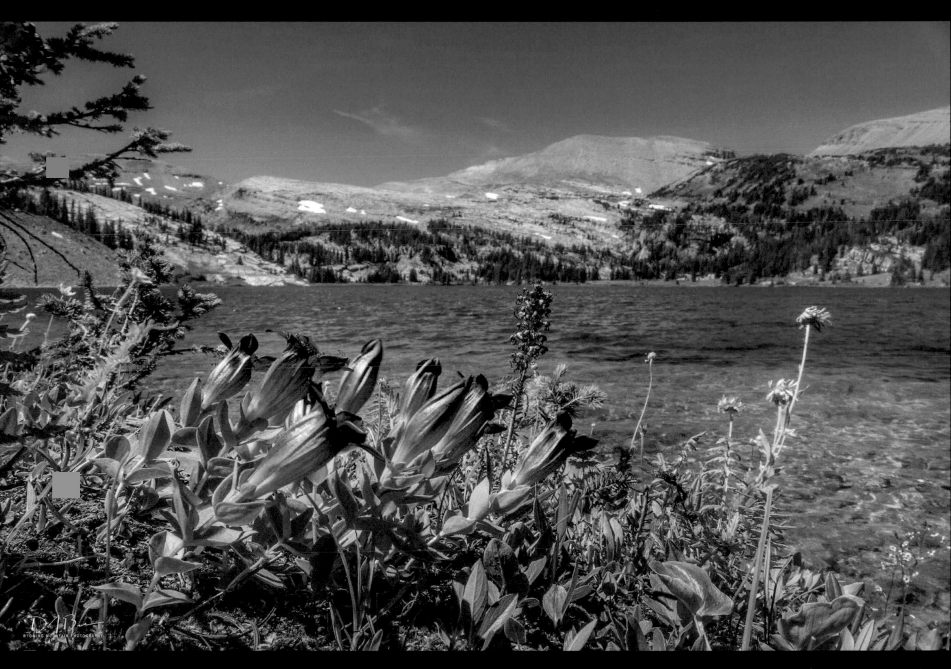

Explorers Gentian

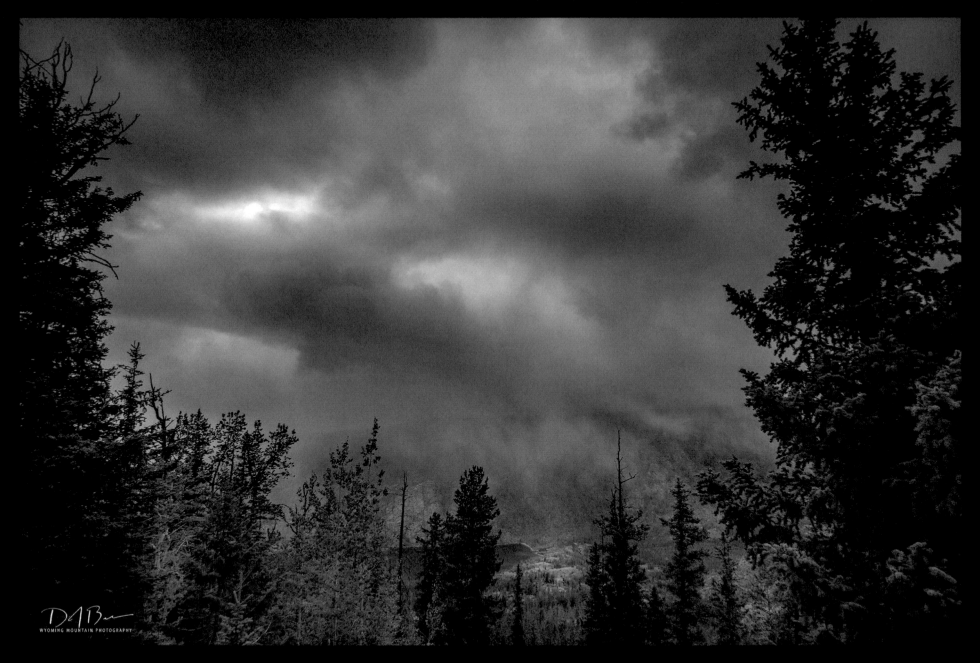

Sun on Head of Fremont Lake

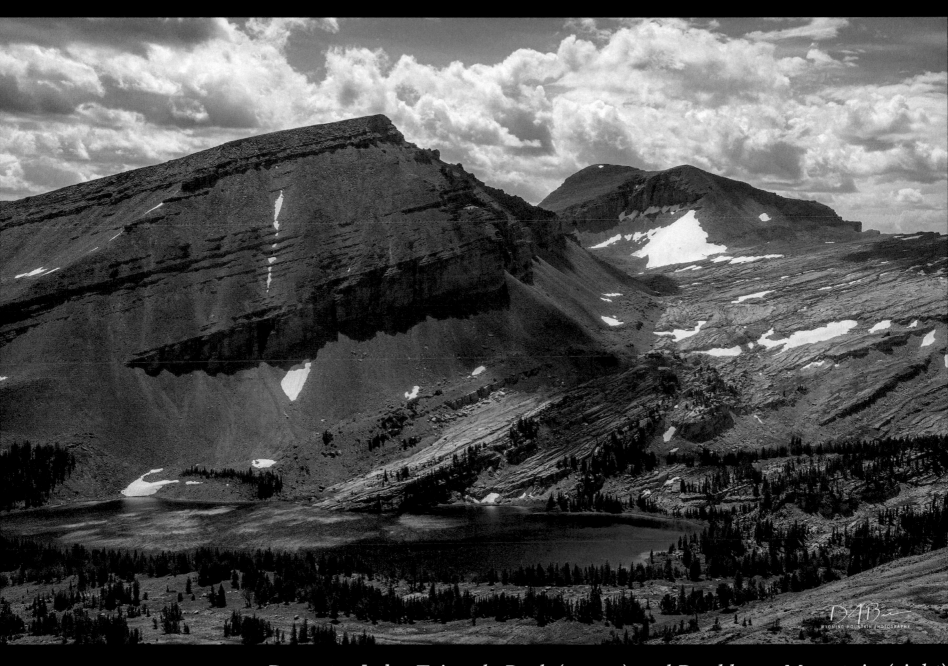

Brewster Lake, Triangle Peak (center) and Doubletop Mountain (right)

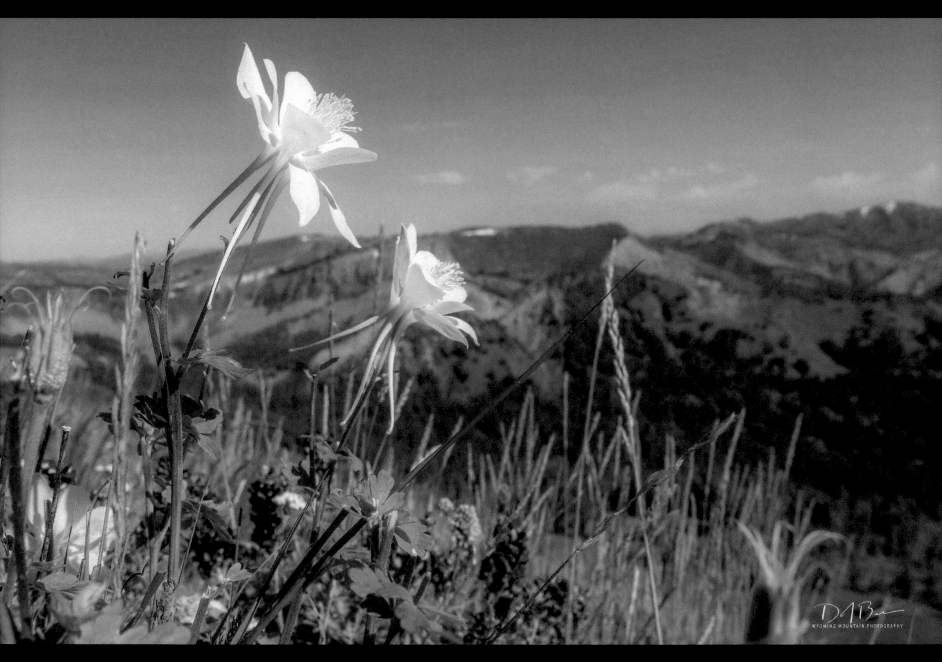

Morning Sun

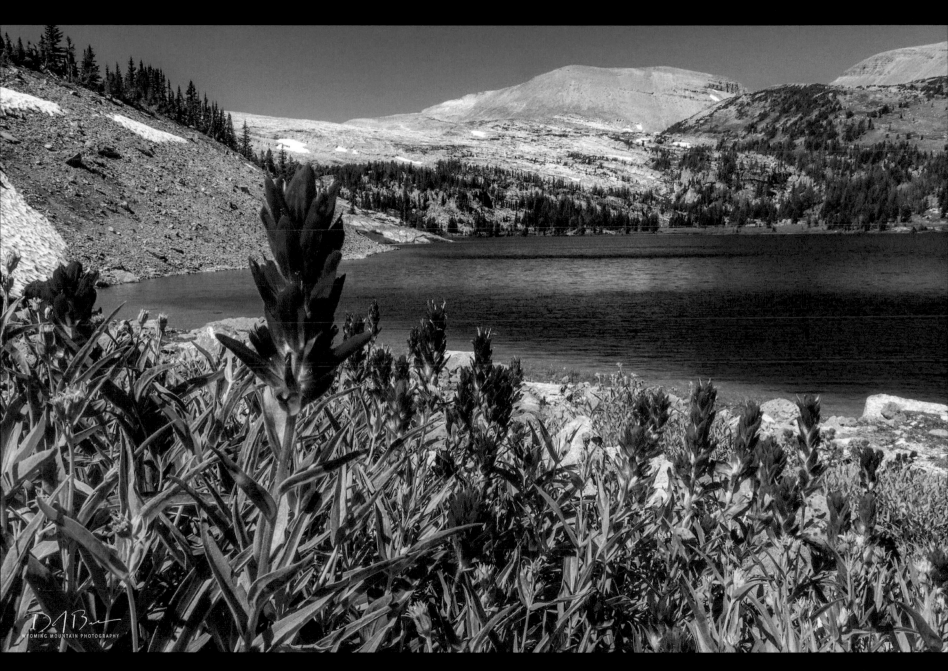

Paintbrush Beauty

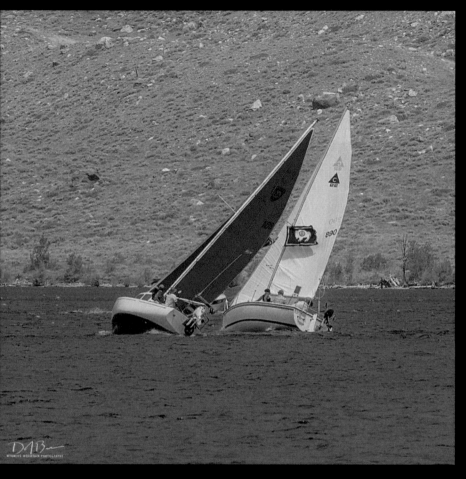

Going Like The Clappers

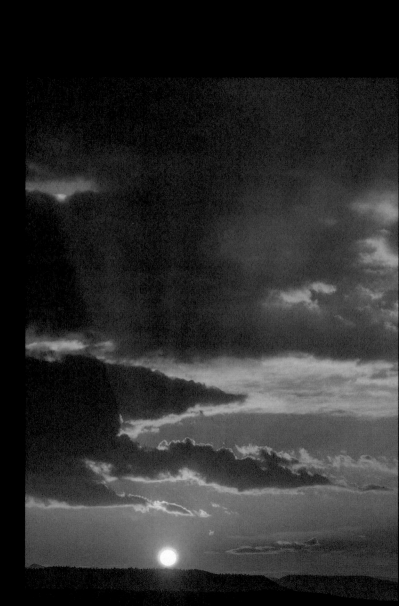

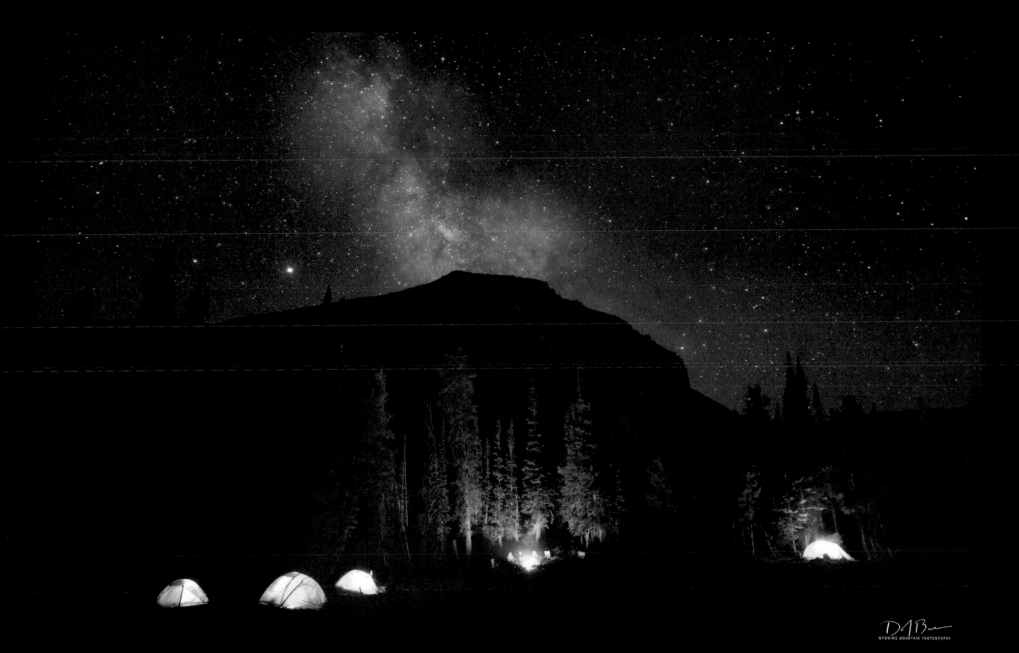

Wyoming Night Skies

SEPTEMBER

Smoke and The Blowdown

September will be remembered as the month of heavy dense smoke from western wildfires, which created some remarkably colorful sunsets. However it will also be remembered for an incredible meteorological event which occurred on the western slope of the Wind River Mountains. A strong downsloping wind developed on Labor Day from a deep early season low-pressure system on the eastern side of the mountains. This storm provided a foot of early snow on Lander; but more importantly, generated hurricane force winds which devastated thousands and thousands of acres of forest on the west side of the range. No trees were spared—dead or alive. The forest and trails were obliterated and will remain a major problem for years and years to come deep within the Bridger Wilderness.

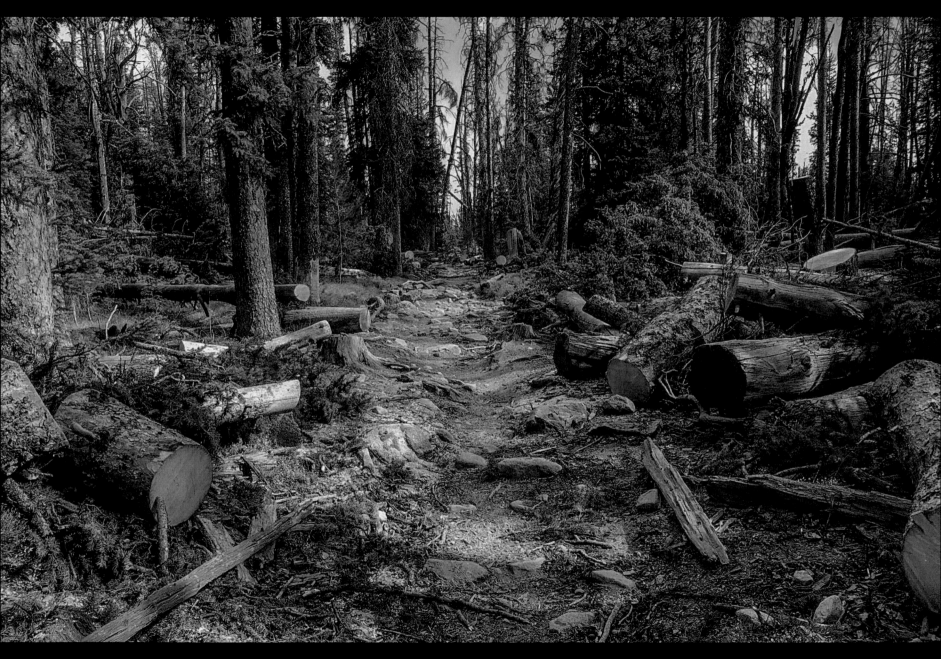

Reopening Trail

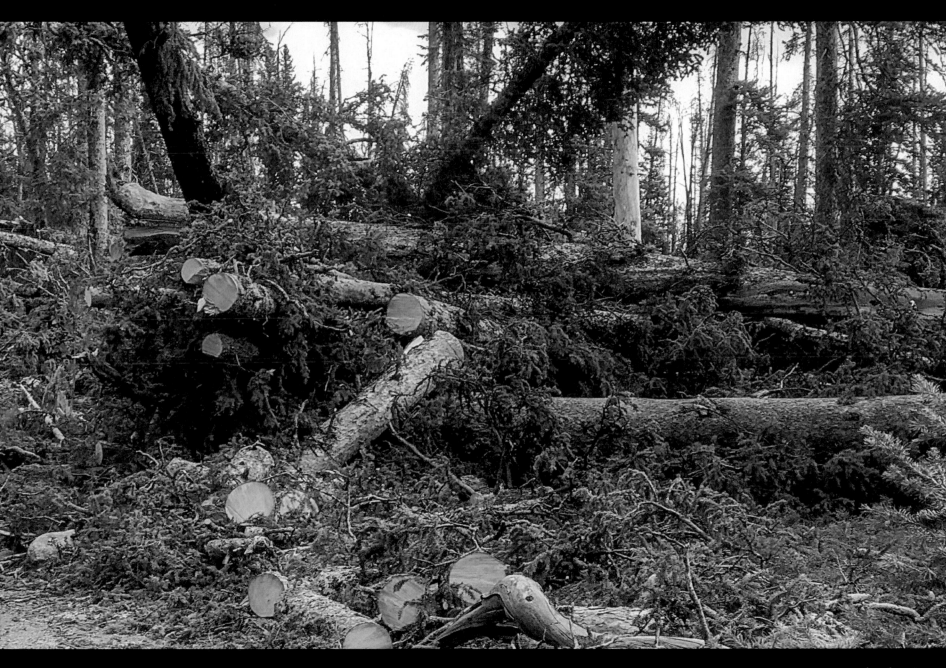

Tangled Mess

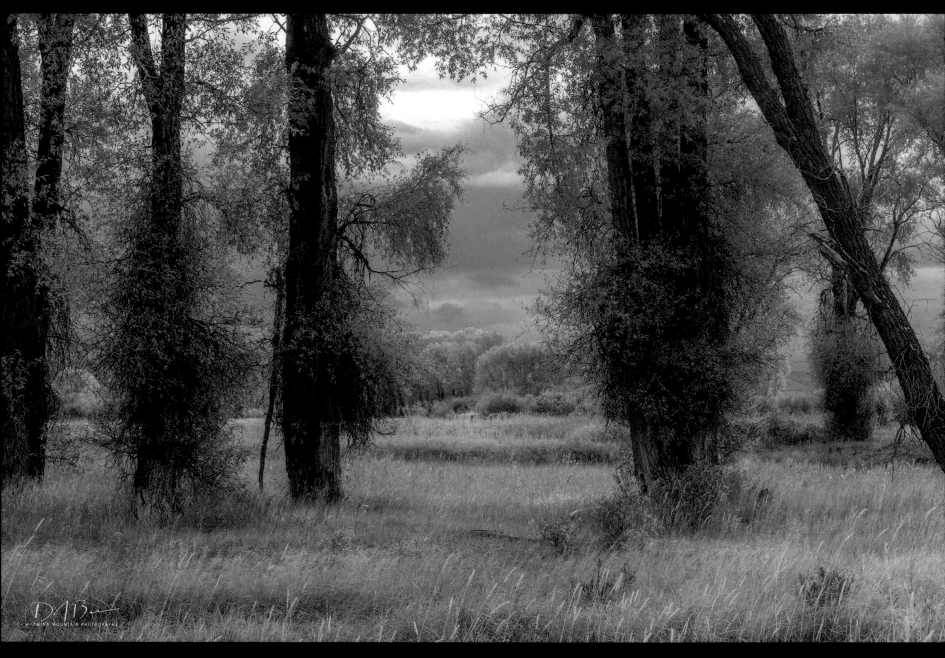

Morning Gold

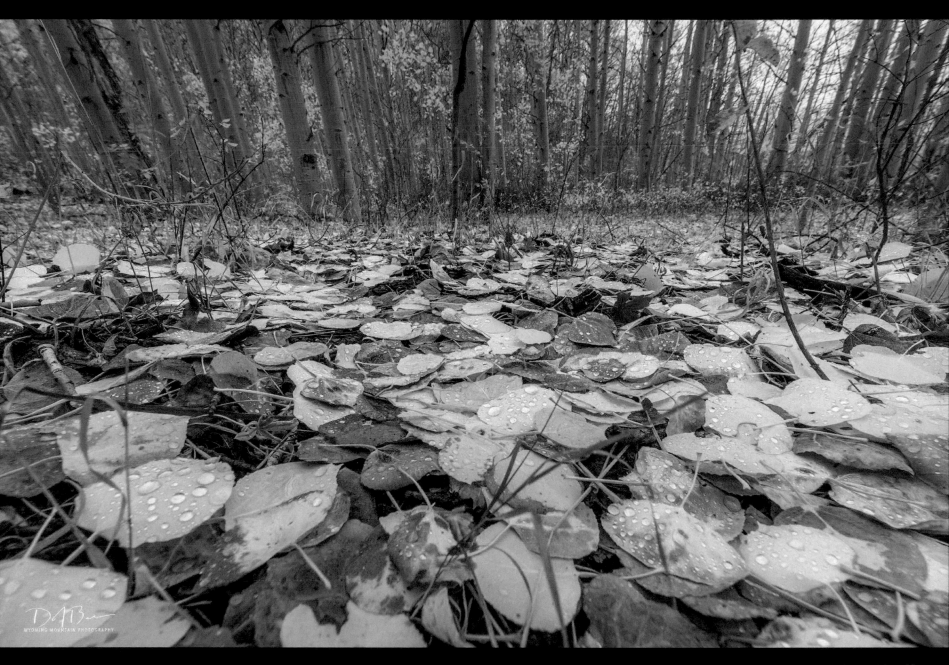

Golden Dollars

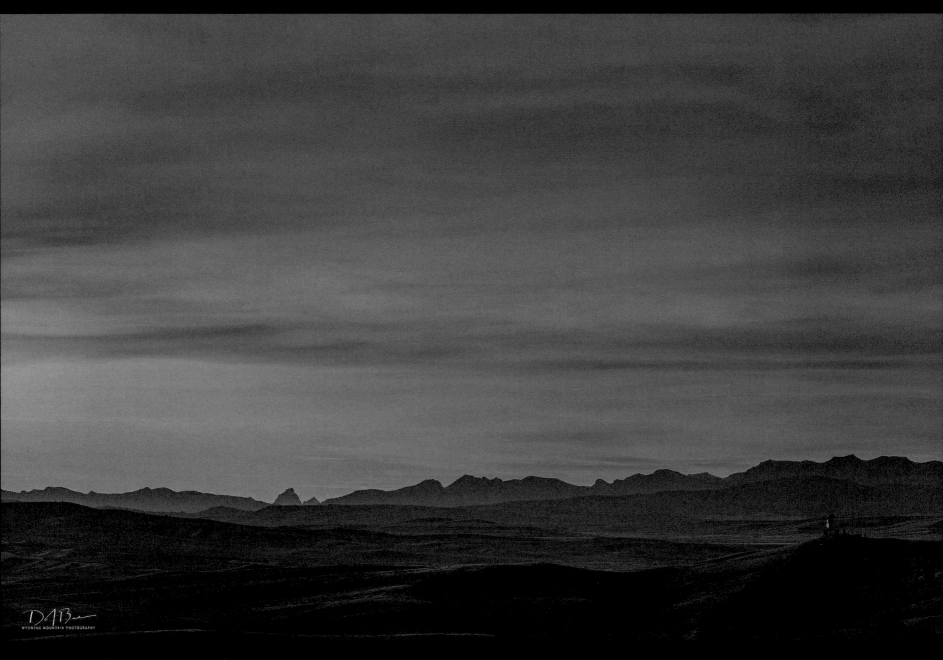

From Mt Airy to Grand Teton

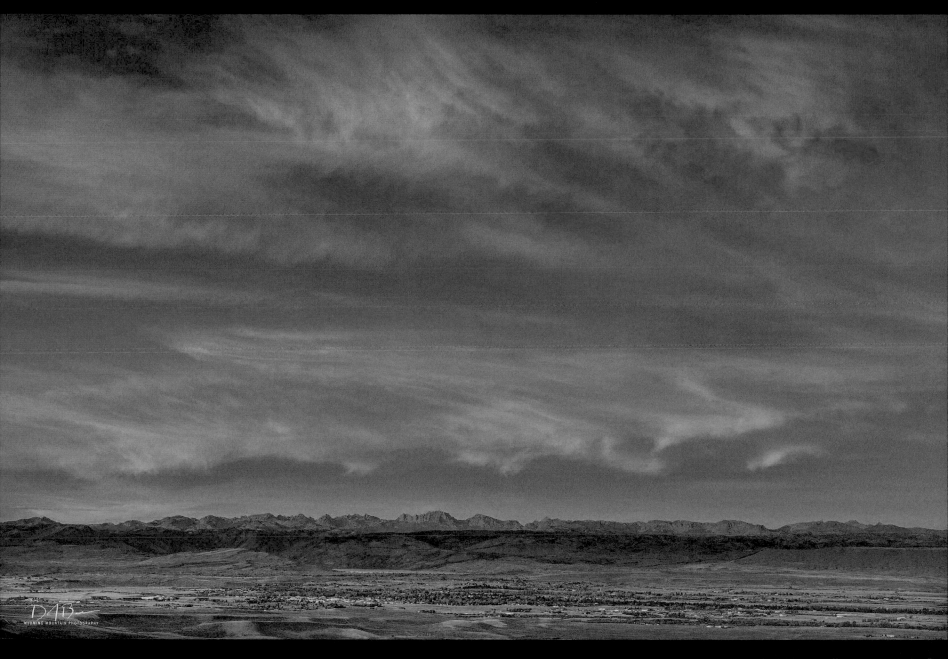

Wind River Range Light

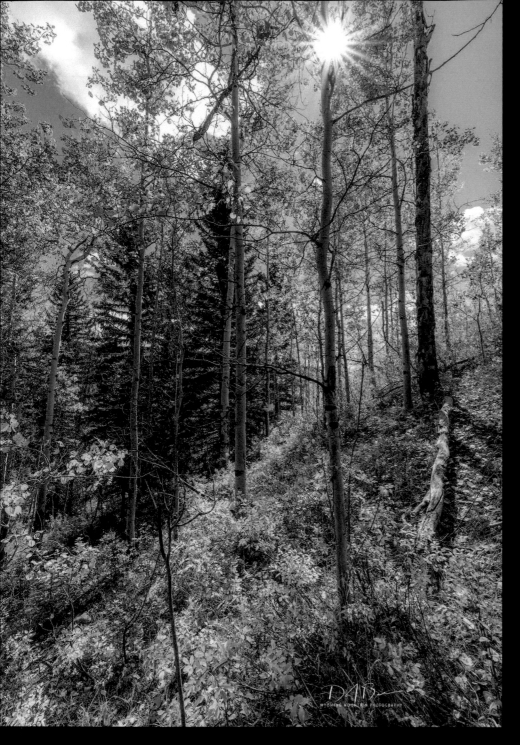

Beautiful Aspens and Foliage

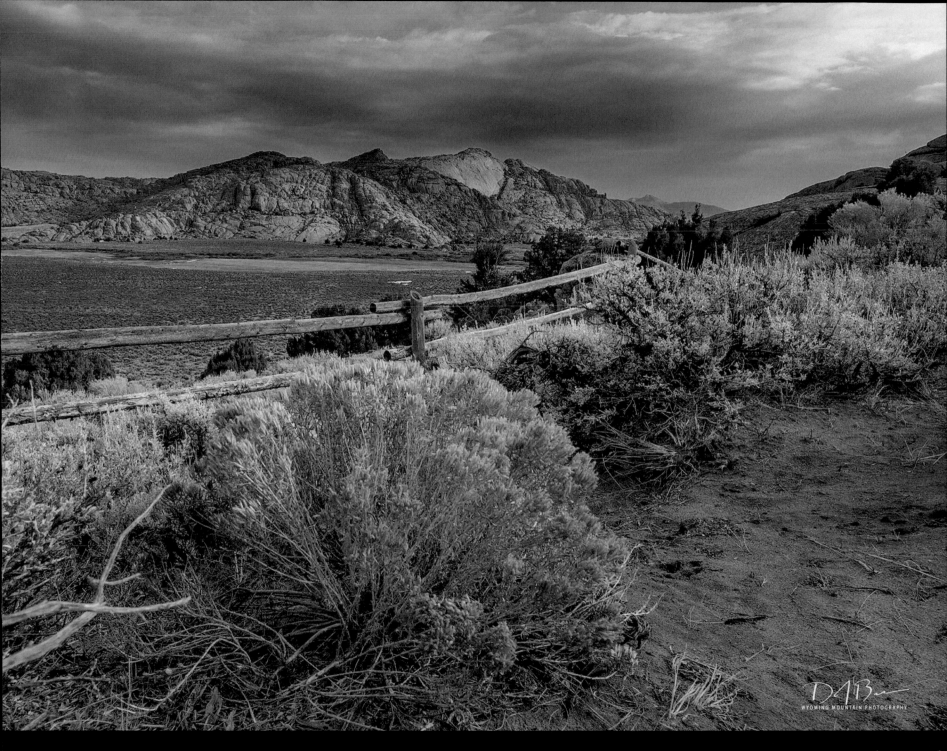

Split Rock

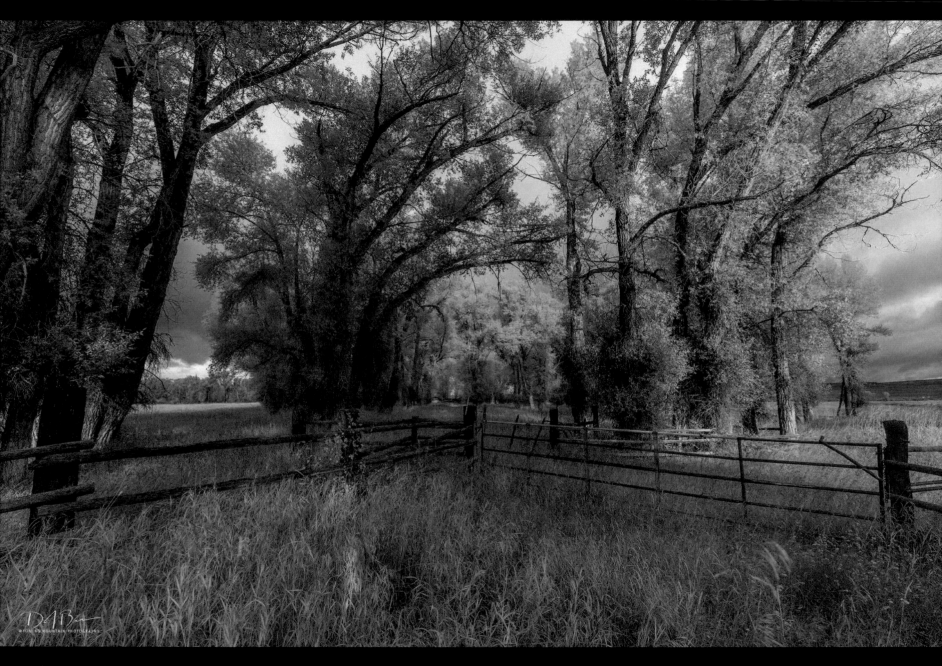

Golden Color

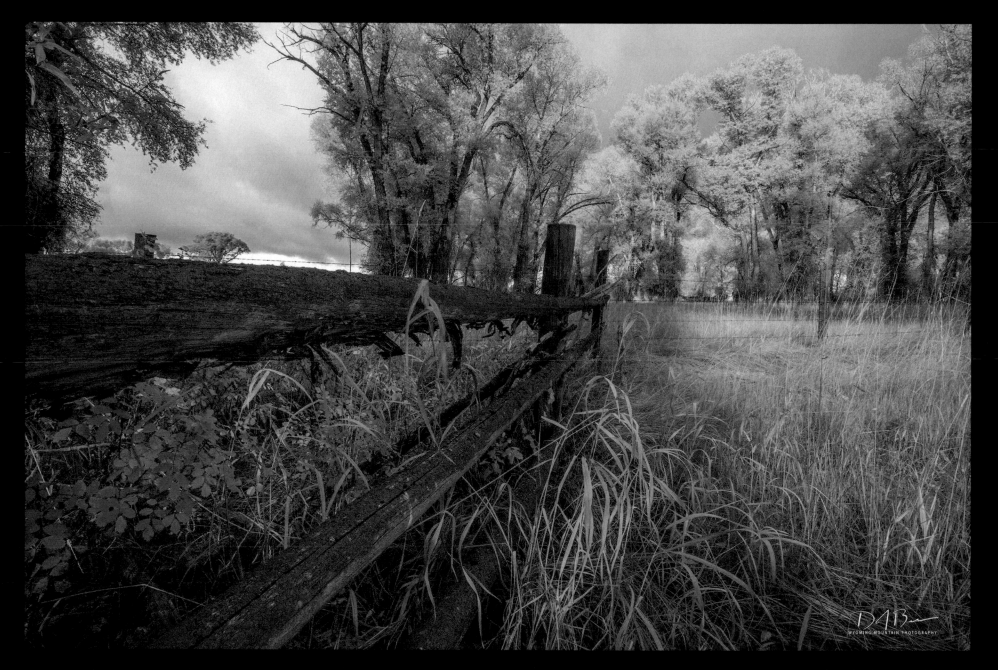

Old Fence Rails

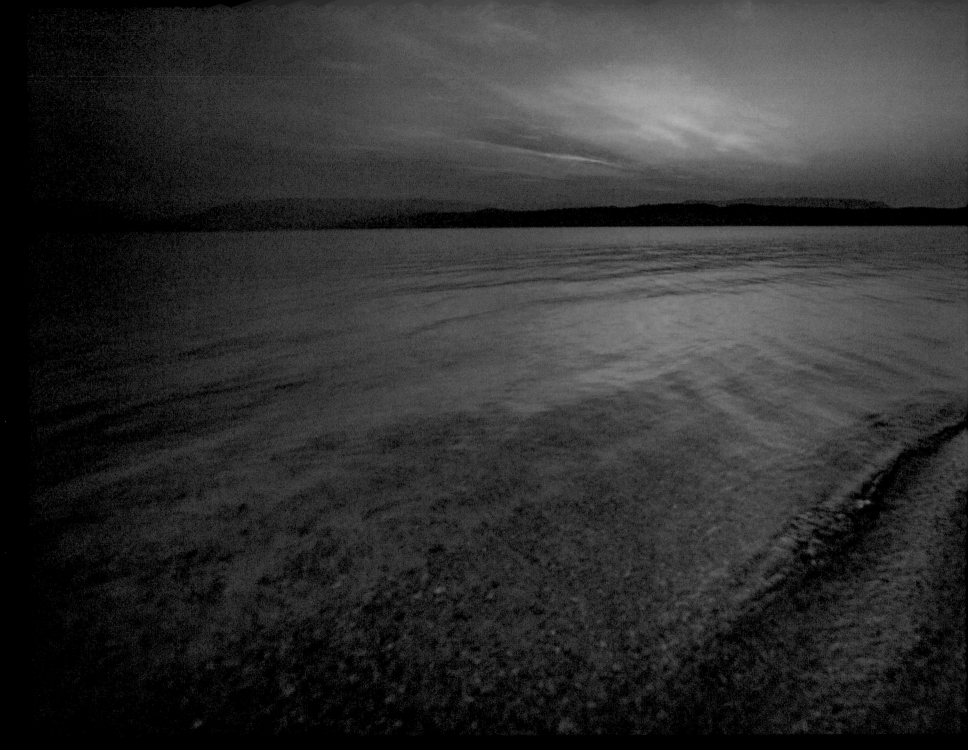

Wonderful Morning Color

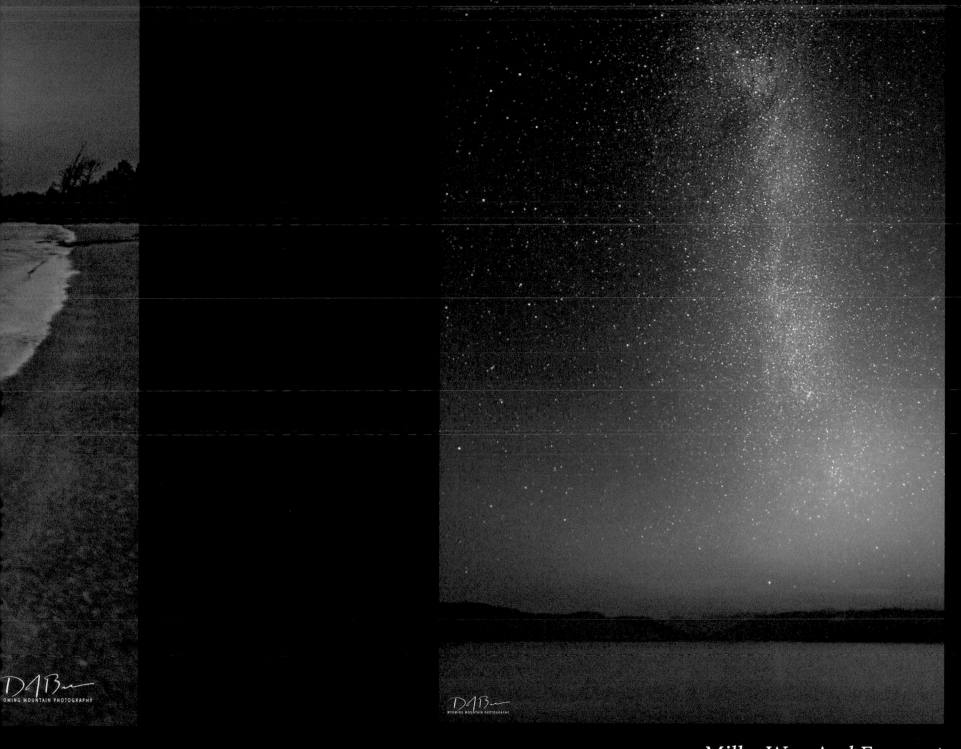

Milky Way And Fremont

OCTOBER

Yellowstone and Grand Teton

An interesting phenomenon of the COVID pandemic was record numbers of tourists traveling throughout the American west. Yellowstone and Grand Teton National Parks greatly outdistanced previous record visitor numbers and October, normally a quiet month, was packed. But, I did make two late season trips to the parks including a trip on closing weekend in Yellowstone. Incredible photography, but little solitude.

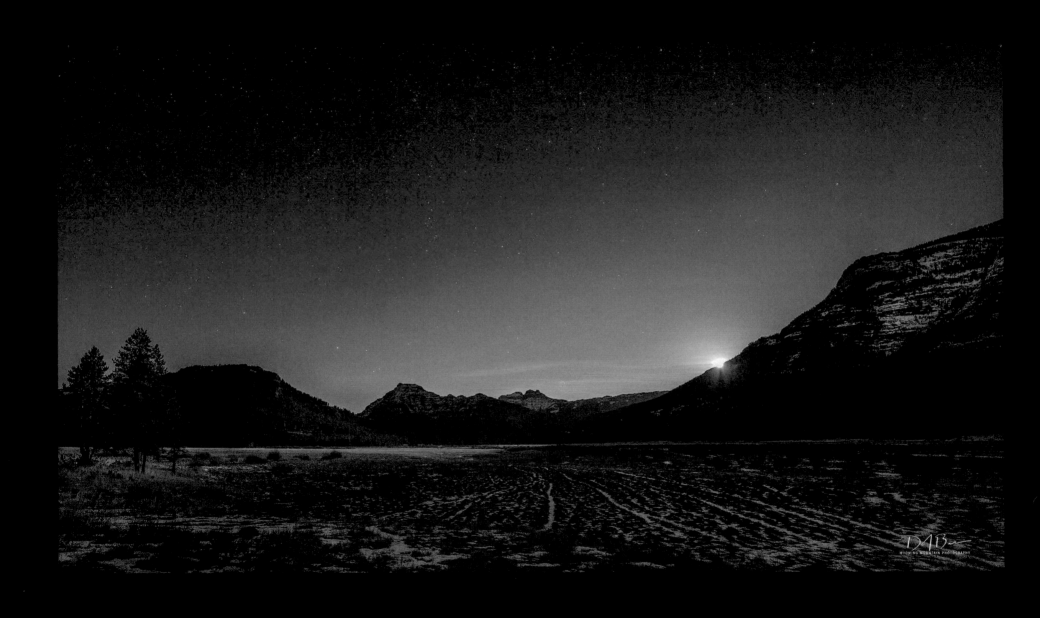

Halloween Moon Rise

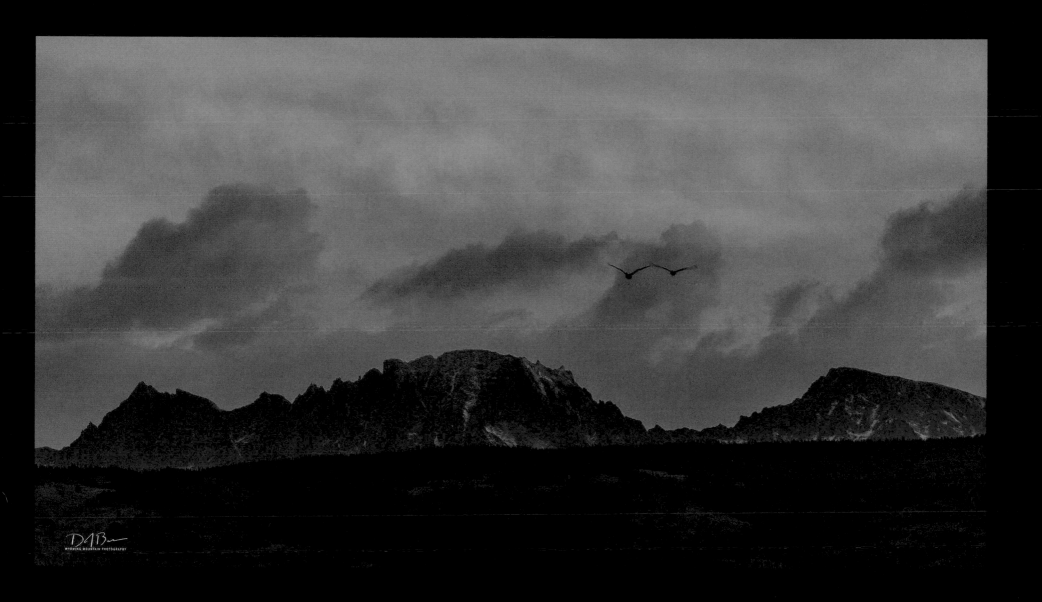

The Geese Know

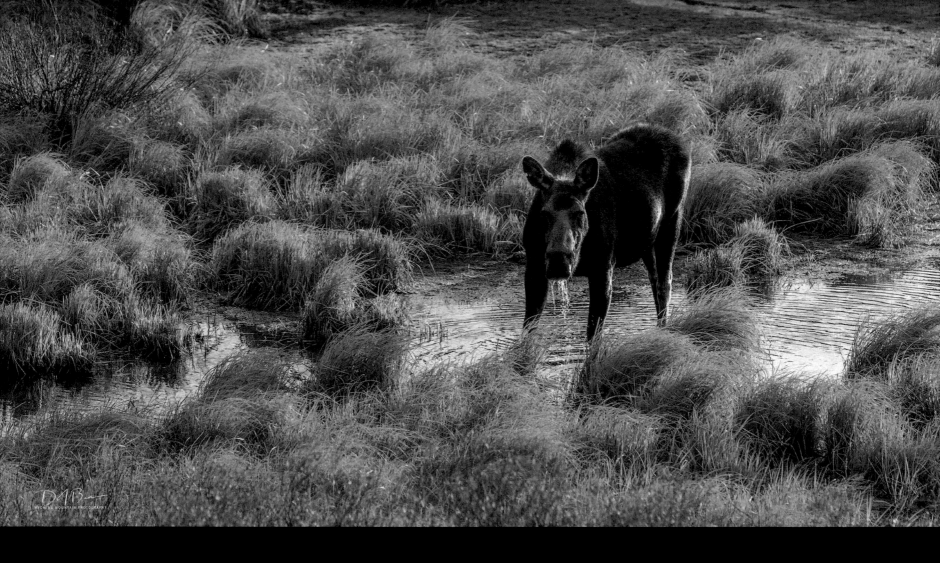

Momma

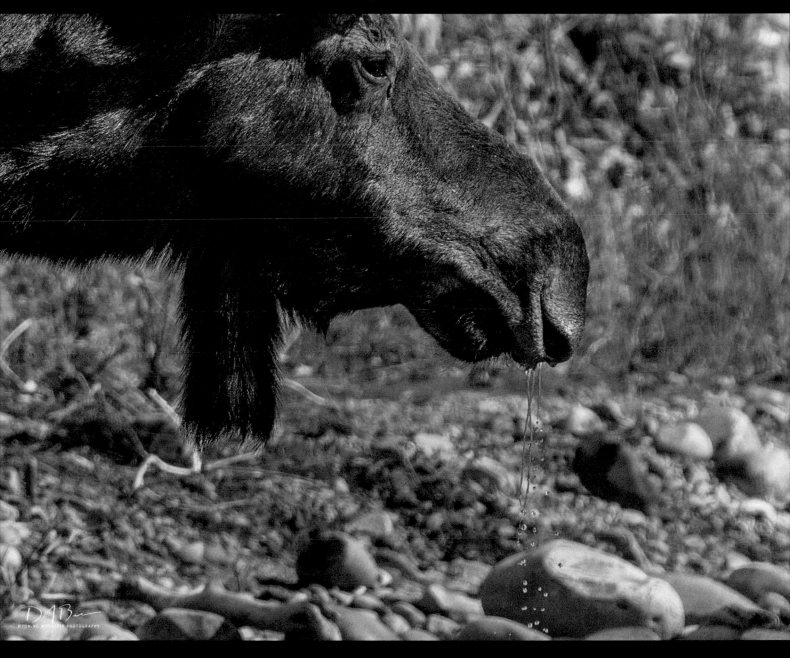

Drippy

October

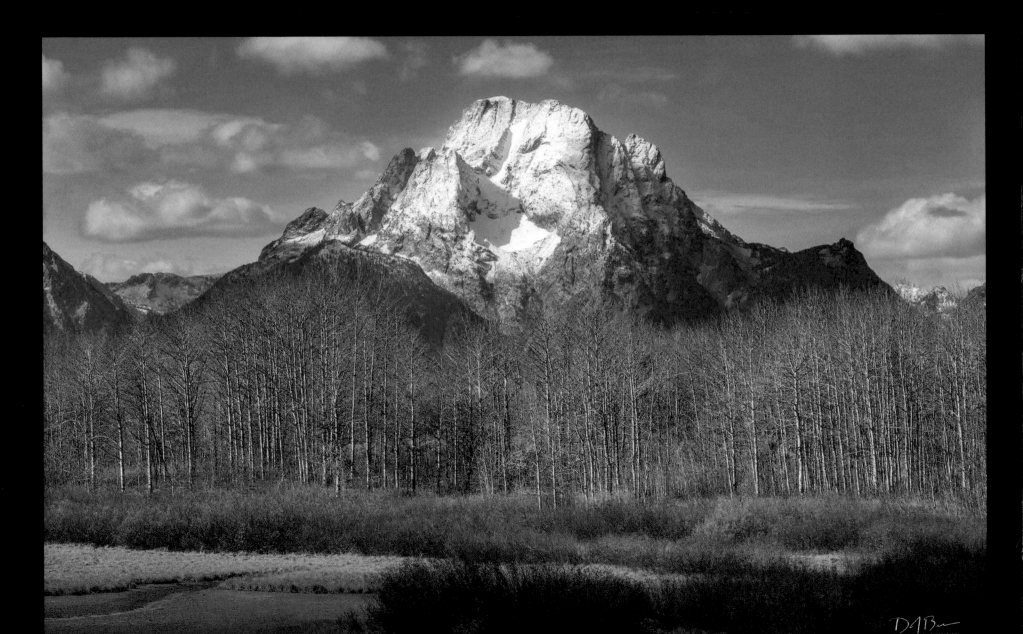

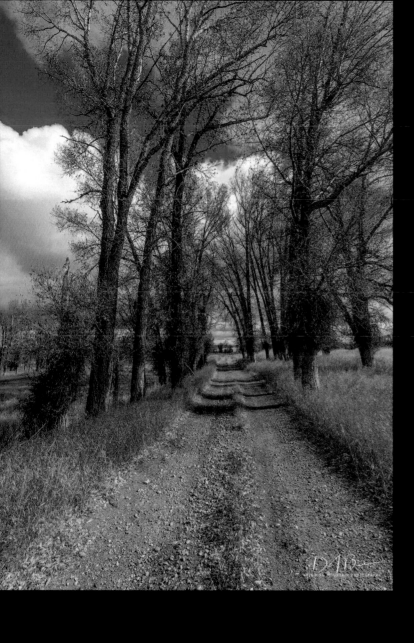

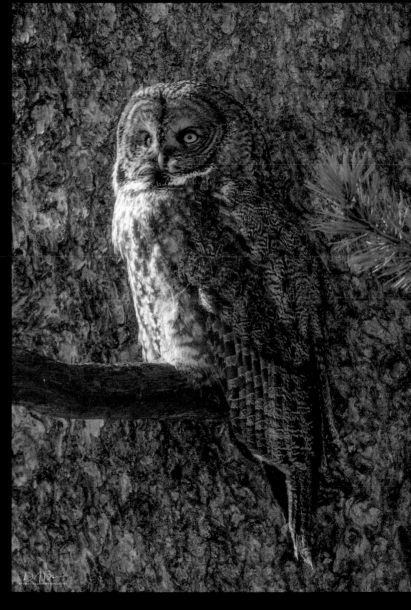

Ranch Road

Great Gray

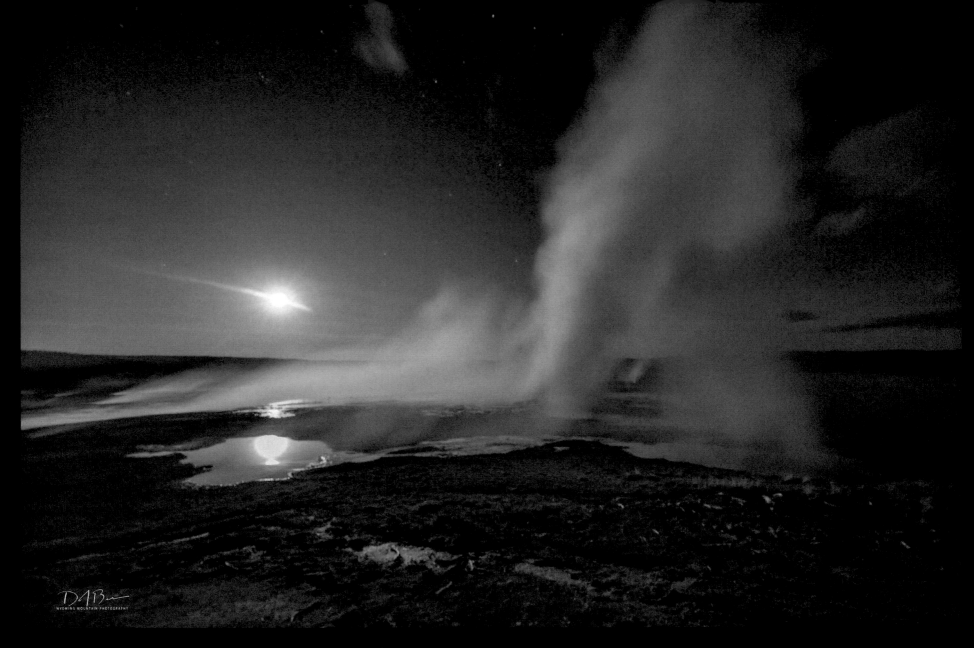

Fountain Geyser - Lower Geyser Basin

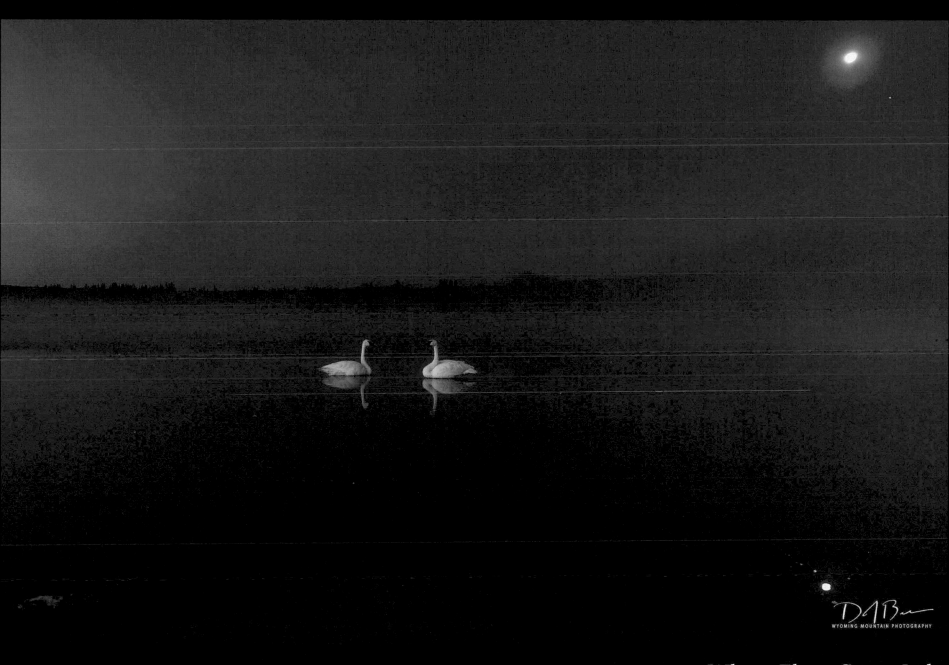

Where Else - Swan Lake

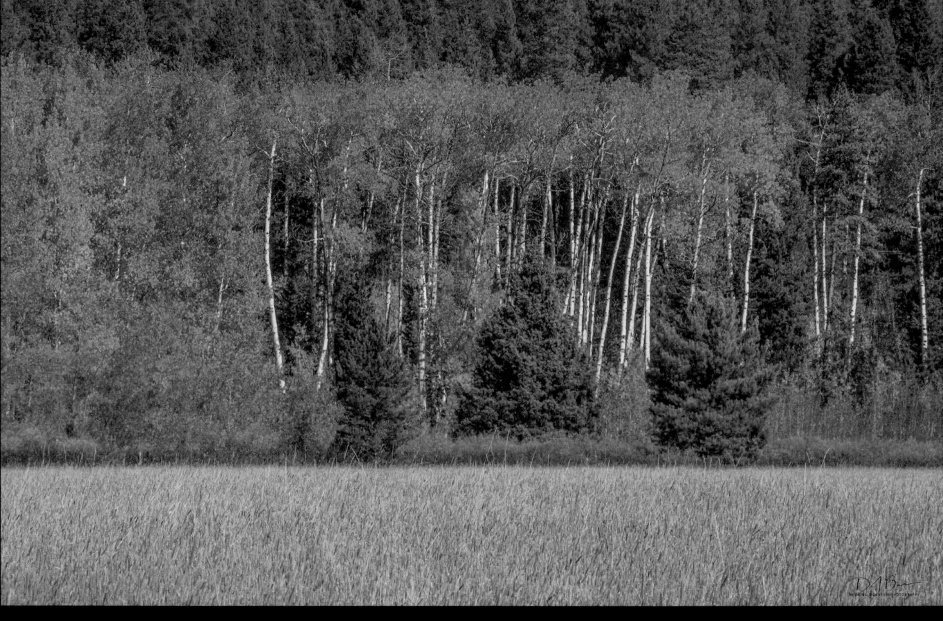

Orange at the Wheat Field

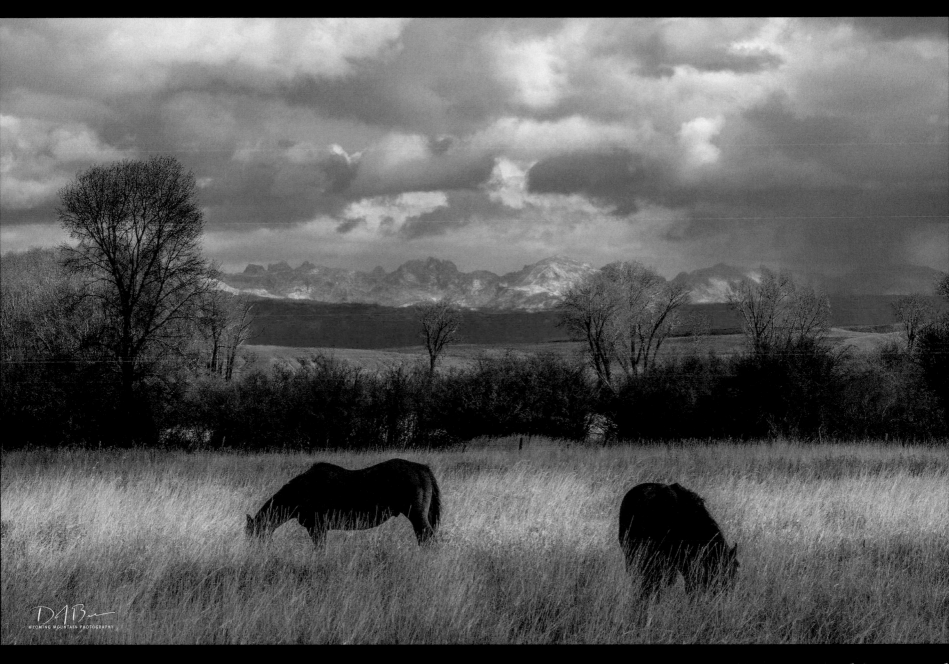

Horses Working Hard

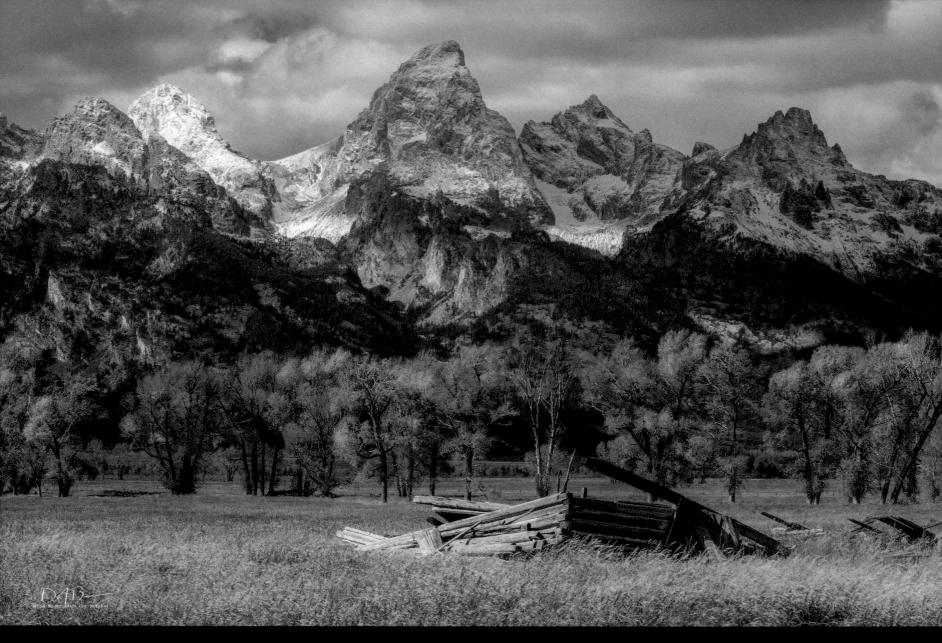

Fall Beauty In The Tetons

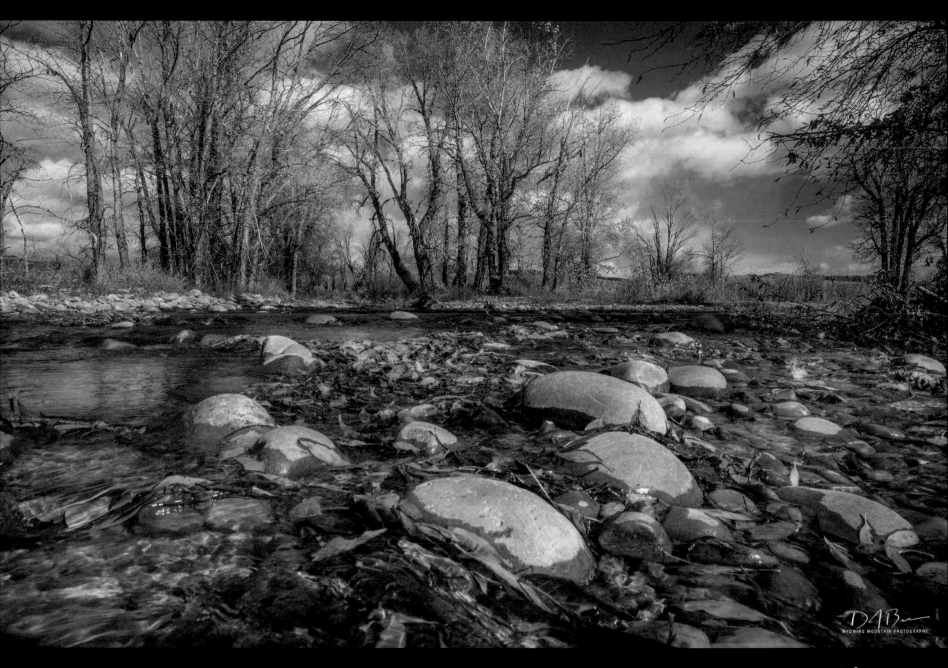

Remnants Of Summer

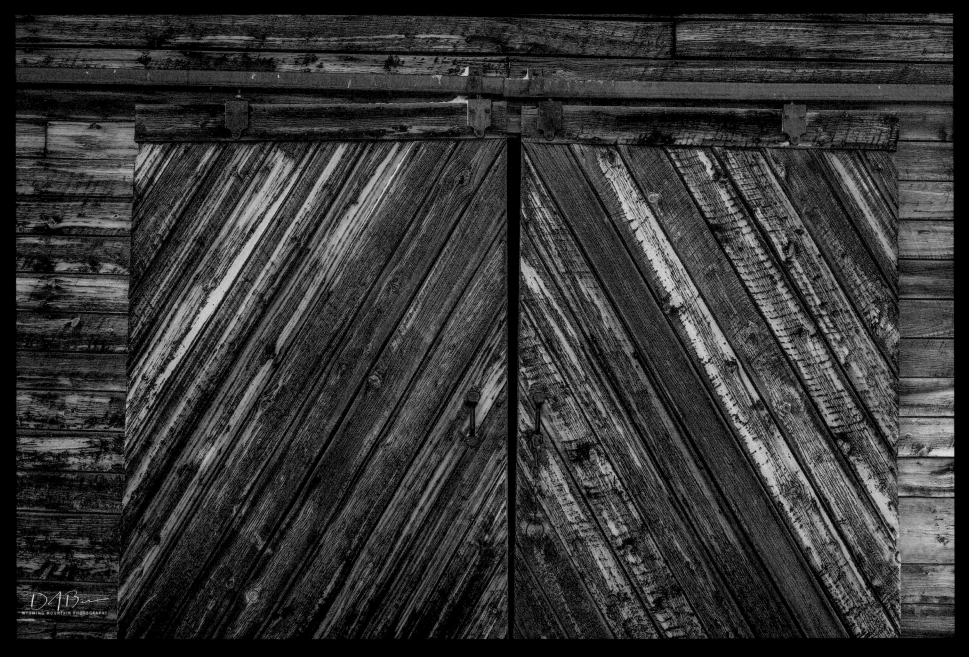

Pride

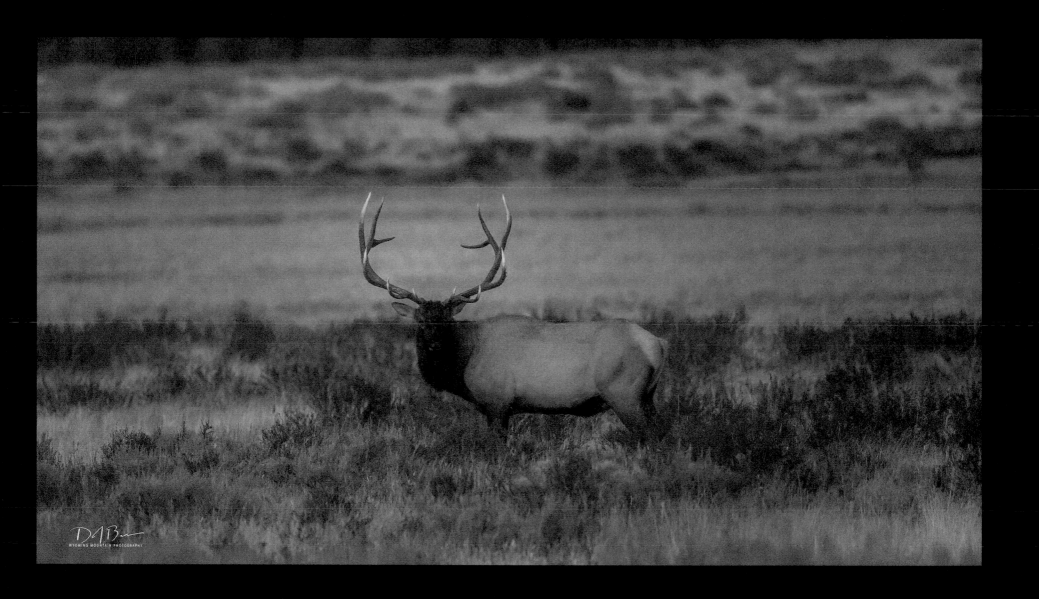

Eyes On Me

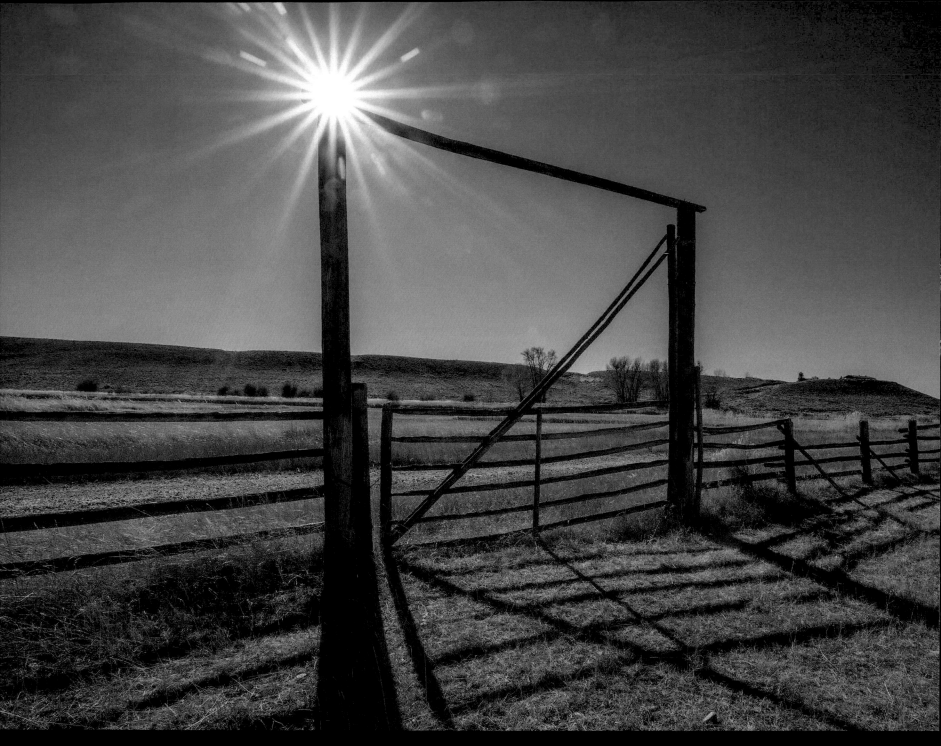

Ranch Gate Shadows

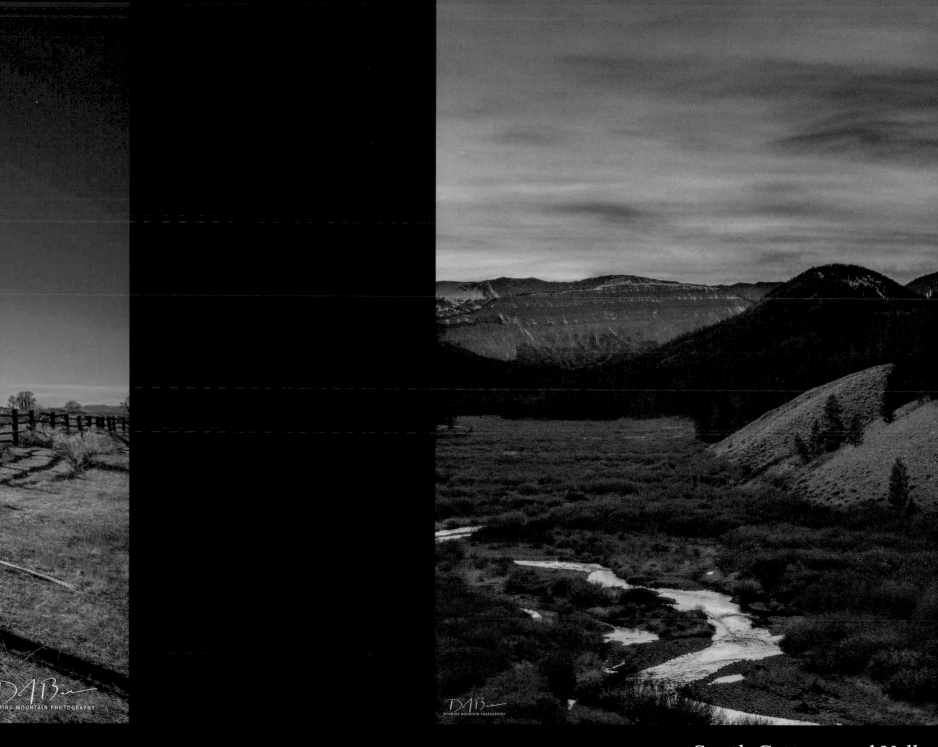

South Cottonwood Valley

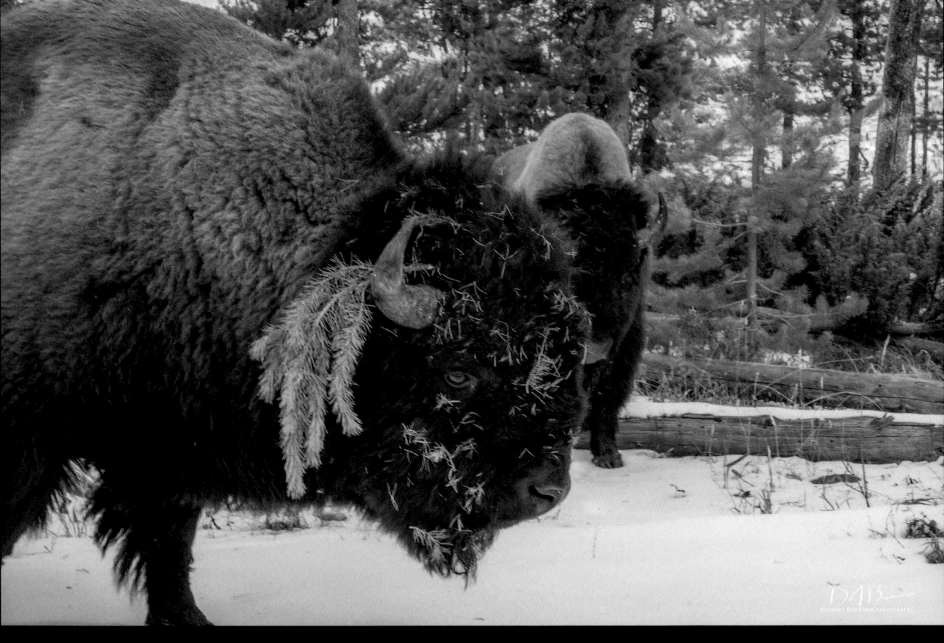

Deck The Halls

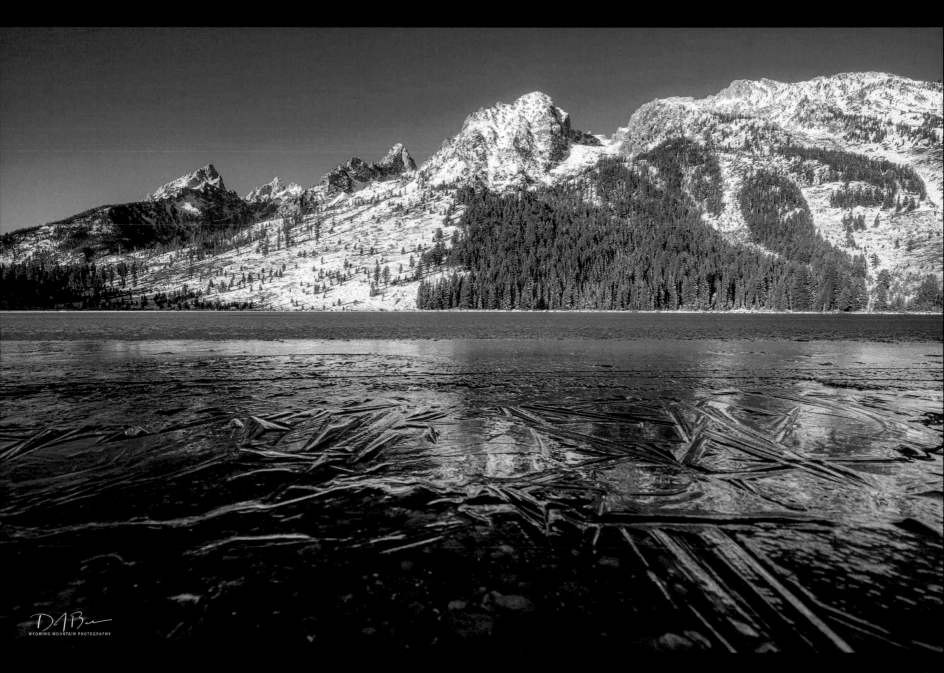

Fresh Ice On String Lake

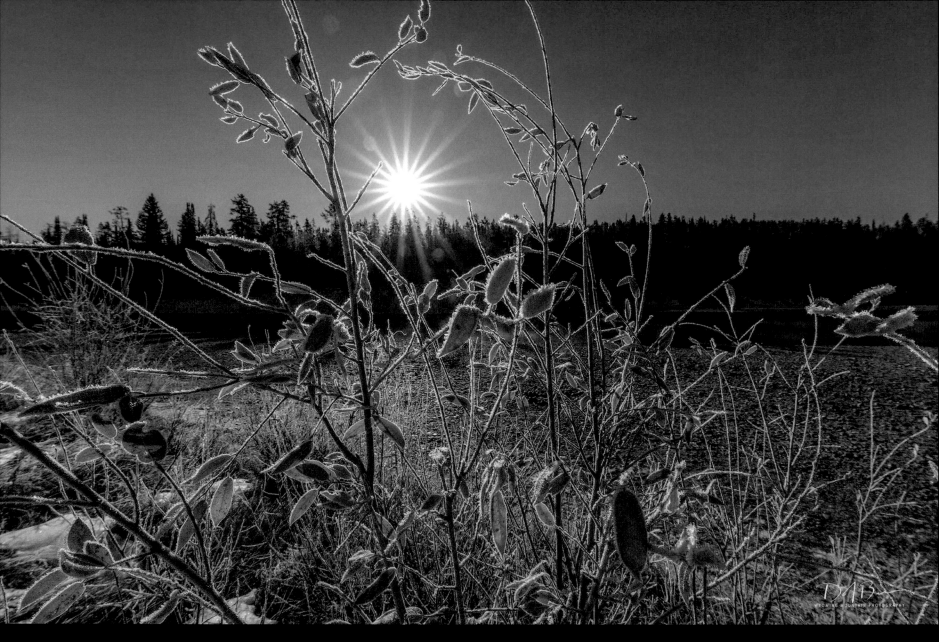

Frosty Morning

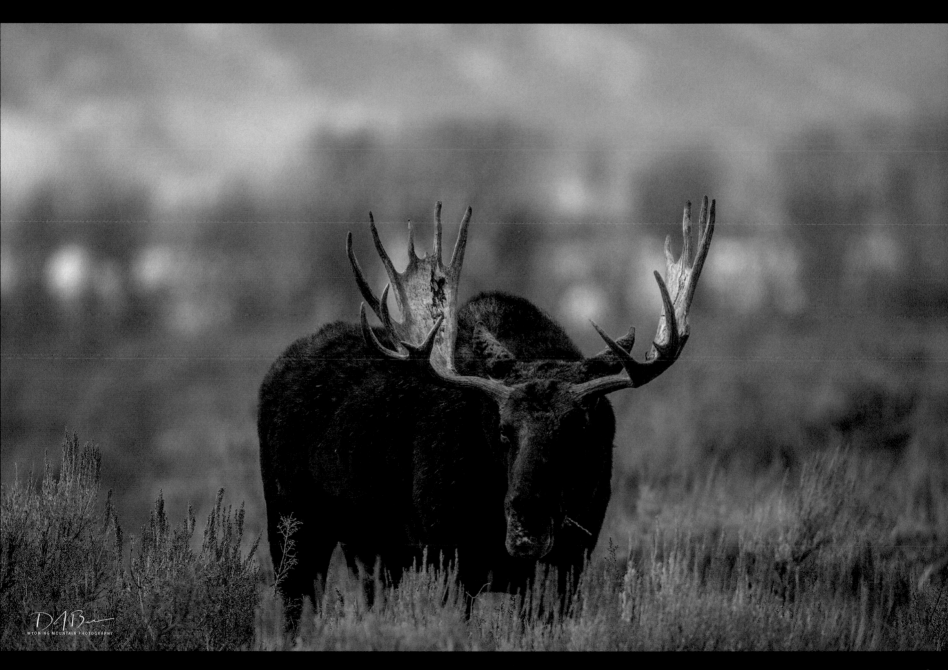

Mr. Beautiful

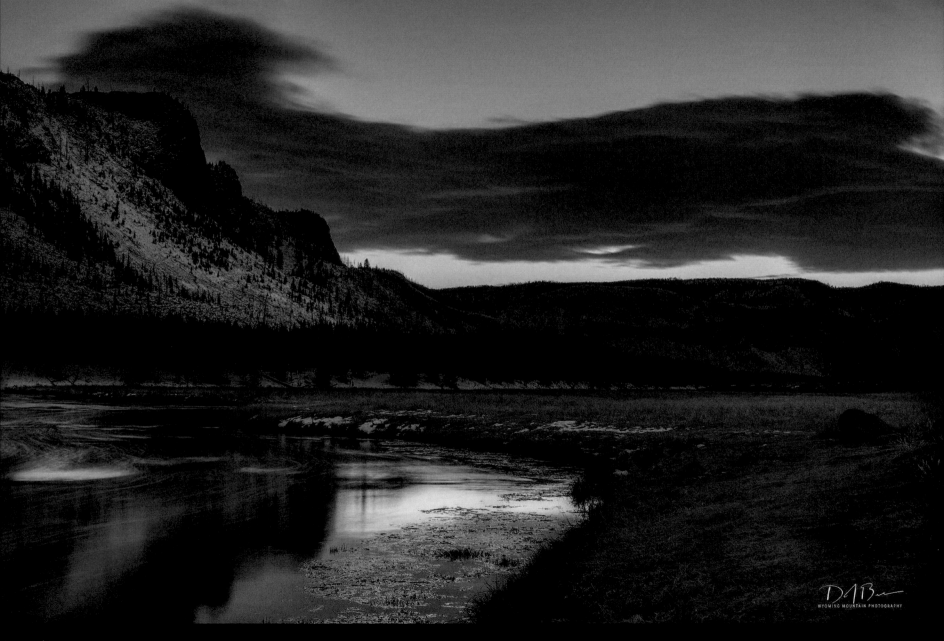

Madison River Sunset

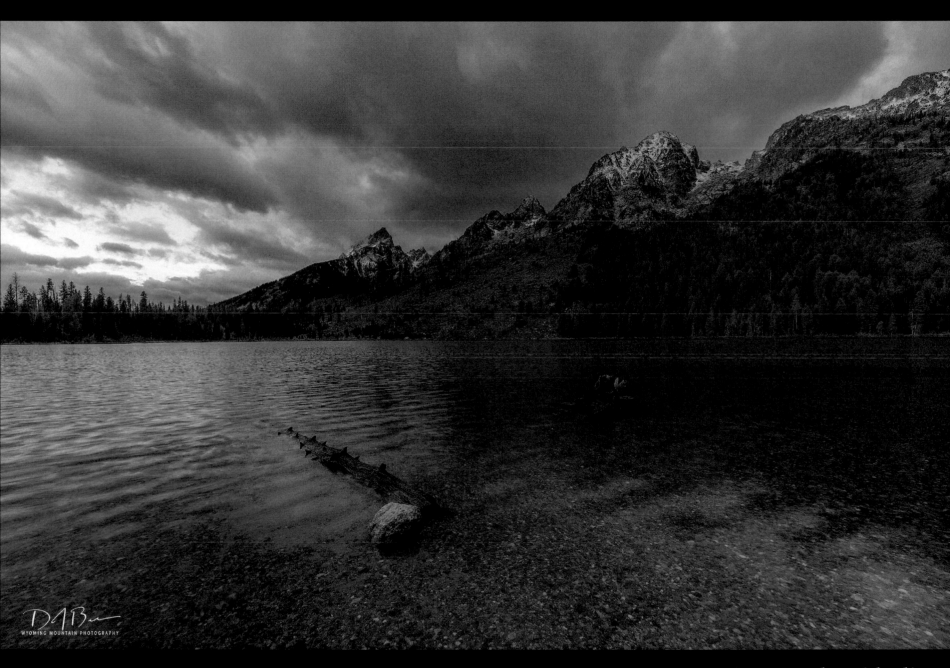

Sun On the Ridgelines

NOVEMBER

Move To The Lake

In November we made a move from our house to our cabin on Fremont Lake to avoid remodeling which was on-going at the house. We were able to witness the lake transition from summer "warmer" water, to nearly freezing, to frozen, producing ice as clear as glass, which occurred after the first of the year (not in this book). Watching this 600-foot-deep high mountain lake transition to winter was absolutely amazing.

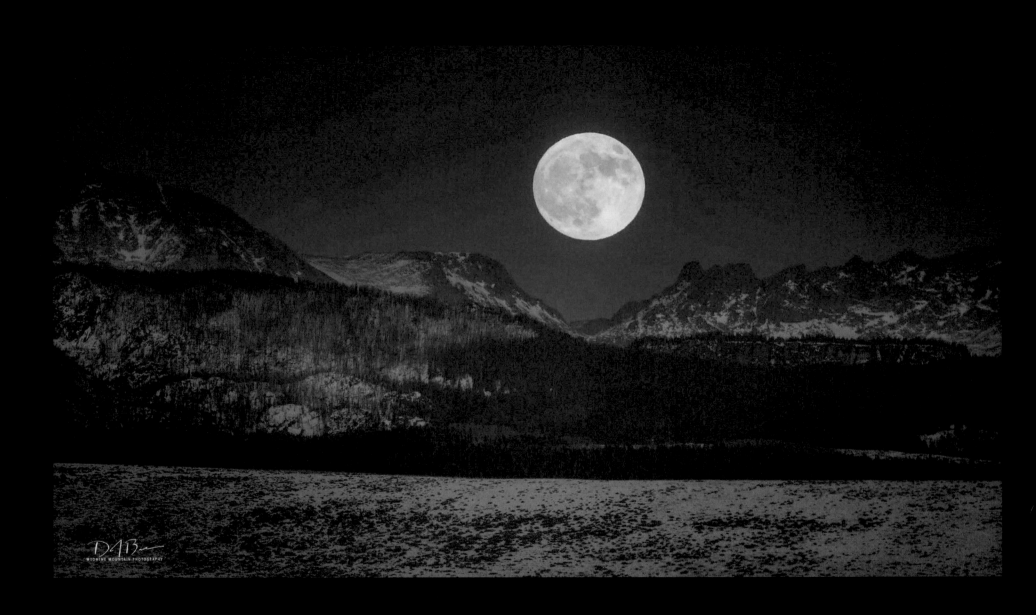

Squared Up On Indian Pass

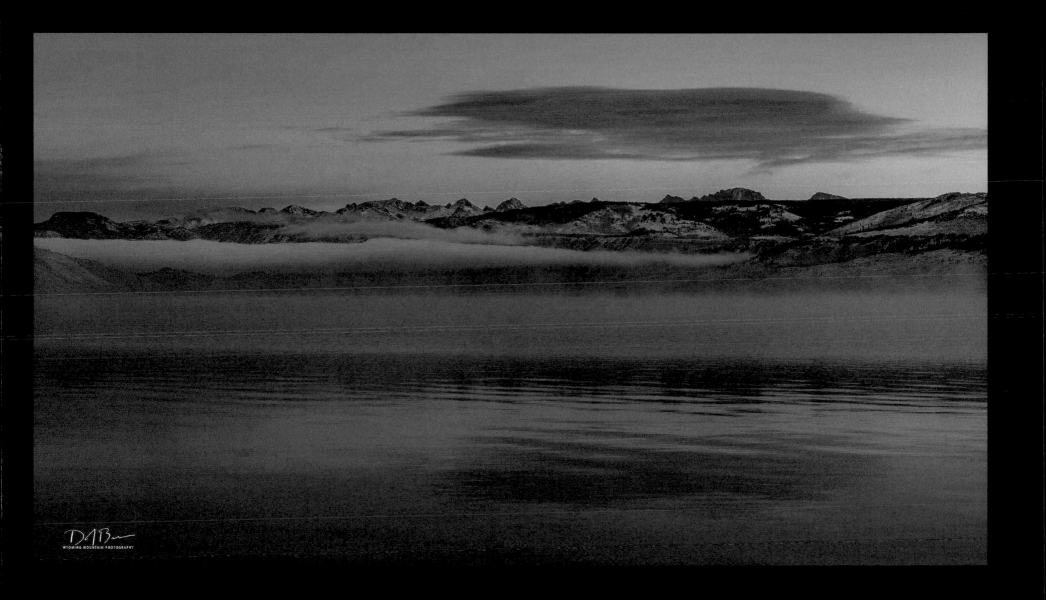

Morning Beauty

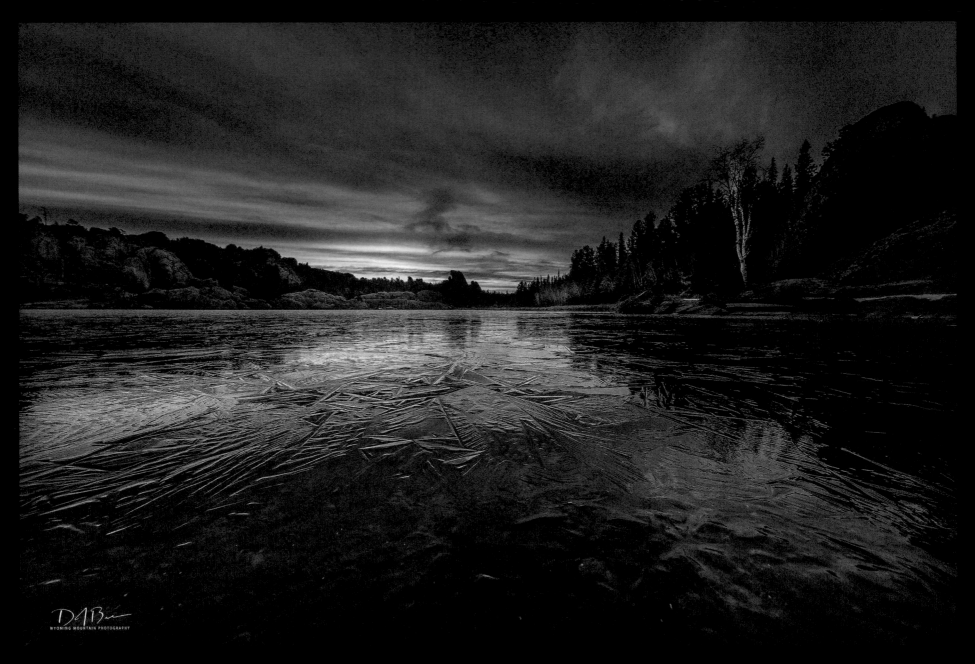

Icy Reflections

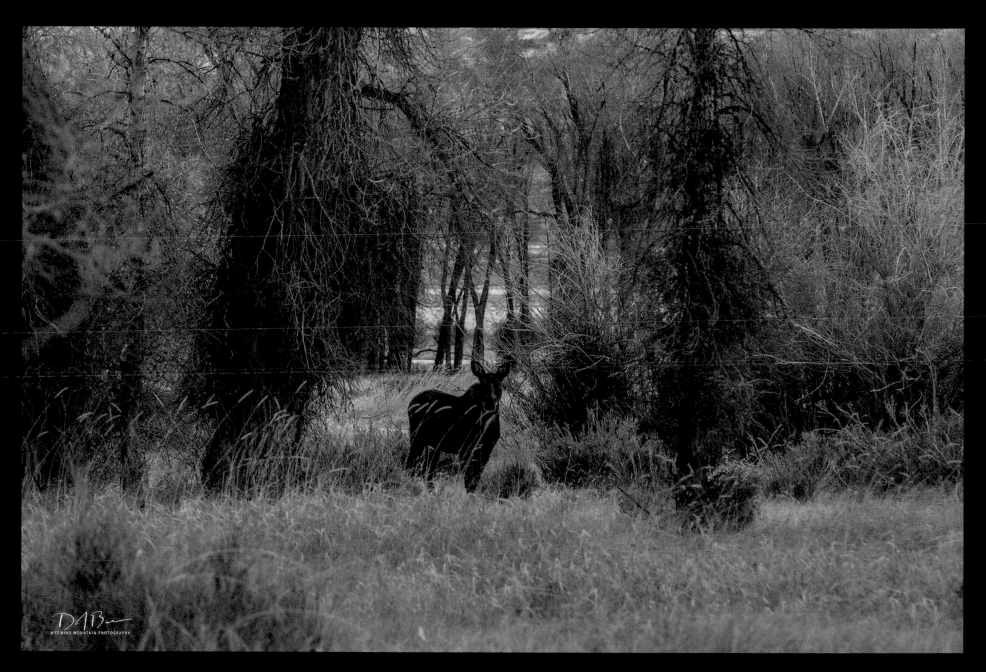

Morning Moose

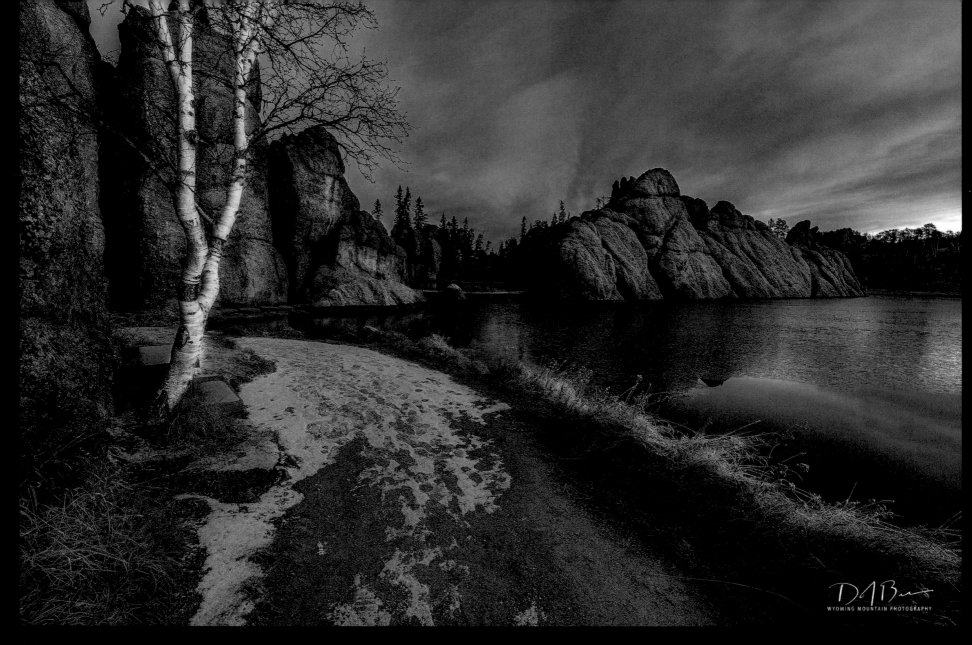

Morning Granite – Sylvan Lake

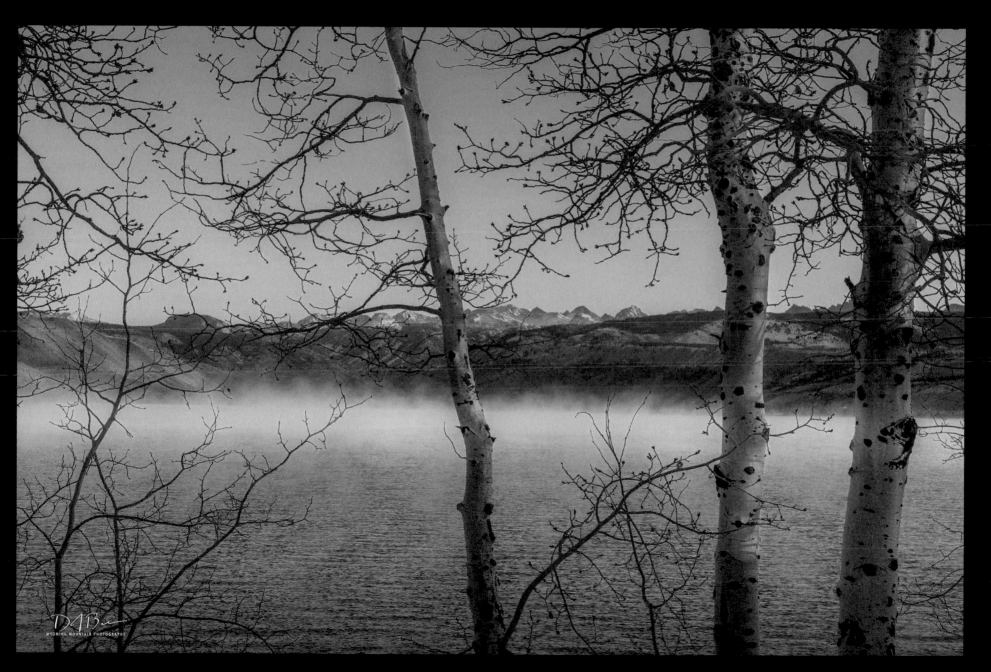

Chilly Early Light

Amazing Water And Color

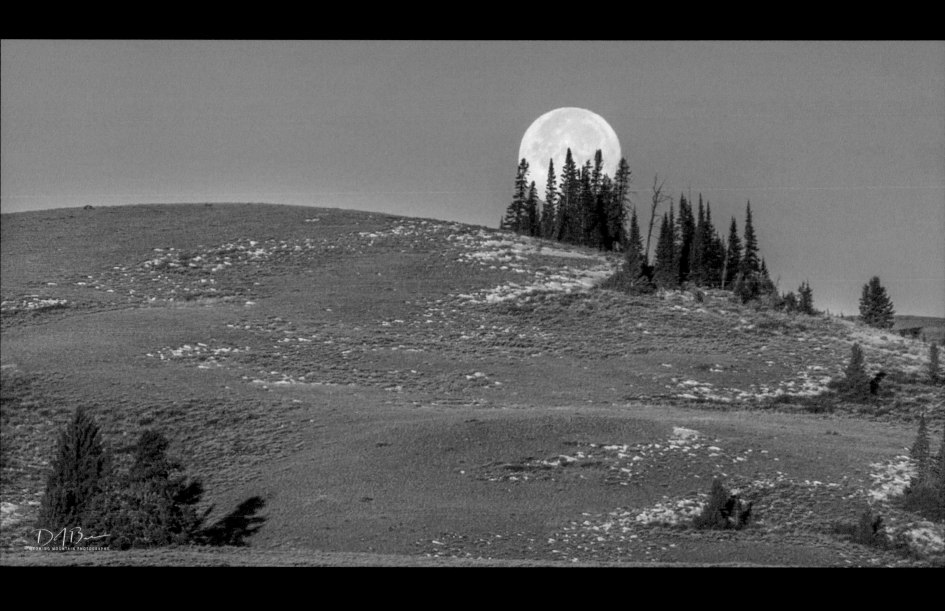

Full Moon Set

DECEMBER

Family and Freeze-Up

The month of December is traditionally a month of family, Christmas and the joys of the season. This year was no exception. We counted our blessings, living in western Wyoming, far, far away from the trials of the big cities and the maddening crowds. In our lives, the year had been a trying one, but not like it has been in many other places. It has been a year of family and the joys of living in Wyoming.

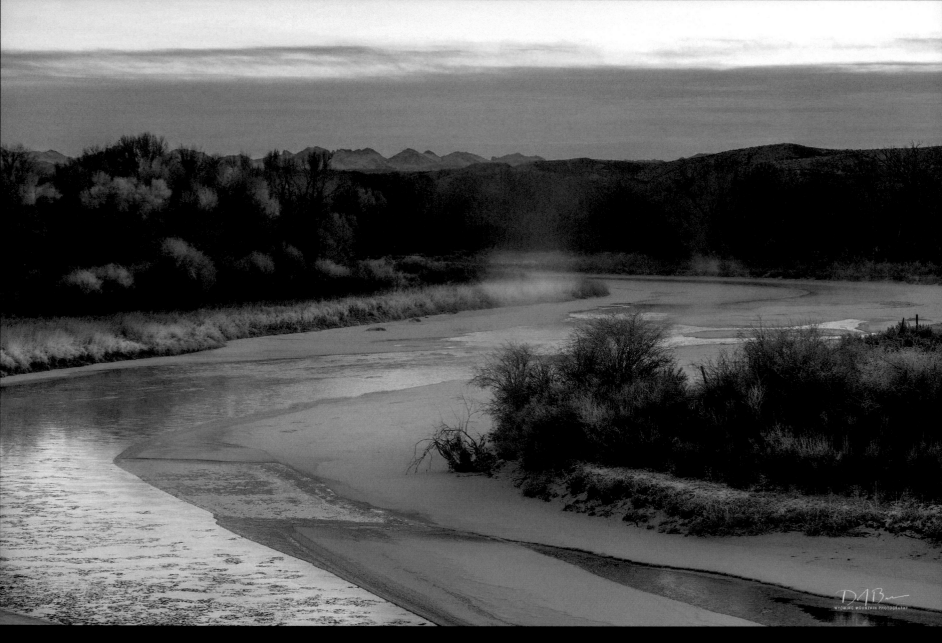

New Fork S-Curve

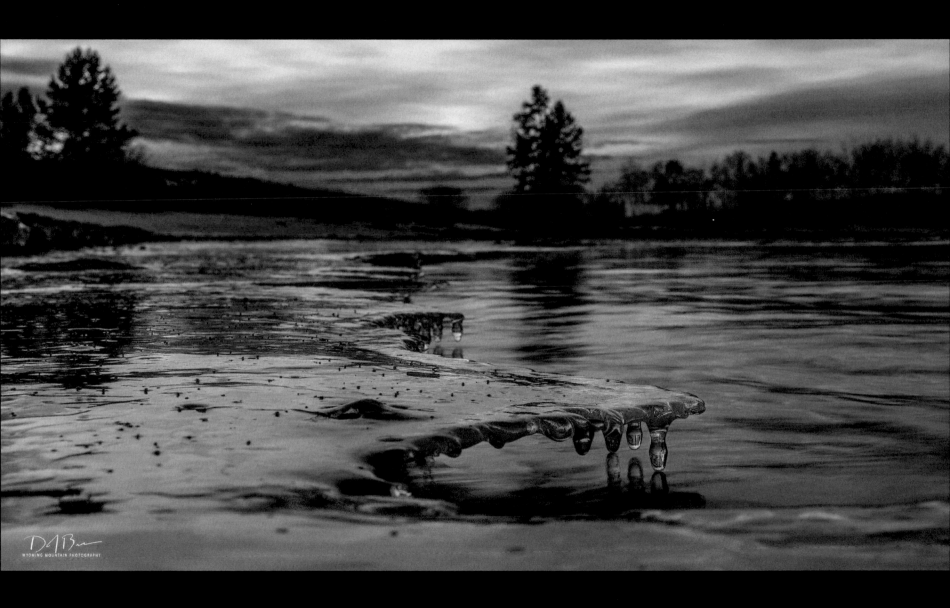

On The Ice Again

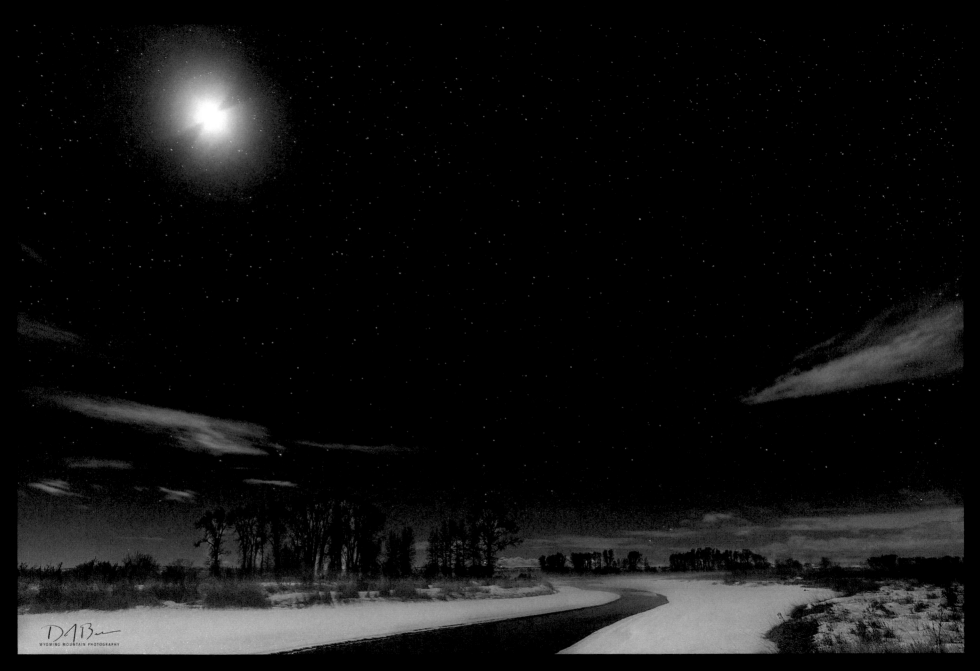

Starry Night On The Green

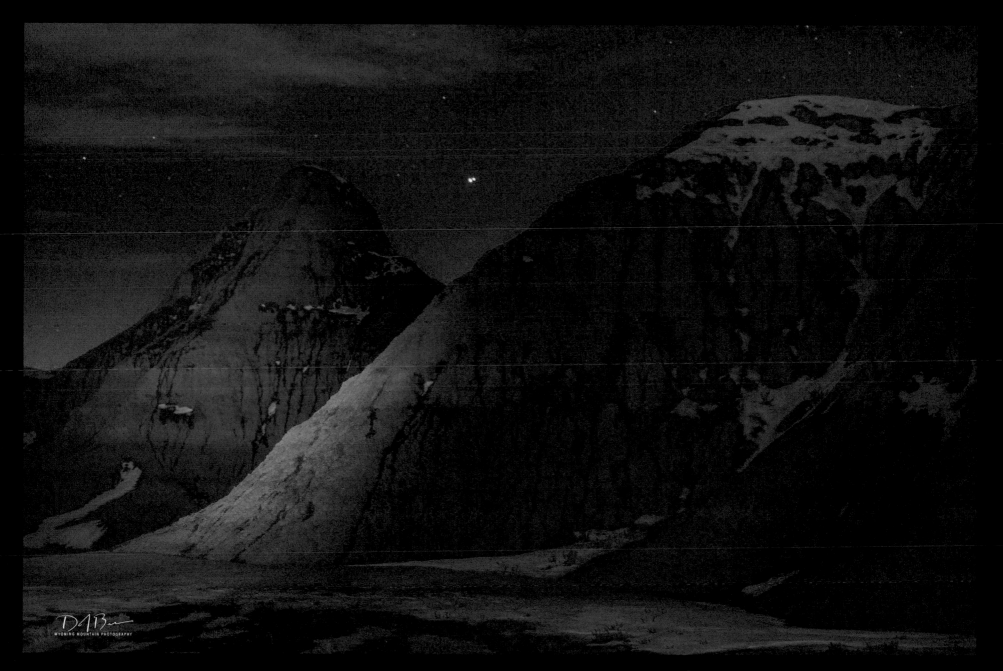

Saturn Jupiter Conjunction Junction

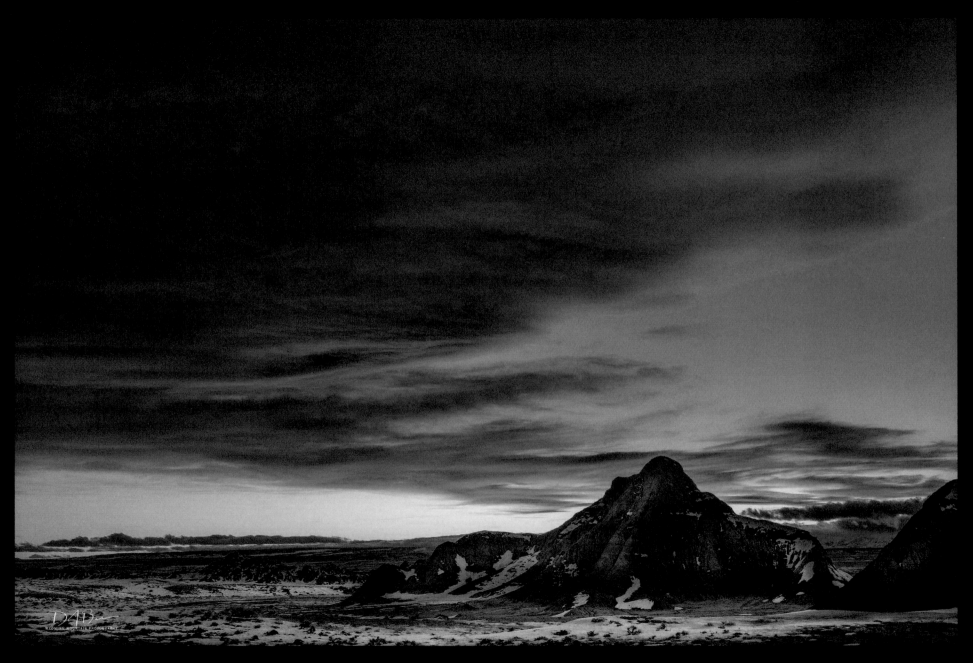

Beautiful Butte

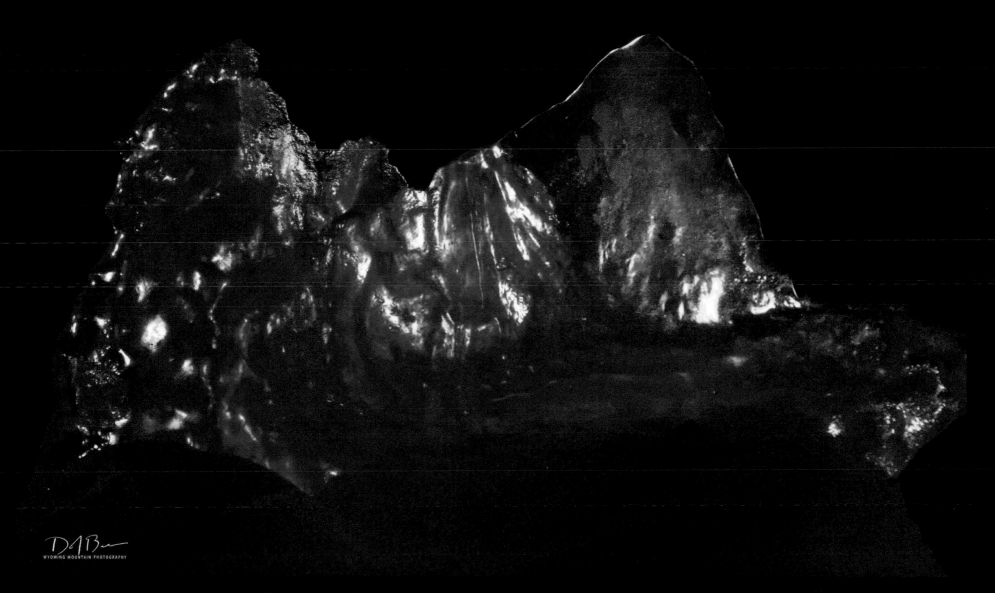

Christmas Ice

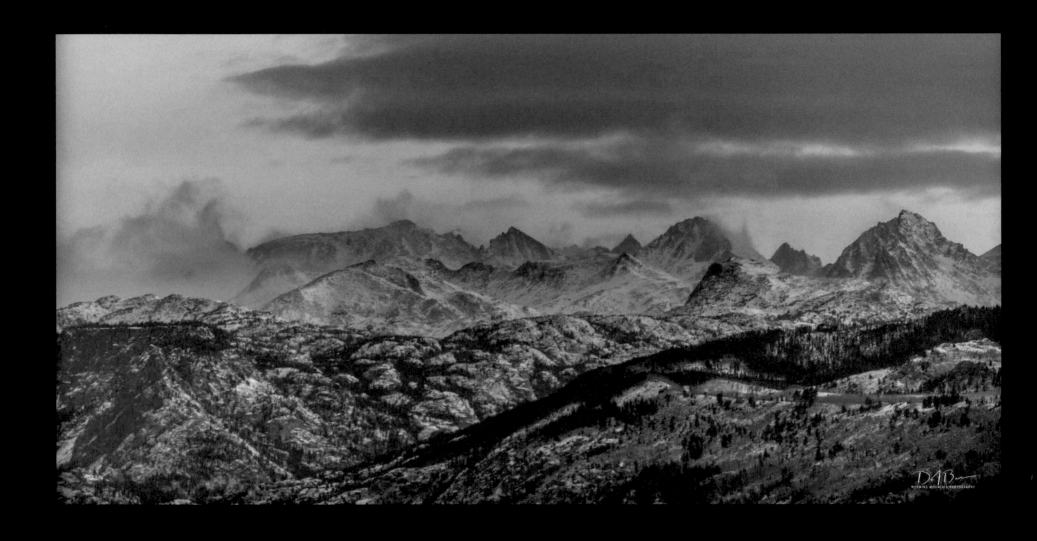

Stormy

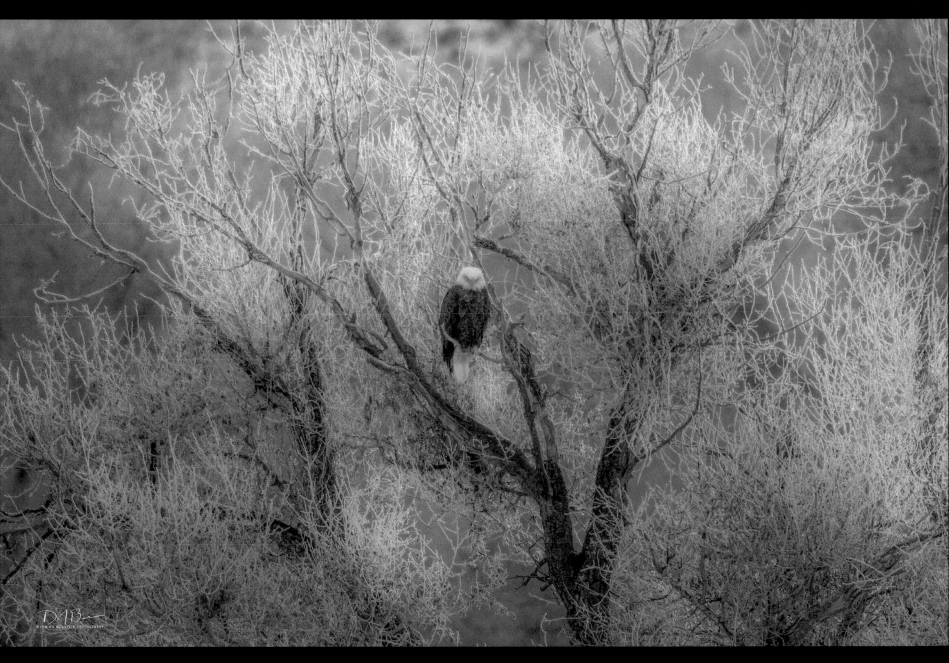

Frosty Eagle In A Frosty Tree

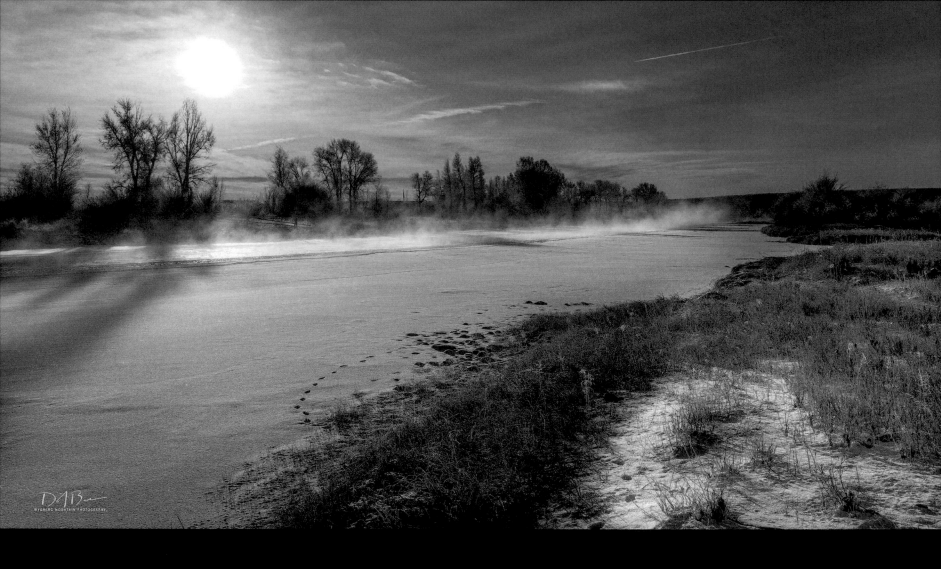

Cold And Steamy

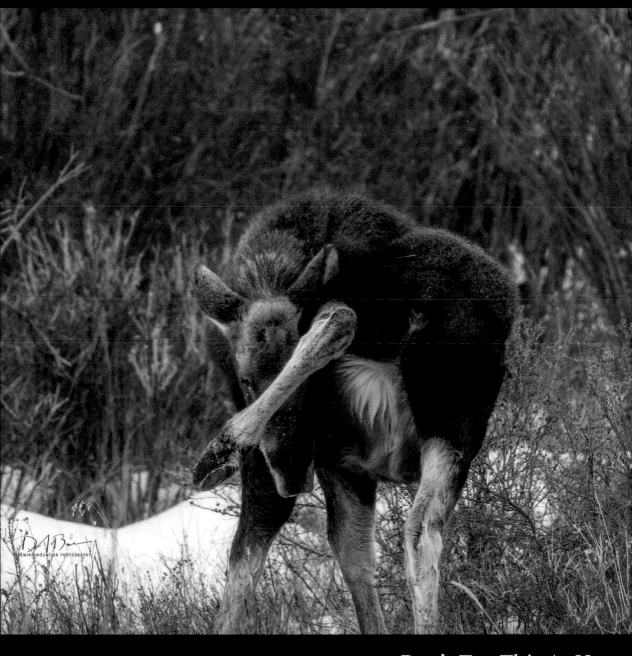

Don't Try This At Home

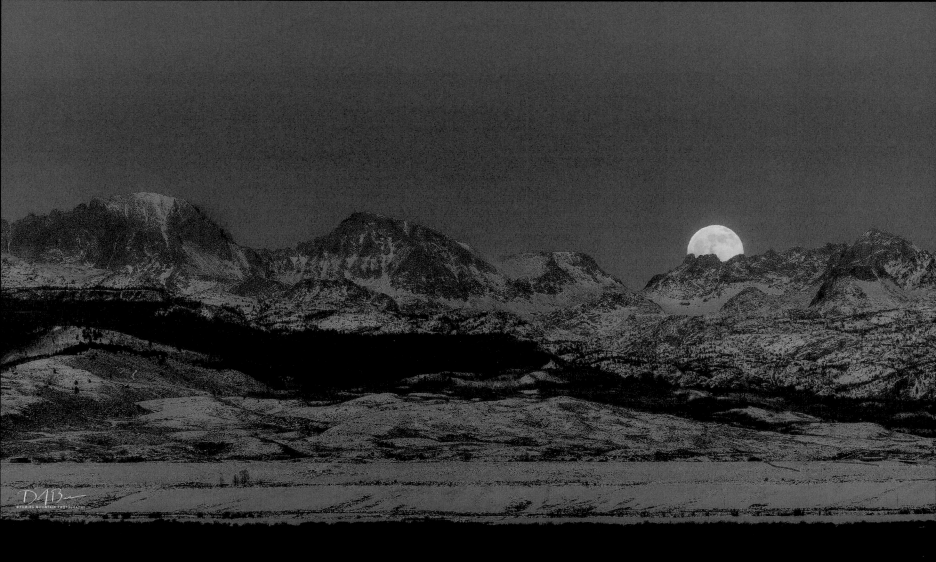

Moon Rise

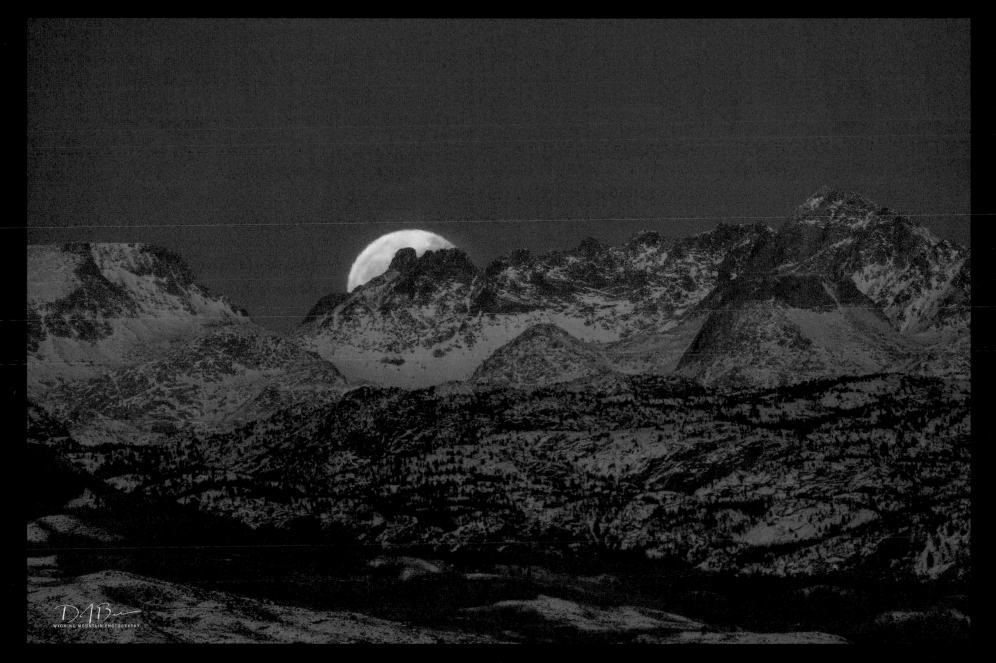

Just a Sliver